We cannot tell the precise moment
when friendship is formed. As
in filling a vessel drop by
drop, there is at last a
drop which makes it
run over; So
 in a
 series of kindnesses
there is at last one
which makes the heart
 run over.
 ...James Boswell

You are such a
wonderful part of
my life.

Jul
'99

Best Friends

ALSO BY SHARON J. WOHLMUTH AND CAROL SALINE

Sisters

Mothers and Daughters

Best Friends

by *Sharon J. Wohlmuth & Carol Saline*

DOUBLEDAY

NEW YORK LONDON TORONTO SYDNEY AUCKLAND

To Larry, my husband and my best friend;
your enduring love and wonderful humor have sweetened my life.

—S.J.W.T.

To my best friends, Roz and Elaine, whose loving counsel, comfort and concern
have enriched and sustained my entire adult life.
To the bird, a nest; to us, friendship!

—C.S.

PUBLISHED BY DOUBLEDAY
a division of Bantam Doubleday Dell Publishing Group, Inc.
1540 Broadway, New York, New York 10036

DOUBLEDAY and the portrayal of an anchor with a dolphin
are trademarks of Doubleday, a division of Bantam Doubleday Dell Publishing Group, Inc.

Book Design by Brian Mulligan

Library of Congress Cataloging-in-Publication Data
Wohlmuth, Sharon J.
Best friends / by Sharon J. Wohlmuth and Carol Saline. —1st ed.
p. cm.
1. Friendship. 2. Friendship—Pictorial works. I. Saline,
Carol. II. Title
BF575.F66W64 1998
302.3'4—dc21 98–37921
CIP

ISBN 0-385-48126-8

December 1998

First Edition

1 3 5 7 9 10 8 6 4 2

Acknowledgments

From Carol and Sharon:

First and foremost, we thank all the participants in this book for letting us into their personal lives and sharing their deepest feelings about friendship.

Our hearts and minds also thank all the following people:

Ellen Levine, our wonderful agent and treasured friend; Pat Mulcahy, who is not only our sensitive editor but a first-rate cheerleader, mediator and nurturer; Denell Downum for her ever-cheerful efficiency and judicious editing; our enthusiastic publicists, Sandy Mendelson and Judy Hilsinger, for putting us on the map and keeping us there; Bob Asman for his good humor, superb darkroom skills and inability to say no—and his daughter Krista for giving us so much of her father's time; Iris Kislin for her kindness in using her many contacts on our behalf; Alan Halpern, the kind of editor every writer wants to have; Cathy Clark, our able personal assistant, for consistently performing any task with speed and grace.

And for their friendship, valued advice and assistance in many different ways: Ed Bacon, Joseph Dibella, Arlene Friedman, Ned Hallowell, Gary Haynes, Suzanne Herz, Roger Hess, Eliot Kaplan, Jay McDonald, Dr. Elliot Mancall, Kim Marshall, Kenneth Norwick, Jill Peterson, Manny Pokotilow, Mario Pulice, Carissa Rosenberg, Amy Sprinkle, Randy and Janet Swartz, Connie Tavel, Singer Travel and Judy Thomas.

From Carol Saline:

Creating this last book in our trilogy about relationships has been both exhilarating and exhausting. The production of three books in six years has taken me on the high-speed ride of a lifetime, and I am grateful for the companions who've sustained me on this amazing journey. I thank my mother, Gertrude, and my family— Sharon and Kenny, Matthew and Rachael, Patsy and David—for putting up with my crazy schedule and providing me with unfailing stress relief through the best medicine of their loving support. To my circle of intimate and beloved friends—Roz, Elaine, Joyce, Freyda, Barbara S., Beverly, Rosanna, Hope, Ros P., Henri, Mike—my thanks for your endless patience and comforting concern for my well-being. And to the memory of my father, whose friendship I dearly miss.

From Sharon J. Wohlmuth:

The seeds of *Sisters* flourished into *Mothers and Daughters,* and now, *Best Friends.*

This three-volume experience has changed my life in profound ways; but throughout, the constant has been the love, encouragement and support of friends and family.

To my sister, Beth Josolowitz, you inspired me to begin this journey, and I am forever grateful.

To Maya, Seth, Zachary, Philip and Aaron, your wondrous and youthful enthusiasm never fails to lift my spirits and lighten my heart. I'm so glad we're friends—in addition to my being your Auntie Sharon.

To Gary, Rachael and Matthew, you all provide humor, good common sense and many surprises.

To Tugger and Lucy, your feline brains may be small but your gift of love and companionship is beyond words.

To Morrie Schwartz, I send you a kiss.

To the Venus Club . . . the Photo Girls . . . and to all my wonderful friends, you are extraordinary people who have touched my life.

*"Think where man's glory most begins and ends,
and say my glory was I had such friends."*

— William Butler Yeats

Contents

Introductions

I know what it means to have best friends. My friendships—several of thirty and forty years' duration—are the food and water that nourish my life. Once someone joins my intimate circle, I'm positively tenacious about keeping them in my loving grip.

Oh yes, I know what it means to have best friends. Let me tell you about Roz and Elaine.

"Ra Rut," as I used to call her, came into my life when I was three years old and her family moved into the identical row house directly across the street. One day she pushed me off my tricycle. I immediately forgave her. We've been best friends ever since. As children we talked about linking our houses with tin cans and string, but we never bothered because the only time we were apart was while we slept.

Our one and only major fight occurred when I lost the election for president of our high school sorority—and Roz won. I was utterly devastated that my best friend would oppose me. Friends aren't supposed to do that! But within a few days, something in my adolescent anguish realized that being friends with Roz mattered more to me than being angry with her. At some unspoken level, I think I recognized that if she wanted something as badly as I did, we both had the right to go for it. There had always been a subtle competition between us. Wherever one of us set the bar, the other strove to match the standard. But rather than creating friction, our rivalry stimulated our personal growth.

We are a living history of each other's lives. Fortunately, our interests and lifestyles have developed along similar lines. One reason our friendship has remained vibrant for so long is that we never outgrew each other. We have grieved together for the loss of parents, and celebrated every joyous occasion from our own fourth birthdays to the fourth birthdays of our grandchildren. Roz is not my family—but she might as well be.

The last thirty-something years of our friendship have included Elaine, who slipped in with us when she and Roz became neighbors in 1962. We leaned on each other as we muddled through child rearing, adjusted to the demands of marriage and tried to figure out what to do with our college-educated dreams. In the year we all turned fifty, Elaine was stricken with a brain tumor, which, thank God, turned out to be benign. Roz and I convinced the doctor to allow us into the recovery room when she came out of anesthesia. As we stood by her bed, placing ice chips in her mouth and mopping her brow with compresses, we recognized that we were as committed in our devotion to each other as any bride and groom reciting their marriage vows.

While we three don't have childhood memories in common, we have weathered the critical years of adulthood in an inextricable intimacy. No one knows my secrets like they do, and no one's advice has been more caring or valuable.

Because of them, my wonderful sister Patsy and a handful of others, I have come to learn that what matters in life is having best friends.

So it is no surprise that Sharon Wohlmuth and I chose to complete our trilogy on relationships by exploring friendship. As with our previous books, *Sisters* and *Mothers and Daughters*, we continue to be drawn to subjects that evoke our passion and draw deeply on our personal experience. Thus it was natural to turn to friendship, which is one of the strongest fibers in the lifeline that keeps us all afloat.

We included men this time because our books are as much

about feelings as about people. And women do not own the friendship franchise, although the pivotal sisterhood of "girlfriends" certainly occupies a class by itself. Some psychologists have even suggested that the closeness of women friends is a reenactment of the instinctive mother-daughter bond.

Yet men are also capable of profound bonding, although in my interviews they often tended to describe their emotional attachment as "the kind of thing women have." Men assume that because women talk so easily to each other, they must reveal more about themselves. Not necessarily. Men can be as connected as women. They just behave differently. Men friends tend to meet around some kind of activity or common interest—like golf, tennis, bowling or business. Women friends tend to meet for lunch, using that activity as nothing more than an excuse for conversation.

But underneath, men and women share the exact same view of a best friend—the sense that this is a person who is always there for you. Someone you can depend on to share your happiness, suffer through your angst or cushion your sorrow. As one man put it, "To me a best friend is somebody that you call if you're on the expressway and get a flat tire at three A.M. and you've been told it's four hours until a tow truck can be sent. Your friend says, 'Tell me exactly where you are and I'll come and get you.'"

A great variety of factors play into the birth of a best friendship—the age and circumstances under which people meet, what first attracts them, why they remain close, how they fill each other's needs. Yet I found the dominant themes that define a best friend were remarkably similar across the broadest range of experiences.

"Safety" was a word I heard over and over. A best friend is a safe harbor. A guaranteed comfort zone. You never have to explain yourself to a best friend because they really, really know who you are. With a best friend, you can drop your guard and let down your hair. You can cry too hard or laugh too loud and never worry what they'll think of you. Because best friends are *nonjudgmental*. They will supply you with feedback or advice if you want it and a kick in the pants if you need it, but a best friend will not stand in judgment or make you ashamed of your behavior. A best friend gives you what you expect from a parent and don't always get: *unconditional love*.

Like Boy Scouts, best friends are *loyal* and *trustworthy*. A best friend is a love affair without sex, a twenty-four-hour intimacy hotline, a vessel where we can store our most embarrassing, revealing and damaging personal secrets with the full confidence they will never be repeated. Best friends can deliver brutally *honest* answers in the most gentle fashion. And best friends are a *mutual admiration* society. What you see reflected in your best friend's eyes is the wonderful person you want to be.

Best friends are the *family we choose*—without the family baggage. They love us because they want to, not because they have to. And for many of us a best friend becomes the sibling we'd hoped for but never had, either because our parents never provided one or because the sister or brother we've been assigned doesn't live up to our expectations.

A man I knew asked his mother on her deathbed, "What has been the most important thing in your life?," fully expecting she'd say her husband, her children or her family. Instead, without a moment's hesitation, she replied sweetly, "My friends."

To everyone who receives our book from a friend, accept it as their tender message of love and appreciation. This gift tells you that, like me, you are blessed to know what it means to have best friends.

— *Carol Saline*
1998

In the room in one's brain where memories are stored, I find it difficult to retrieve images of myself as a young child playing with a best friend.

Nor can I search and retrieve from boxes of old childhood photographs many images of myself smiling into the camera with my arms wrapped around a best friend. In most of the photographs I am with my relatives—cousins, aunts and uncles at our Sunday family gatherings.

Yet, there are dozens of pictures of my sister, Beth, and her best friend, Joanie, our neighbor—toothy three-year-olds embracing in Halloween costumes; and now, forty years later, still with their arms around each other at Beth's son's bar mitzvah. Their friendship over the years has become as well worn as the path that connected our backyards.

Why there are so few pictures of my own childhood friends doesn't really seem important to me now.

I realize as an adult that, unknowingly, my own journey to friendship began with a two-hundred-year-old oak tree that stood between my parents' and our neighbors' houses, dominating the landscape.

The oak provided the perfect "home" for the games of hide-and-seek that we used to play. I loved the texture of its worn bark.

The massive trunk, too large for me to wrap my arms around, represented permanence and security.

My friends today remind me of that oak.

Now my arms reach all the way around, and my friends embrace me back. These friendships, full of love and affirmation, fortify my adult life, providing oxygen, color and texture. I look at my friends countless times every day, for photographs of them spill across my refrigerator door.

We explored a wide spectrum of relationships in *Best Friends*, as we did in our other two books, but in this one I found the same themes resonating throughout: trust, family, security, happiness, validation. Friendship is an elective bond, a relationship bound by connection and mutual admiration; and in many ways, it is all the more precious because something so powerful can spring from origins as elusive as a chance meeting or a shared interest. In the course of creating this book, and getting to know the many wonderful people who participated in it, I have become all the more aware that friendship is a uniquely valuable bond, one that we all need and should treasure.

Ironically, though, the process of making this book took me away from my own friends for long periods of time. Now, as I write this, I look forward to sitting down over many cups of tea and catching up with those I cherish.

— *Sharon J. Wohlmuth*
1998

Ali, Morgan and Juliette

Would you girls like to introduce yourselves?

"Hi. My name is Ali and I'm five-and-a-half. No, three-quarters, I think."

"You're five-and-a-half," Juliette corrects her.

"My name is Morgan and I'm six. Wait, I have to count because I might be six-and-a-half. I'm not sure."

"You're six," Juliette says.

"No! I am not plain six. My birthday was in February. And now it's June."

"And I am Juliette. I'm five-and-three-quarters, and my mommy says that we've been friends since we were one-and-a-half. We all go to school together."

"We get along very well," says Morgan. "You have to always like your best friend and *never* hurt their feelings or else they won't like you."

"We all take turns being the boss," Juliette says.

"Sometimes if me and Juliette hurt Morgan's feelings, we just say, 'I'm sorry,'" Ali pipes up. "Then we hug and kiss each other and say, 'I'll never do it again, and I'll still be your best friend forever.'"

"That time you came over to my house, you didn't do that," Morgan argues.

"I did," Ali reminds her. "I tickled you."

"Did not."

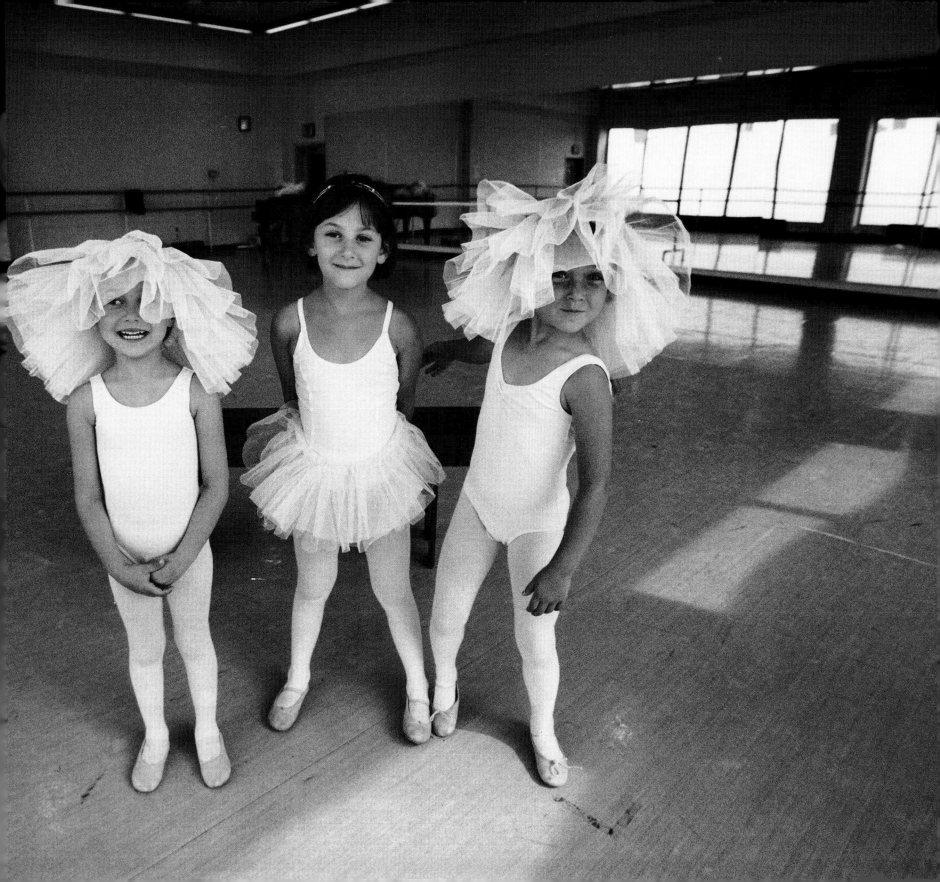

"Did too."

"What we always do is run away and chase each other," Juliette says. "And we start laughing and we get to be friends again. But, sometimes Ali and me aren't best friends 'cause I hurt her feelings. At lunchtime at school we get very, very mad at each other when I want to sit next to other people."

"Wait. Wait. Let me tell it," Ali breaks in. "When she doesn't sit next to me, she promises to do it the next day. And she doesn't break her promise."

Can you tell us what makes you best friends?

"We like to play with each other and stay over at each other's house and never let each other go," Morgan says.

"And we like to color together," Juliette adds.

"Once, because we were best friends, me and Juliette got married," Ali says. "We pretended we were the bride and groom. I put on a long black skirt so I could be a cool bride."

"First I was the boy," Juliette says. "And then *she* was the boy. And we said, 'I do, I do,' and we kissed each other and walked down the aisle."

"Another time, I married Morgan," Ali continues, "only *she* was a flower girl because she didn't want to be a *boy*."

"But our favorite game is playing house," Juliette says. "Morgan's the big sister. I'm the baby and Ali's the mom. Our daddies are in the war."

"No. They're in the army, Juliette," insists Morgan.

"Right. The army," Juliette agrees.

Could you make up a story about best friends?

"Once upon a time," Morgan begins, "there were three princesses and they each had their own palace."

"When they wanted to have a slumber party for their birthday, they would walk or take a limo to the other palace," Juliette continues.

"My palace was big, big, big. *Really* big and white with lots of balconies. And I had lots of sleep-overs," Morgan goes on.

"Mine was very big, too," Juliette butts in. "With towers that had very, very pointy things that made it look tall. And the rooms had pretty wallpaper with flowers. We got to be best friends because our moms went to camp together. And we really, really loved each other and cared about each other. One day a mean witch came to Morgan's slumber party and wanted to lock us up and put spells on us."

"One of the spells was to be her servant and take us far, far away to her castle in Paris," Ali joins in. "She took all three of us to this really scary house. With spiders in it. And red ants and green ants. It was very dangerous."

"And we loved each other so much, we didn't want anybody to get hurt," Juliette suggests.

"So we sneaked out the door and escaped," Ali concludes.

"You stole that part from me," Morgan pouts. "They had more turns than me. They did! I had a turn, then Jules had a turn, then Ali had a turn, then Jules had a turn, then Ali had a turn. So I don't want to say anything else about best friends." And she begins to cry.

"I'm sorry," Juliette says, taking her hand.

"Don't cry, Morgan. Don't cry. It's all right," Ali says sweetly, giving her a kiss on the cheek and wiping her tears.

"I love you," Juliette assures her with a hug. "I love you."

"How could anyone not like you?" Ali asks. "Why don't you finish the story?"

"Well," Morgan says, sniffling, "I was going to say—when the princesses grew up, they all lived together. Because they were best friends, they lived happily ever after."

Morrie and Charlie

"When I think of Morrie, I think of lightness and pleasure. And dancing. Morrie was a fantastic dancer."

Charlie sits in his cluttered professor's office at Boston College, unconsciously caressing a small book called *Letting Go,* written by his best friend, Morrie Schwartz, who died in 1995.

"On Wednesday nights we'd often go to something called Dance Free at a church in Harvard Square. It was a place where people either danced alone or in groups, but not touching. I carry this image of Morrie in blue sweatpants and a T-shirt, his white towel wrapped around his neck. He's swaying and weaving to his own rhythm with this wonderful, uninhibited expression on his face. A love machine in motion. That was Morrie. A walking, dancing love machine. I'd come from a stoical, chin-up kind of family, and Morrie took this constricted heart of mine and kept adding pieces to it. He showed me what a loving heart is all about. That was his legacy."

They met in 1969. Charlie, a fiery twenty-four-year-old radical, was recruited to teach at Brandeis College in the same department where Morrie, then in his mid-forties, was already a respected sociology professor. "I was very green. Very crazy. A wild young political advocate," Charlie says, "and Morrie was very sympathetic. He liked stirring the pot behind the scenes. He basically lived on an

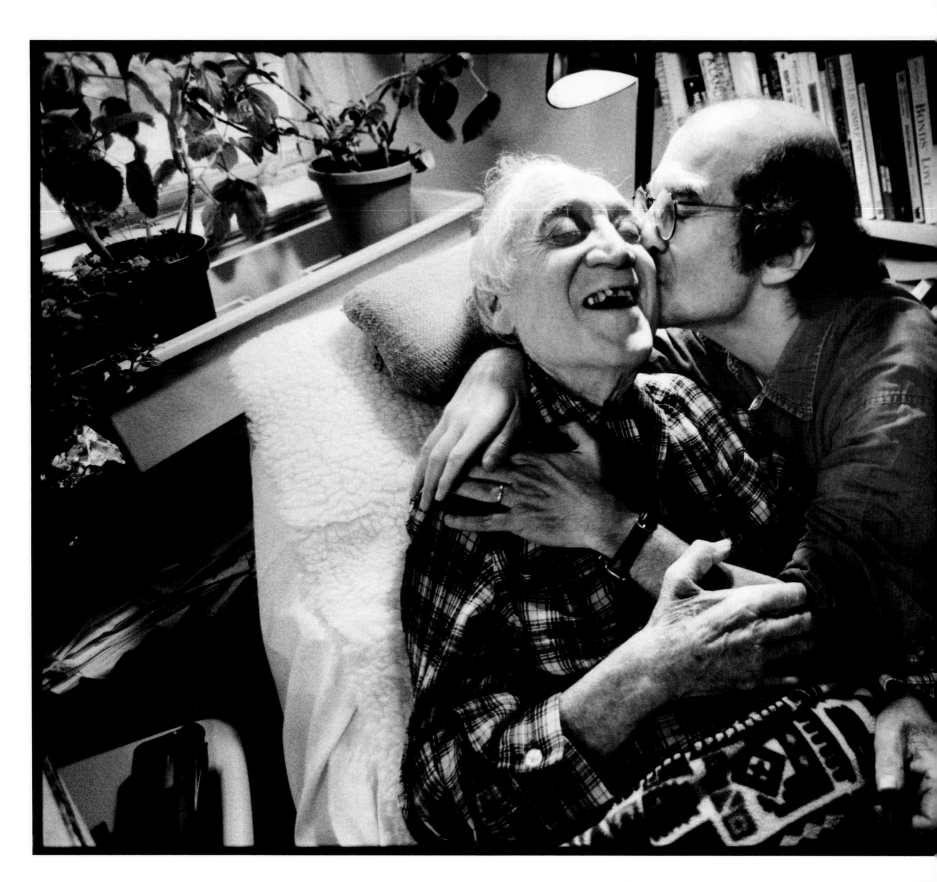

emotional plane, and I think he was excited and energized by my intellect and my left-wing activism. People who saw us together all the time thought we were father and son, but we never really identified that way. I had a sweet, gentle father and didn't need a substitute. I always related to Morrie as my peer and very nurturing friend. Oh, I suppose there was some of the good parent between us and a little of the brother-to-brother feeling, as well as the therapist and patient—and even some spouselike qualities. But our relationship was too multi-faceted to be reduced to any of those things alone. We had a total emotional range of openness and sharing. It was truly a love relationship. Not in any physical way, of course. We both had wives."

Unexpectedly, it was a health problem that cemented their friendship. During the summer of the Watergate hearings Morrie was confined at home after back surgery. Every single day, Charlie came over and they sat together, glued to the television set. "Friendship has its obligations," Charlie muses aloud, "and one of them is a strong sense of commitment. I think my showing up every day was important to Morrie because his mother had died when he was eight, and he was always afraid of being abandoned. This assured him that I was a very loyal person and would be by his side—even if he were down and out. But the truth is that he was by my side when I was often down and out. I always worried that I was taking, taking, taking, and Morrie would say, 'You don't understand. You give me back so much.' I did love the guy, and I was fairly vocal about my appreciation. Also, I needed him, and he needed to be needed."

Even when Charlie left Brandeis after losing a bitter tenure battle (despite Morrie's fervent support), the two continued to see each other regularly and to share their work as teachers and writers. They swam together, danced, attended meetings and lectures, but their activity was always secondary to their conversation. What they did best was talk. They relished having the kind of relationship men often envy in women, a relationship built on *being together* rather than *doing something*. "Male friendship is usually about men slapping each other on the back and watching and playing sports," Charlie points out. "My relationships with men have always violated that stereotype, and Morrie was no exception. I believe men and women are both quite capable of deep and sensitive friendships. For men to deny this part of themselves is to deny a big thing."

In the summer of their twenty-fourth year as best friends, Morrie was diagnosed with ALS, a progressively fatal and crippling illness commonly known as Lou Gehrig's disease. His long crawl to death would later be tenderly chronicled in the best-seller *Tuesdays with Morrie*.

Morrie, the man who loved to dance, would slowly lose the use of his body until he became entirely dependent on others. "In the end, he couldn't even wipe his own ass," Charlie says sadly, "but you never left his house feeling depressed. Morrie's house of dying was filled with joyous people, and Morrie was the most joyful of all."

Much of the world witnessed Morrie's valiant battle with the inevitable on three poignant broadcasts done from his bedroom with *Nightline*'s Ted Koppel. One subject not covered on those television shows was friendship. Morrie saved his views on that for a private conversation with Charlie taped shortly before his death, when his vocal cords were just about the only organ that still functioned.

Grasping Charlie's hand with barely enough strength to hold on to a balloon, Morrie speaks in a raspy whisper. "Charlie, Charlie. You've given me twenty-five wonderful years of love. I could always depend on you. Your insight. Your intelligence. Always there when I needed you. You allowed me to be helpful and useful."

"That's one of the greatest understatements of all time," Charlie answers, weeping without embarrassment. *"I don't think I would have made it without you, Morrie. You taught me what it* meant to be intimate. Taught me there was a person I could totally trust. Taught me the meaning of effortless communication. Our friendship was of the heart; then of the mind; and now of the soul."

"That's the whole point of friendship," Morrie says, with a weak attempt at a smile. *"You allowed me to be who I am and helped me become the person I was meant to be."*

"What a beautiful definition of a best friend," Charlie whispers. *"Someone who helps you be who you most want to be and gives you the respect and affirmation to be it."*

"Ah, Charlie." Morrie struggles to breathe air into his almost useless lungs. *"My best friend. My best person. You validate me for all the lovely qualities you believe I have. It would have been such a great loss in my life if I hadn't had you for my friend."*

Charlie kisses Morrie's clammy forehead. "We made a lot of life for each other, buddy. Made it beautiful for each other."

"Yup. Yup." Morrie nods, too exhausted to go on.

When Morrie died, Charlie got the news by phone. "I was sitting alone by myself," he remembers. "I'm not a very psychic person but I had a palpable sense—a physical jolt—of somebody entering my heart and my body. Clearly it was Morrie. I thought of the last time I'd seen him, just a few days earlier before he lapsed into unconsciousness. We had our hands on each other's hearts. He said he was passing into me, and I told him that I felt I'd already internalized a big part of him. He was worrying about what would happen to me in his absence. It was so typical of him to be oriented outward—even at the very end. And he reminded me that death ends a life. It doesn't end a relationship."

Patti and Norma

Laaaaadies and Gentlemen . . . Miss Patti LaBelle.

Her glorious bosom leading the way, she sashays onstage in her trademark stiletto Patti pumps, every inch the star. Her voluptuous body is squeezed into a tight and shiny creation, and when she opens her cherry-red lips, that big, lush voice with the power of a hurricane soars effortlessly to the last row in the balcony, then suddenly pulls back to caress a lyric with the softness of a summer breeze. This baby can hold on to a note longer than a lover to the first passionate kiss.

"Ooooh, let me tell you people, these hot flashes are gonna kill me," she says, flicking a copious stream of perspiration from her dripping face. Whether she's singing or signifying, Patti's style is up close and personal. She starts another song and suddenly stops in the middle. "Folks, you gotta know this: I need to pee. Would you rather me finish the song or leave now and come back?"

"Go, Patti, go. We ain't movin'," the audience yells.

"But you don't understand all the stuff I have to go through before I can pee."

"It's okay, Patti," they holler, roaring with laughter, "we'll be here."

Patti puts down the mike and hustles off to her dressing room, where a self-effacing, handsome woman stands patiently waiting. For more than twenty-five years, Norma has been Patti's traveling companion, hairdresser and best friend, and she orchestrates this familiar bathroom drill with split-second timing.

"Patti never runs to the ladies' room," she says. "We have her little bucket ready, right here, and I can get her in and out before she knows it." That requires undoing four layers of clothing. "Patti's wearing her panty girdle. She's also got a girdle holding up her stockings, then her little waist cincher and her dress. I have to unzip the gown, unsnap what needs unsnapping, then I catch up the dress and hold out my two arms. She leans on me and pees in the bucket."

That, sweetheart, is a true friend!

The whole operation lasts no more than two minutes, and La Diva reappears onstage, flashing her diamond-studded fingers and her million-dollar smile as she announces to the audience, "And I washed my hands, too."

Norma and Patti have a long history together—prominently linked to toilets. They met in the sixties when Patti, barely out of her teens, was desperately trying to find the ladies' room at a fancy New York department store where Norma was employed in a high school work-study program. "You almost never saw any black people on my floor, because it was so expensive," Norma remembers. "They sold all that Gucci and Pucci."

"I couldn't afford any of their things," Patti interjects. "But I had those shopping eyes."

"Anyways," Norma goes on, "all of a sudden, this young woman comes running around the corner real fast, saying, 'Please, I gotta use the bathroom. Where's the bathroom?' I offered to take her and then I said, 'Wait a minute. You're Patti LaBelle.' And she says, 'Yeah, yeah. But I ain't got time. I *gotta* go to the bathroom.' So I took her and she invited me to her show in Harlem. I'll never forget that first egg sandwich she made for me backstage."

In those days, Patti cooked for herself and her trio out of necessity; now she whips up meals for her friends in her dressing room by choice. "I had my electric fry pan that I always carried around," she says nostalgically, "because I wasn't spending my itty-bitty per diem on food. I bought sardines and eggs and made everybody sandwiches. We were so poor then, we all shopped at Woolworth's for our clothes."

Until Norma entered the picture. She immediately became fast friends with Patti LaBelle and the Bluebelles and arranged for them to return to the department store for a little shopping spree—on her. Norma happened to be as-

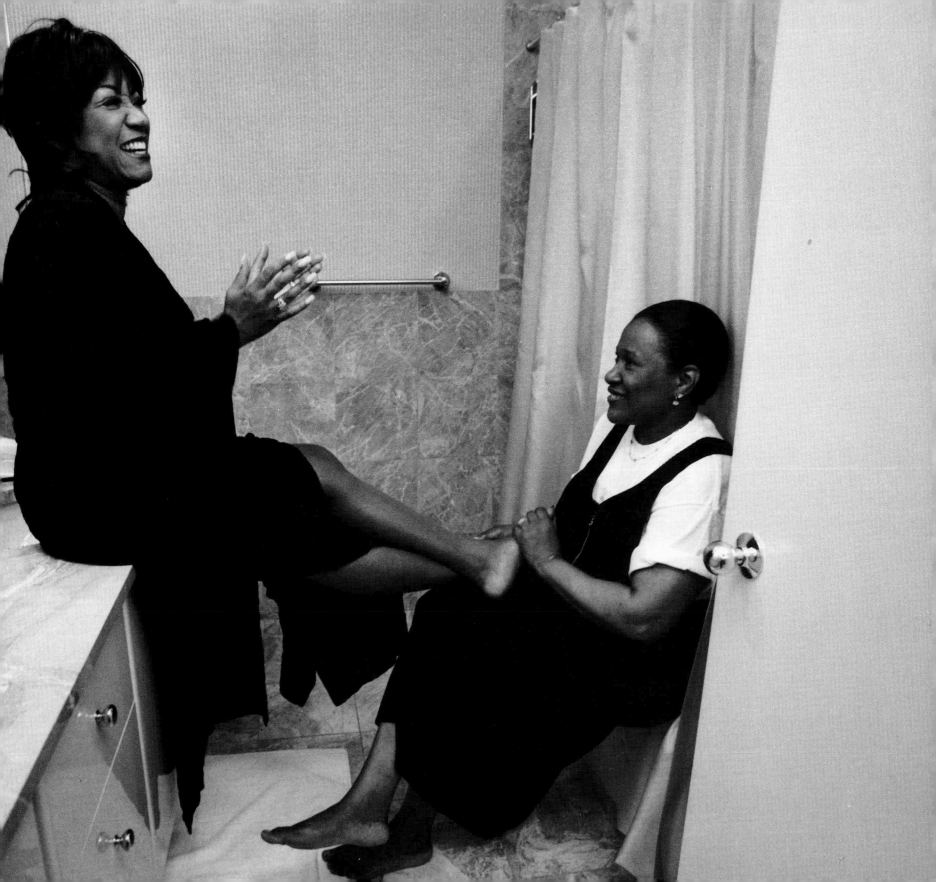

signed to the sample room where dresses were marked down before going on sale. "The girls picked out four matching outfits," Norma says, "and I put them in a bag, fixed it up nice and let them walk out."

"Bottom line, we were stealing!" Patti confesses, tapping her long red nails on the table. "Me, who wouldn't take a spool of thread from Woolworth's! But I'll tell you, we were the cutest girls at the Apollo in our new drag from Fifth Avenue."

Fortunately, Norma possessed other talents that were more useful and more legal. She'd picked up a knack for hairdressing from her mother, who was a beautician, and as soon as she finished high school—she's four years younger than Patti—she began going on the road with Patti and the Bluebelles, fixing their wigs and their hair, running errands and hanging out. "Growing up, I didn't have too many friends, because I was scared," Norma says. "Girls was just so cruel, such troublemakers. So I stayed away from them. But Patti and the Bluebelles weren't like that. They were real people."

Patti immediately sensed a special quality in Norma. "There was something about her I liked from the beginning. She was very clean-looking," Patti says. "She dressed conservative, like a Ralph Lauren type. Didn't look like one of those hootchy mamas. I loved her honesty and the way she carried herself. I thought, This woman could be my friend. As time went on, we grew stronger together and became like sisters. It was nice having somebody around that I could trust and tell anything to, knowing it would stay with her until she leaves this planet.

"And Norma loves my family, too. When you find someone who respects your people as much as they respect you, it's not a show business thing. Norma's not here because I'm Patti the celebrity, the hot item of the month. She's here because I'm Patti the person who she can call her best friend. And I feel good

about calling her my best friend because I know she'd do anything for me—even if I never sang another note."

When the Bluebelles broke up and Patti took her act solo, Norma stayed with her. She created those outrageous hairdos that stood twice as high on Patti's head as the stiletto heels on her feet. After years and years of road trips, they've probably spent more time with each other than with the husbands they've added to their lives along the way. "The road is really boring," Patti says. "It's hurry up. Do something. Go to sleep. Wake up. But we have such a good friendship that I cannot be bored around her."

The only thing they fight about on the road is Norma's tendency to forget to use the chain lock on the doors of their hotel suites—which drives Patti, a lock freak, crazy. "I got so mad one day, I lied and told her one of those room service guys used his key and came in on me naked. She's gonna get us killed because she doesn't chain-lock that door." But sometimes Patti's endless riffs on Norma tend to have unforeseen consequences. Like the time in an exotic restaurant that she ordered Norma chicken salad because it's one her favorites. Norma liked it so much that she had a second helping, and then Patti told her she'd been eating snake meat. "I went to bathroom," Norma recalls, "and I threw up."

They've shared the best of times—the birth of Patti's son, the Grammy Awards ceremony in 1991, when Patti finally won after years and years of nominations. And Norma will never forget seeing Patti, who'd never even finished school, get an honorary doctorate from Boston's Berklee College of Music in 1996. "When I saw her walk down the aisle in a cap and gown, it was amazing," Norma says. And they've also shared the worst of times. Within the space of a few years, Patti lost her three sisters to cancer, then her mother and her father. At every funeral Norma was by her side, holding her up. "I just

get special comfort from her," Patti says. "It makes me feel better when she's here."

Taking care of Patti is Norma's mission. "I have to remember every little thing," Norma says, "and just make sure that Patti's comfortable, because she works too hard. I stay in the dressing room settin' up her shoes and doing her wardrobe, because she changes three times. Then I'll have her pajamas ready, because right after the show she leaves the theater in pajamas under her nice coat and gets in her limousine. When we get home, I make her a nice bubble bath with Epsom salts and I scrub her like she's my kid. And I massage her feet. I don't close my eyes until I know she's in bed and comfortable."

"Truth is," Patti says, "Norma is my everything. She's my mother, my sister, my protector, my bodyguard. She'll kick your ass if you look like you're going to come too close to me the wrong way. On a scale of one to ten, Norma is a twenty-five. I can't ever pay her enough, so I'll give little surprise stuff to her. Anything. Furniture. Money for her mother, because she won't take it for herself. And she'd never ask. That's what I love about her. She doesn't take advantage of me. I feel very safe with Norma. She's been with me forever. With all my family problems. For everything."

If you're wondering how this employer and employee successfully juggle a hierarchical business relationship and a friendship of equals, here's Norma's explanation: "I separate it. I have to. When I'm working, I'm working. And Patti's my boss, even though she don't like for me to say that. But when my job is finished, we're friends—more like family, really, and then I can play with her. She treats me real good. Real good. If it wasn't for her, I would never have gotten to see the world. The South of France. Los Angeles. Patti's helped me a whole lot. She's good people. She has a good heart. She's my world."

"I think good people seek out good people—and I found the best," Patti says emotionally. "Damn," she wails, dabbing the corner of her eyes with her perfectly manicured pinky finger. "I have to do a show soon and my makeup is gonna come off." Then she stops and takes a deep breath. "I can't tell you enough how wonderful it is to have Norma in my life. Of course, my husband is there for me, but being a man, he can't relate in the same way. He's not Norma. Nothing's the same as having a best girlfriend."

John and Terri

Terri most certainly would have been the apple of her father's eye while she was growing up, except that she didn't meet him until she was already an adult. By then, having missed the chance to be Daddy's little girl, Terri wound up becoming his best friend instead.

Adopted at birth by a loving couple, Terri grew up with very little interest in where she'd come from. "I never felt anything was lacking in my life," she says. "But I eventually got curious about my heritage, and one day I thought, Okay, now I'm thirty. It's time to resolve things in my life." With her adopted mother's blessing (her adopted father had died a few years earlier), she set out to find her birth mother without any expectation of finding her father as well. Having little more to go on than her mother's maiden name, the social worker conducting the search succeeded with her first call. A man listed in the phone directory with that surname turned out to be the brother of Terri's mother. "It was like fate," Terri says. "Boom, boom, boom, everything fell right into place."

The first phone call between Terri and her birth mother, Barbara, lasted nearly an hour. "Just as we were about to hang up," Terri remembers, "Barbara said to me, 'I have something else to tell you. Are you sitting down? Would you like to know who your father is?' I said yes, but I'd been afraid to ask. 'Well, his name is John. And he's my husband.'"

She then learned that her birth parents had married a year or so after Terri's adoption and had given birth to two more children. "At that moment," Terri says, "I was actually more excited about learning that I had a brother and sister than I was about finding my father."

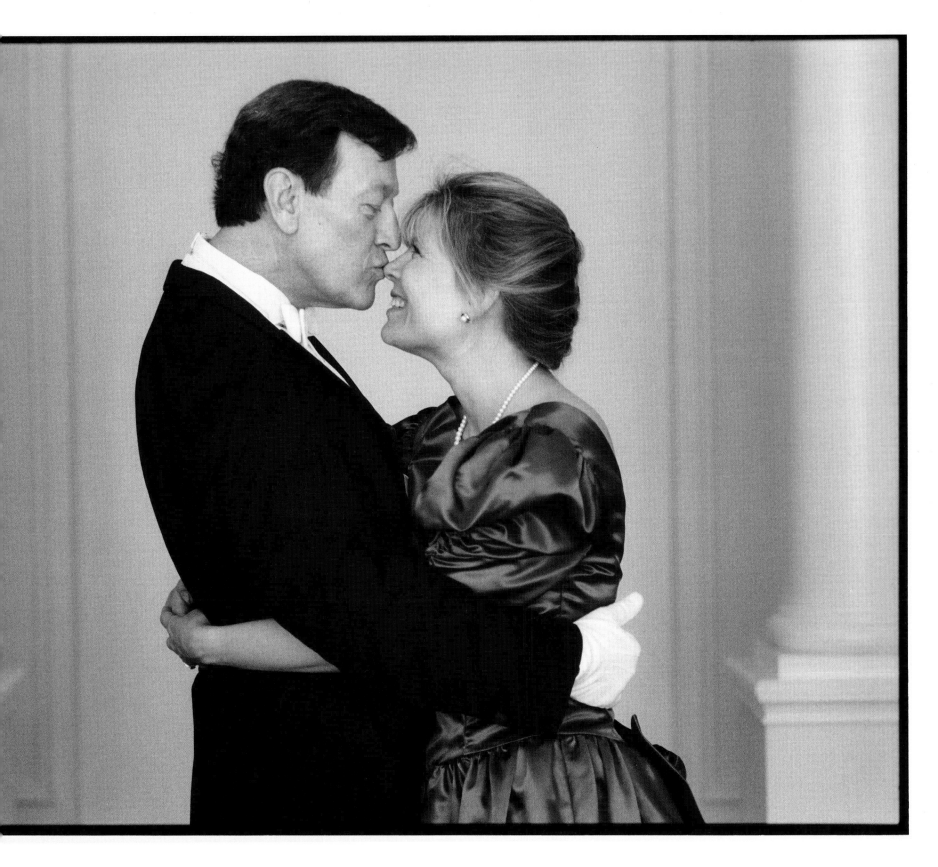

Terri and Barbara arranged to meet in a city midway between where they both lived. Their lunch was cordial but somewhat awkward. "We were kind of matter-of-fact, like, 'What have you been doing for the last thirty years?'" Terri recalls. "Sometimes you just run out of things to say."

But with her father it was just the opposite. "He'd been waiting nearby to give us some time alone, and I was real nervous about meeting him," Terri says. "I didn't know whether to shake his hand or hug him. But he bounded up the steps and gave me a kiss. My first thought was how much he looked like my other father. It was uncanny. Then we started talking, and we've never stopped. We just clicked right away. From the first minute we saw each other. No, from the first second! I started showing him pictures I'd brought, and it almost didn't matter. We had this mental thing immediately. You know how you can meet somebody and sense right away that this person looks at the world the same way you do. Growing up, I'd always felt different from my parents, but after an hour with John, I knew exactly why I am the way I am."

For John, reuniting with Terri was like an answered prayer. "Barbara was scared and distraught when the social worker first called," he explains. "She'd never told anyone about the adoption. But I was tickled to death. I'd been sort of scheming on my own how I might possibly find Terri without involving Barbara. When Terri was a child, I used to think about her a lot. But I was a great believer that people are a product of their environment, and by the time she was a teenager, I figured there was probably not much of me left in her. I imagined that if we met now, it wouldn't be so much like a long-lost parent and child—but we might be good friends."

And that's exactly what happened. Meeting for the first time as adults, unencumbered by family baggage and the prescribed roles of father and daughter, they had a unique opportunity to create a friendship from scratch—a friendship that had all the advantages of their genetic similarities but none of the disadvantages of old hurts and unmet needs. John says, "I learned that genetics is not just your eyes and whether you have big ears. It's something deeper . . . in the spirit or in the heart. Terri does so many of the same things I do. But we have no history. No changing her diapers, disciplining her, going to PTA meetings, living through her high school sweethearts, sending her to college. No stuff that gets in the way. I have a great relationship with my other daughter, Kristin, but there's more of a father thing going on with her. I'm concerned with what Kristin does and that it's the right thing. I feel more parental toward her. Maybe a bit more protective."

Drawn by a desire to be closer to her newfound family, Terri, who is an unmarried newspaper reporter, moved to Philadelphia, where John lives and works part-time as a management consultant. (His home with Barbara is about an hour away.) Not having grown up with the day-to-day parent-child intimacy has allowed Terri and John to cultivate an entirely different kind of closeness.

"It's not like I don't depend on John for father things," Terri says. "Like when I had a bat in my house at one A.M., he was the only person I'd call. But I talk to him about a lot more than I ever told my other father. You know how you just have these deep, dark secrets. Mistakes you've made. Failures. Things you wouldn't tell the father you grew up with. It's different with John. He's not going to judge me or say, 'How *could* a daughter of mine do this?' He's not like that. I don't think I've ever trusted anybody more than I trust him. He's my friend who I can talk to and depend on to advise me and guide me. He offers me not only an older perspective but a male perspective, too. We're really each other's biggest fans."

"We depend on each other to bounce things off of," John

adds. "I'd venture to say most males go through life never having someone to really talk to. In business, by God, if you have a problem, you keep it to yourself. So at this stage of my life it's really wonderful to have someone nonjudgmental, not just to share things with but to discuss things with. We talk about what's going on inside us, our observations, our appreciation of the world."

These two could jabber forever, but they also love *doing* things together. They've spent summer weekends restoring an old house and share a mutual fascination for turn-of-the-century art and culture. John is a train buff, and they often take jaunts through the countryside on steam engine excursions. "We do things as adults," he says, "that we might have done as a father with a little girl. Only we both have fun."

"Right," Terri chimes in. "Now we both act like children. It's almost magic when we're together. Doors open and things fall into place."

"We'll go into a restaurant and the next thing you know we're talking to the chef," John elaborates. "Or we're visiting an old railcar and soon the owner is bringing out the gin and tonic and hors d'oeuvres."

They've also discovered a joint passion for ballroom dancing. "I've always loved swing and jitterbug," Terri says, "but I never really had anyone to dance with until John came along."

"It's neat that I got to teach two daughters to dance," John notes. "With Kris, it was easier because she was little and I put her left foot on my right foot. But Terri's a little heavy for that." And they both laugh.

Their friendship fills a vacuum in both their lives. Many of Terri's dearest female friends have moved to other parts of the country, and her coworkers tend to be married and busy raising families. "At this stage, it's hard to start up new friendships," she says. Which leaves lots of time for Dad. They exude such positive energy when they're out and about that John and Terri are often mistaken for brother and sister or, even, husband and wife. "But people soon discount the wife thing," John says jokingly, "because we get along too well."

They both recognize that their life situations and their natural affinity for each other have a tendency to keep them from seeking out their peers—and sometimes to isolate them from other family members. "So what do we do?" John asks. "Not chat so much? Not go to dinner? Because this is an extraordinary and unusual relationship and we're having a great time, it's hard to strike the right balance. Maybe in some cases we do things together that Terri might be doing with some other guy. With a father and daughter, whew! It's not a straight line. It wavers. Sometimes we wonder what would have happened had we met each other and not known we were related."

"But we're very clear," Terri says. "I know who John is. I've always known he's my father, from the minute I met him."

"When you recognize something's good," John says with gravity, "you treasure it. You don't take it for granted. Friends can so easily disappoint. We're best friends, but this is a very fragile thing. I have a strong consciousness of how Terri thinks and feels, and I know she has the same about me, which is why we're always polite and respectful toward each other. We say 'please' and 'thank you.' I know it doesn't take much for a friendship to go wrong. Any little silly something can escalate and become irreversible. So we're careful, and we jealously guard what we have."

"When I tell people our story," Terri concludes, "they say, 'Wow. Just like on *Oprah*.' But on *Oprah*, the big deal would be the story of how we met. For us, the interesting thing is what developed afterward. Once we went through those missing thirty years in our lives, it wasn't the end. It was just the beginning."

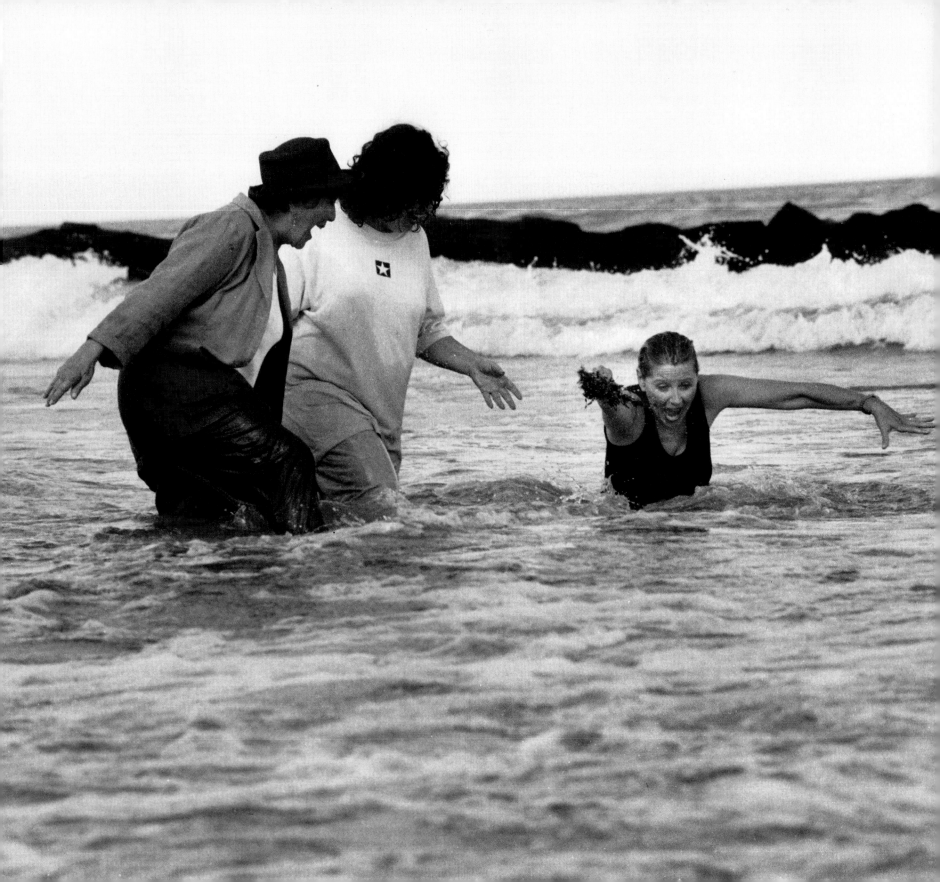

Gail, Carol and Toby

At least four weekends every single summer, Gail, Carol and Toby arrange to be together at one of their family's beach houses, where they repeat the same ritual: they jump into the ocean, ride the waves and get their hair wet, just like they did forty-some years ago when their skin glowed pink and was unwrinkled, their thighs didn't jiggle and their parents were all still alive. On the record these are three healthy fifty-five-year-old women. But off the record, where the heart keeps statistics, they embody everything that is meant by those treasured words: my childhood girlfriends.

When they took a trip to a dude ranch to celebrate their fiftieth birthdays, they were mortally wounded because nobody seemed the least bit surprised by the number 50 on the T-shirts they had made to announce why they'd come.

"Couldn't somebody have said we looked forty?" Carol asks with mock disappointment. "Shows you how we look at each other through these wonderful rose-colored glasses. With Gail and Toby, I never see a changed face. We share this feeling that we are perpetually young. There is nothing, *nothing,* we don't know about each other. It would take *another* lifetime for me to get as intimate with a woman I met now as I am with them."

Only a woman who is lucky enough to hold on to the beloved girlfriends of her youth truly understands the power of these special forever friendships. Sure, we all make wonderful new friends as adults. And we can tell them all the stories about how we grew up. But never, ever can they know us in the same complete way as the precious girlfriend who got the phone call immediately after our first date, after our first period, our first heartbreak, our first child, our first success, our first failure. Nothing in our lives is quite like that irreplaceable girlfriend who experienced all the events that shaped who we were and who we became.

"When you've known each other's families since childhood," Toby says, "seen the inside of each other's junk drawer, played jacks together on the floor, gone to camp together; when you remember the sheets on their bed and their mothers' pineapple upside-down cakes—those connections are wired into your brain."

Toby and Gail sucked on the same rattle in the playpen where their mothers put them down together. When they entered kindergarten, their teacher observed, "Well, these two are in business for themselves," and that's how they stayed until Carol came along to form their trio. As Carol tells it, "I was fourteen, just becoming aware of my magnetic qualities toward men. I'd gone off to summer camp and a friend told me that my boyfriend had taken up with a very flirtatious blue-eyed honey named Toby. When I got home I called her to establish my territorial rights. 'Do you realize he's *mine*?' The upshot was Toby and I both dropped him, and that was the beginning of the three of us. I can tell you there'd never be a man in our lives that we'd drop each other for."

Since they've become adults, married and raised families, time and space have squeezed their schedules, but nothing can diminish their friendship. Toby, who is a successful graphic de-

signer, and Gail, who is a human resources consultant to Fortune 500 companies, live in the same town about a half hour from each other and are consumed by their careers. Carol lives two hours away and does a million things—none of which produces a paycheck. To see each other requires setting a date, which is something they've committed to doing on a regular basis for the last twenty years. Whether they're prowling a flea market together looking for bargains or lolling around locked into one of their marathon Scrabble tournaments, it's a guarantee that they'll spend most of the time laughing.

"My smile lines are definitely more substantial when I've been with the two of them," Gail says.

Carol adds, "When I know I'm going to see them, my calendar book has a great big circle on it. It's a focal point for me. It's the juice. I can get excited about other things I'm going to do, but not about other people, no matter what the thing is."

These three pals have never jockeyed for position. Nor felt an ounce of competition or jealousy. And their husbands and children are openly envious of the absolute trust and connectedness they share. "Sometimes after we've been together," Gail says, "one of my children will ask, 'How much time did I get today in the group's review?'" The trio of mothers puts great stock in having the freedom to discuss their personal and family problems with total honesty. Gail continues, "We're not afraid to say something the other wouldn't want to hear if we think it's in their best interest."

"And you know how adults tell you only the wonderful stuff about their kids and you don't hear about the downside?" Toby says. "Well, we're not afraid to reveal every last imperfection of our not-so-perfect children."

Or their sex lives. Or their spouses. "I went through some challenging times early in my marriage," Gail confides, "and I remember more than once I was on the verge of stomping out

the door. I might not have stayed with it if it hadn't been for the way these two friends held up a mirror to my life and helped me look at the whole picture."

To get a sense of the depth of their feelings, one only need ask them to describe each other. They all clamor to go first.

"After my immediate family, these are the two most important people in my life," Toby exclaims passionately. "They are my heart and soul. Gail's nickname is Sunshine. She lights up a room. She is totally accepting, wonderful, loving. She books the tickets for our trips, makes sure we arrive at the airport on time. Never says a bad thing. Now, Carol is the funster. She's the one who keeps us up at pajama parties until four in the morning, who says, 'Get the bikes out.' She's the instigator. Gets us out of our negativity. She's not just fun, she's brilliant. People gravitate toward her."

It's Carol's turn. "Toby is the realest person. When she speaks, it's from her guts, raw and uncensored. She's given me unparalleled life lessons. This woman is a God-given artist. The eye of eyes. She's tremendously perceptive, not only with graphics, paintings, decoration and beauty, but with people, too. These two are pure gold. And that they think the same of me is very empowering."

Gail can't keep still. "The best times I can remember are always with them. I know how to play the corporate game, but they've taught me the better side of life. How to enjoy the moment. My spirit soars when I'm with them. As we go through the cycles of our life, Carol and Toby respond to me in a way that is totally authentic, meaningful and renewing."

"It's not just that we understand each other," Toby says. "It's the way we accept, accept, accept each other. And I have the comfort of knowing that if anything should happen to me, my children have two other mothers."

Her explanation for their lifelong solidarity is a tribute to their own mothers. "We grew up pretty much with the same decent values, the same race and religion. But here's the key: We were all very good, loved daughters. Our mothers knew and respected each other. They let us know we were special. That our friendship was special. And they encouraged us not to let anything get in the way of our closeness."

And being good girls, they did exactly what they were told.

Julio and John

"**S**omething's wrong with my eyes, Julio. I can't see. I'm going blind."

Julio patted John's arm and tried to sound reassuring. "You're probably having some kind of dizzy spell. We can get you eyedrops when we land."

But John knew he needed something more than eyedrops. In the two hours since they'd boarded the plane, he'd watched the inside of the cabin turn as pitch-black as the inky night outside the windows. "No. I'm telling you I'm in real trouble," he said. "The pain is awful. I feel like a thousand needles are sticking in my eyes."

Julio stared at the frightened figure buckled in the seat next to him, this man he barely knew who'd suddenly become his unwanted responsibility. How could their vacation lark have slid so quickly into disaster?

They'd met by chance just a week earlier in Los Angeles on the set of a music video that John was directing. They were both single, in their early twenties, beginning their professional careers. John's regular assistant had called in sick and Julio arrived as a replacement cameraman. They clicked almost immediately at some unspoken creative level. John recalls, "From the way Julio assessed the lighting—'Why don't you put a bounce card here, a light over there'—I instantly recognized that he knew *exactly* what he was doing."

"We have a saying in Spanish," Julio interjects. "*Al buen entendedor con pocas palabras basta*. To a person who understands well, few words are necessary. There was a shorthand right away between us. I immediately liked John—how competent he was and how humble about it."

Maybe that was why, when their workday ended, Julio spontaneously mentioned that he was leaving in a few days to ski and visit his relatives in Argentina, where he'd been born. Would John like to come along?

John replied, "You shouldn't make me an offer like that unless you're serious, because I'll do it."

Which is how they found themselves a few days later at Bariloche, a ski resort high in the Andes. Because it was October, late spring in South America, they had to ascend to an altitude of 12,000 feet to reach any decent snow. On the unusually bright and sunny morning of their third and last day skiing, John fell and broke his sunglasses. Determined not to miss a moment of the glorious scenery and perfect weather, he stayed on the slopes for several more hours with the intense sun searing his face. By the time they'd descended the mountain for the plane ride back to Buenos Aires, John's eyes had already begun stinging and burning. Within hours he'd lost his vision completely.

At the hospital in Buenos Aires, the doctor diagnosed John as having a severe case of snow blindness. With Julio translating from Spanish, he explained that the damage to John's eyes was equivalent to what a welder would experience after working all day without goggles. He'd regain his sight, however, providing he followed a very strict treatment regimen—keeping his eyes completely bandaged for at least five days, with a medicated gel applied under the lids every six hours. It was obvious that for the next week John would be as dependent on Julio as a newborn on its mother.

"I guess I could have left him stranded," Julio says, "or put him on a plane alone back to Los Angeles or gotten him a nurse and taken off to visit my family. But for me that was unthinkable."

Instead, Julio called a taxi, led his blindfolded colleague to a cousin's borrowed apartment and gently nursed him back to health.

To anyone who noticed them getting into that cab, they must have looked like an odd couple. Julio is big, dark and bearlike, with jet-black eyebrows arched like a crow in flight. John is slight in build and fair, with handsomely chiseled features. One simmers with Latin intensity; the other, Anglo to the bone. But by the end of the week they'd be as close as brothers.

"It must have been four A.M. when we got back to his cousin's place," John remembers. "I was still in incredible pain. There was a noise at the door. I heard Julio check the lock. Then I fell asleep and I had this nightmare that somebody had broken into the apartment and was jabbing me in the eyes with an ice pick. I woke up screaming, 'Julio, somebody's trying to kill me!' I'm sure that was the moment he thought, What the hell have I gotten into? This guy's not only lost his eyesight, he's lost his mind."

"I was certainly upset that my vacation had turned into caring for this blind person," Julio admits. "But I kept reminding myself that John was much more upset than I was. It was a matter of survival and we had to get through it."

Normally, relationships develop from an emotional base. First comes talking; later, touching. In their case it was just the opposite. Julio had to do everything for John: take him to the bathroom, help him shower, cut his food and treat his injured eyes. "It's a very intimate thing to deal with someone's precious eyes, you know," Julio says. "There has to be a high trust level."

Alone and shut off from the world, there was little for them to do but talk. Fortunately, they were both gabbers. "You can only imagine the amount of dialogue that goes on when you're together five days straight, every moment," Julio says. "We talked about everything that good friends eventually end up talking about."

"I remember distinctly talking about movies," John says, "especially obscure foreign films, and other things we both liked—photography and music—and we'd realize how much we had in common in terms of our taste."

"You don't find many people you can spend so much non-stop time with and still get along at the end," Julio says. "It's probably the way people become friends in prison. Something forces you to develop a relationship, so you make the best of it and find out you really share a lot. I respected how John was adapting to all of this. And I was surprised that I was able to give so much time and effort to him and didn't want anything back. I think that's really the basis for friendship. You give without expecting anything in return."

"I certainly felt some guilt because he was ruining his holiday to care for me," John says. "But what was interesting was that, once the pain went away and the doctor convinced me I wouldn't have any permanent damage, we both kind of got off creatively on what was happening to me. I mean, how many people get to experience temporary blindness? And talk about seeing a foreign country through someone else's eyes! I literally did that with someone who was a cinematographer and made his living visually."

But, for John, the defining moment of their friendship occurred when his bandages were removed and Julio insisted that instead of going home to Los Angeles, John go with him to meet his Argentinean relatives. "I still definitely needed to be cared for," John recalls. "Everything would be blurry for at least another ten days, and I couldn't see at night. I was shaky and worried about being a burden, but his family just took me in like a son. That's when I realized where Julio got his generosity."

"I felt we'd kind of passed the point of no return," Julio explains, "and visiting with my family meant the trip wouldn't be

25

a complete wash. I admired John's courage and I thought it was a sign of great character that anybody who gets through this much is willing to keep going. This is the kind of person I want to hang out with."

They've been hanging out together one way or another ever since. For a couple of years after their aborted vacation, they worked side by side on a series of video projects. Then they wandered off in different directions—John to Australia for a few years to direct films and commercials, and Julio to Hollywood, where, among other things, he became director of photography for the hit film *Home Alone*.

By then they were bonded friends for life. Julio says, "We may not talk for months, but we're always in touch. He was best man at my wedding. He also tried to talk me out of marrying her." He laughs heartily. "I should have listened. Later, when my marriage was in trouble and I met the woman who changed my life, John was right there saying, 'Follow your dream. Do what feels right.' He was very supportive."

When John recently met the love of his life, he immediately called Julio for his approval. "When we all had dinner, Julio's reaction was exactly what I wanted," John says happily. "I already knew that this woman was the one, but it meant so much to have my best friend affirm it. I wanted him to like her,

because what two guys talk about is their relationships. Just like women do. The more intimate your relationship, the more you talk about it. Julio has told me the most personal details about his life. For instance, I know exactly how he likes sex and what turns him on. He's also told me some incredibly unflattering things about himself. I've thought, Oh my god, I'd never tell anyone that. But he trusted me. He knew I wasn't going to judge him."

"That's what a best friend is," Julio says. "You can say anything and they won't condemn you for it. It's like with your mother. She's going to love you no matter how ugly you are. When I'm feeling down and inadequate and full of low self-esteem, I know John can listen and handle it with the care it deserves."

"Julio has really redefined my definition of a best friend as somebody who would be there to save your life," John says thoughtfully. "I not only know that Julio would attempt to save me, I have the confidence that he'd definitely succeed. Because of how he cared for me when we hardly knew each other, I never worry, Do I have somebody who would do *anything* for me? Julio could be in the middle of the most intense big-budget movie and if something happened to me, he would leave. And I'm sure he knows that I would do the same for him. In spades."

Andréa
and Jennifer

CASTING NOTICE: *Young-and-Hot Productions will be holding auditions for a TV pilot about two young women from New York—Jennifer and Andréa—who met in a high school drama class and followed their dream to Hollywood. Producer seeks two actresses about 28 years old with a strong physical resemblance that often causes people to mistake them for sisters. Both should be about 5'6", with taut, lean bodies, light hair and fair skin, a dislike for makeup and a preference for wearing jeans and T-shirts.*

The storyline will focus on their lives as best friends—hanging out, shopping, cooking, going to the gym, watching videos, fretting over boyfriends. Jen has a job in a wildly popular television series and lives in a sunny Mediterranean-style house high in the Hollywood Hills with a pool, a beautiful garden and a stunning view of the Pacific Ocean. Drey lived with her for a while—they'd always fantasized about being college roommates—and then moved into her own apartment. She works on a sitcom that tapes two stages away from Jen's show on the same lot, so they have lunch together nearly every day—which suits them fine, since they are practically joined at the hip. Each week viewers will watch them attempting to remain normal and unspoiled in the fishbowl called Fame by supporting, advising, protecting and nurturing each other.

So far, nobody has approached real-life actresses Jennifer Aniston and Andréa Bendewald to create such a sitcom about their lives—but they'd love it if somebody did.

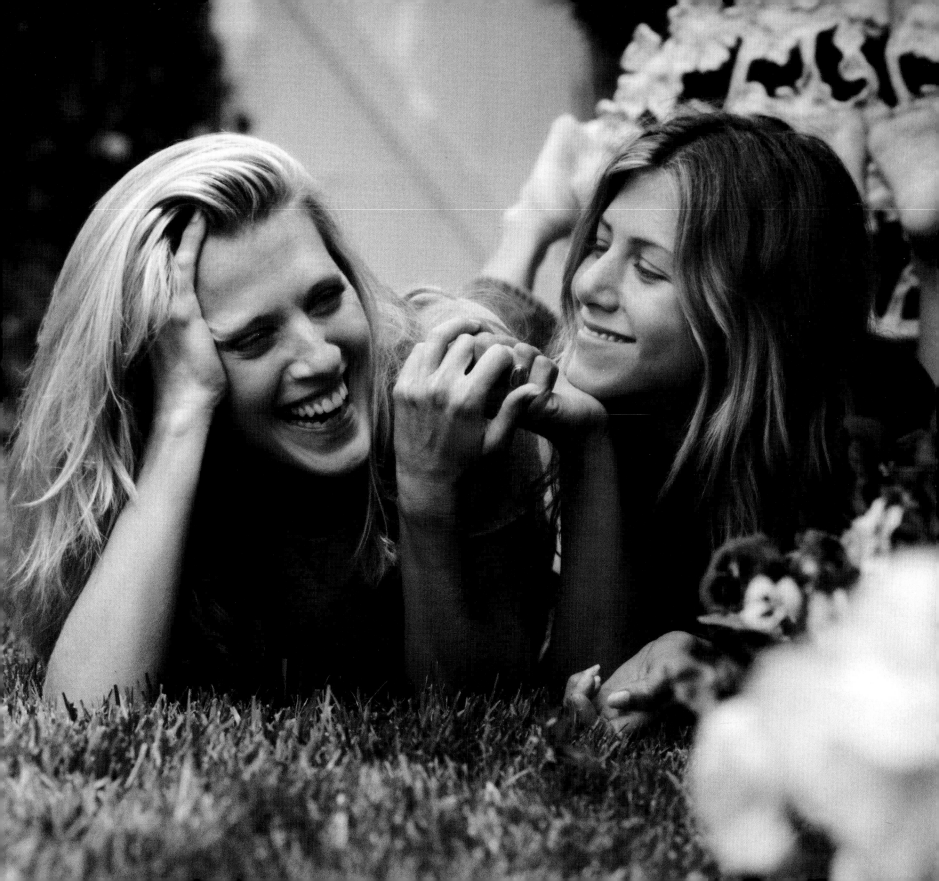

"It would be the coolest thing in the world if there were a show about two best girl-friends and, out of all the actresses in the world, they chose us," says Jennifer. "We would just have the most fun."

She and Andréa have been sharing laughter—and tears—since the day they entered the drama program at New York's High School of the Performing Arts, where neither of them yet had any friends. "It was remarkable finding each other right away," Jennifer says. "I thought, She looks cool. She's got pretty blond hair and a ponytail. So I walked up and introduced myself."

Andréa continues. "She said something like, 'What are you doing this weekend? Will your mother let you sleep over?' And we were inseparable from that day on. Both our parents were going through divorces, so having each other was a wonderful solace."

After graduation, Andréa decided to attend college, while Jennifer took the more traditional actress route of waitressing, auditioning and getting bit parts in soaps. They'd constantly agonize over who'd made the right choice.

Jennifer would say, "Drey, what am I doing? I'm going to miss out on this whole transitional period, this great opportunity to learn."

"And," Andréa recalls, "I thought she was being so gutsy. I'd be sitting in college out in Ohio watching Jen on TV, wondering, What the hell am I doing *studying* acting when I ought to be with her in California *doing* it? I remember this intense letter Jen wrote me, channeling some wild thoughts about why we are where we are. That there are no mistakes. 'We don't know what it all means now, but someday it will reveal itself.' That's how she spoke back in high school."

By the time Andréa reached Hollywood, Jennifer had been there for five years and was a veteran at swimming in the choppy waters of showbiz. On the one hand, it was tough for Andréa just starting out, because she kept comparing herself to Jennifer's success (her show *Friends* had been an instant hit). On the other hand, Andréa reaped the benefit of her friend's experience.

"Because Jennifer had gone down the road of doing pilots and series," Andréa says, "I could tell her, 'I have this audition, blah-blah-blah'—and she could explain, 'Well, that means A, B and C.' Everybody here has war stories. I had to learn that people can make 'No' sound like 'Yes,' but unless they actually say 'Yes,' you haven't got the job. For instance, after I got my first big break on a pilot, I had my feet knocked out from under

me. I was *devastated*! And Jen was really there to get me through it. In high school she'd kind of looked up to me. Now she had the role of Mom.

"But since she's gotten so well known with TV and movies and magazine covers—I have a hard time actually saying 'famous'—I've gotten real protective of *her*. She's been swarmed by fans a couple of times where I've definitely forgotten I was in high heels and instantly became her bodyguard, grabbing her and pushing people away."

There's never been any jealousy or competitiveness between them. Andréa surprised Jennifer on her birthday with a scrapbook she'd put together crammed with clippings, press releases and souvenirs of Jen's career. "I couldn't believe how on earth she'd collected all this stuff without my knowing," Jennifer says. "It showed such caring and sharing. It was the best gift I'd ever received."

Still, they'll admit that occasionally the celebrity routine does get tricky for them.

"We bumped into an old high school friend whom I'd been a lot closer to," Andréa says, "and the person made a much bigger deal about seeing Jennifer, because she's all over the place now."

"I'm not any different," Jennifer emphasizes. "People just assume I'm different. And they treat me differently. I've been the luckiest human being on the planet with the way *Friends* took off so fast. But being in the public eye is such an illusion. It's weird how Hollywood and the media change the public's perception of you. I can see how people go off the deep end, or into drugs, or running with a bad crowd. What's so great with Andréa is that I'm still the same person I always was. It's been wonderful to have a best friend who knew me before this whirlwind. Somebody I can go home to. Somebody who knows what's real."

"I get to share her success," Andréa says, beaming, "and her clothes! I can come over anytime and say, 'Dress me.' She's got an eye for fashion. And impeccable taste. Right now, she's also got more money."

Jennifer gives her a little shove. "Like you're not working, working, working. Like it's not happening for you."

Watching them together is like observing two kittens raised in the same litter who can't leave each other alone. As they sit cuddling side by side, they absentmindedly fuss with each other's hair and play with each other's fingers. Standing next to each other, one will slip her hand into the pocket of the other's jeans.

"When something happens, good or bad, we call each other first," Andréa says.

"I trust her with parts of myself I don't trust with anybody else, and I can be honest about confessing things to her—even when it doesn't feel good," Jennifer elaborates, characteristically pursing her heart-shaped lips. "We never fight. Even when it gets icky, we just talk it out. She's blood. She's my chosen family. I couldn't imagine my life not having Andréa in it. Ever. Ever. Ever."

"Exactly," Andréa says. "Whenever we're out and we see two elderly women, I tell Jen, 'Look, that's us someday.'"

Like many women who don't have biological sisters, Jennifer and Andréa (who both have brothers) have transformed their friendship into their fantasy of what an ideal sister would be—if they did have one. "We know how we'd wish our family to act, and that's how we react for each other," Andréa explains.

"If you tell a family member about a job you got, or a play you're thinking about doing," Jennifer says, "they might raise all sorts of questions . . ."

"As opposed to us," Andréa goes on. "We're like, 'Oh my God. That's amazing.' Nothing but love and support and excitement."

"But it isn't always crazy and fun and flippant," Jennifer says, snapping her fingers. "There are times of conflict where we have to do a check-in and remind each other of the lessons we've already learned. I think it helps that, as much as we're alike—we have the same sense of humor—we're also different. She's a Pisces. She's more cerebral and practical."

"And you're an Aquarius. More spur-of-the-moment and optimistic," Andréa points out. "I can say, hands down, that we'll be best friends—"

"Until we're in the ground and cold," Jennifer interrupts her.

With great seriousness, they hook pinkies on the promise. And then they dissolve in laughter.

Louise, Evelyn, Marjorie, Angelun, Catherine, Mae, Marie and Dorothy

Way, way back in 1932, when the country wallowed in the depths of the Depression, Angelun was a pretty, high-spirited seventeen-year-old convinced that life should not be lived in doom and gloom. No siree. She preferred to party. So she gathered a few of her high school girlfriends and organized a club for the sole purpose of getting together regularly to eat, drink and enjoy life. She even created its name, Yadrutas, which was Saturday spelled backwards—because they planned to meet at each other's homes every other Saturday afternoon. And for the last *sixty-six years* that's exactly what the

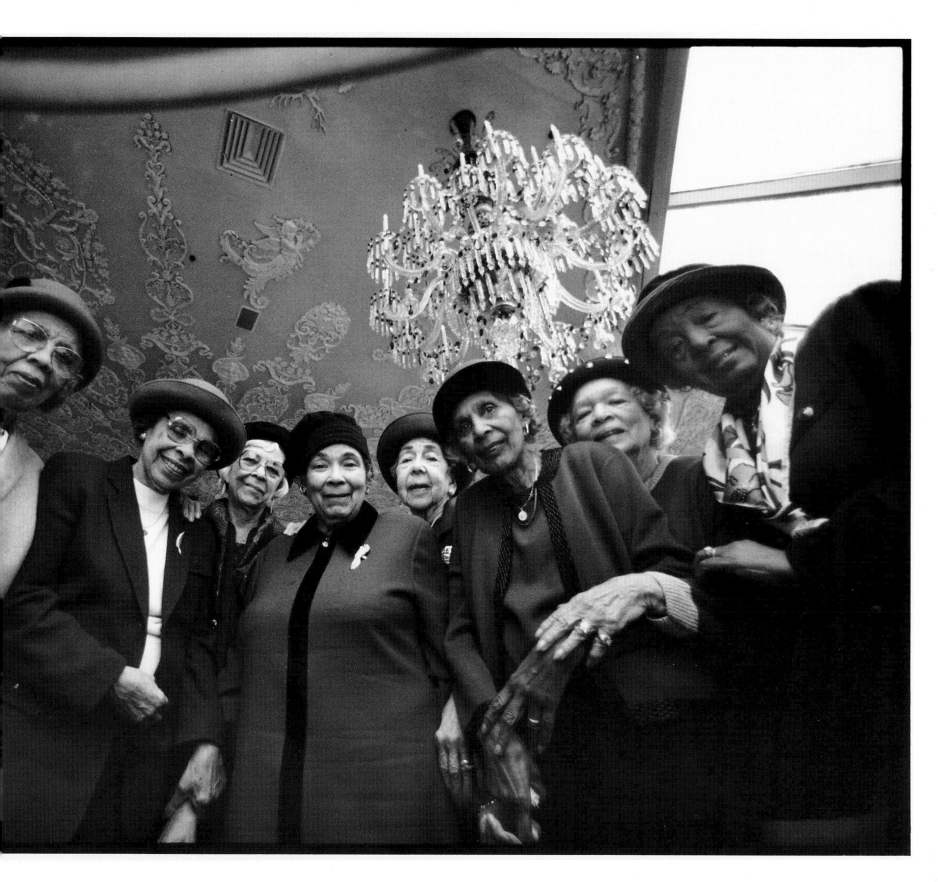

members have been doing. If you add up all their happy times, that makes their January 1998 luncheon at New York's popular Tavern on the Green restaurant their seventeen hundredth meeting (and that's not counting the zillions of bridge games that weren't considered official club functions).

Even the winter cold and snow didn't affect this day's attendance. Bad weather was never considered an excuse for not showing up, and, in the early days, you got fined a dime for coming late. In recent years, they've had to ease up on their rigid every-other-Saturday schedule. "Because we're old," Louise grumbles. "We have arthur-itis and there are some Saturdays when Arthur won't even let us go out."

Of the eight long-standing members seated at the table (two of the original group have moved South and three have died), eighty-two-year-old Marjorie is the youngest, while Mae, the oldest, recently celebrated her ninetieth birthday. Except for her hearing—*Could you repeat that, please?*—she's doing just fine, thank you. As always, when they dine out instead of at one of their homes, they are dressed to the nines. This day they've parked their worn fur coats in the restaurant checkroom—trophies from husbands, most of whom have passed away. In the pale winter light, their brightly colored clothes, a rainbow of purples, reds, greens and blues, are no match for the dazzle of the spry and lively ladies themselves. And, as might be expected of their generation, they all wear hats. They almost never go on outings without hats. Gloves, however, are no longer de rigueur.

Tucked away under their stylish suits and dresses, near their weakening hearts, linked so long in friendship, each one wears a treasured possession: a gold locket engraved with a Y and the date 1932.

"We treated ourselves for the fiftieth anniversary of the club. I never take mine off," says Dorothy, who is the treasurer and mainstay of Yadrutas. She runs the phone chain, spreading good news—so-and-so's daughter is engaged, son had a baby, great-grandson was born—and nowadays, often bad news. So-and-so's in the hospital; so-and-so's funeral is Thursday. Funerals are a red alert for the club to rally around the member who's grieving, to order the food and take care of her guests when they return to her home.

In sixty-six years there is little these ladies they haven't done together. "Remember the time we went to Minsky's?" Dorothy prods, reminding these very proper octogenarians and nonagenarians of their risqué visit to the famous burlesque hall. "We saved all our money and were determined to see the whole show because we'd paid for it. But we were so embarrassed we sat way in the back. We'd have never gone without each other, and nobody could say anything bad about us because we were all there together."

They've attended each other's weddings and each other's children's weddings. In their single days, they rented halls and held dances. After marriage, they took weekend jaunts with their husbands in tow. When children came along, the afternoon meetings became Saturday night dinners, and the men usually played poker while the wives laughed and chattered in another room. "Our husbands became friends, too," Evelyn says, "but we would have managed without them if they hadn't. The men had nothing to do with what *we* decided to do. They just came along."

To be perfectly honest, they do occasionally get on each other's nerves. "But there's never anything deep," Evelyn insists. "Never anything we take home from a meeting. It's just thrashed out and forgotten and we're still friends."

"If it carries on and on, it could become a big deal. So we drop it," Louise says. "It doesn't really matter what one of us says because there's no malice. But sometimes I just do a little cuss word under my breath."

"We've been friends so long anything else is trivial to our

friendship," Marjorie concludes, and the others nod in agreement.

Once they lived within hollering distance of each other in Brooklyn. Now they live within a half-hour drive. At a time when it certainly wasn't the norm for African-American women to go to universities, five of the eight attended college. And all but Mae, who was always a housewife, worked—mostly as educators and administrators. Nobody got rich; nobody slipped into poverty. "None of us ever had much more than the other," Catherine, the club secretary and historian, says. Dorothy adds, "I don't think anybody's really changed all that much." That may be the key to why they don't think it's at all unusual for eight women to have maintained such an enduring friendship for over sixty years. Yadrutas is so woven into the fabric of their lives, they have no idea how special it is. They have family, husbands, children, grandchildren—and they have Yadrutas. Their friendship has become as natural as breathing.

When asked to put their feelings about one another into words, their heartfelt responses are surprisingly short and simple.

Louise, typically the one who makes everybody laugh, wells up and says, "Each girl here in her own way has contributed to my happiness. I love and appreciate every one of you, and I'm thankful I met you. If I ever mistreated your feelings, I apologize now." The others break into applause. It's hard for them to remain serious.

"I don't even have the words," Evelyn begins. "I come from a big family, but this is different. I feel especially warm to them. They are extra family. I can tell these girls things that I might not tell my own sisters. I know I can call on each and every one. I love them dearly."

"Well, I don't have anybody. I'm literally the last of my line," Marjorie says, looking around the table. "*This* is my fam-

ily. I'd be lost without them. There's a closeness I really appreciate. It's like a security blanket. When I was in the hospital, I thought, Who am I gonna call? And it was good to know I could call any of them and ask for anything and they'd be there. And they'll always send a gift, too."

By contrast, Angelun, the consummate organizer, who has served as club president for the last twenty years, has a large family to rely on. "But there are lots of little things," she says, "that I would call my friends for before I'd call my daughter. I feel blessed and lucky. I have my children *and* my friends. I'll never be alone."

Catherine, eager to speak her heart, says, "We don't have to put on pretenses. It's like a given. Come to the house. Welcome. Sit down. We're like an extended family."

And Mae, steady, reliable wash-on-Monday, iron-on-Tuesday, church-on-Sunday Mae, utters just one line. "They are my friends. I look to them for everything."

Marie is especially grateful for the way the club helped her with her children when her husband died and how they comforted her during a recent illness. "They sent me cards; they called all the time and came to see me. One day in the hospital I looked up and Evelyn, who lives far away, was standing there. 'How did you get here?' I asked her. 'Did you drive?' 'Oh, I took a few buses,' she said. And that's how we support each other."

Dorothy spins Marie's thread a bit longer. "Yadrutas means sharing everything," she says with authority. "The good times as well as the sorrows, and we've had our share of each. We're there for the tragedies, and we get excited for each other's joys. A big part of what connects us is remembering the fun we used to have. I really don't think Yadrutas spells Saturday backwards. I think that Yadrutas spells love. L-O-V-E. Friendship and love."

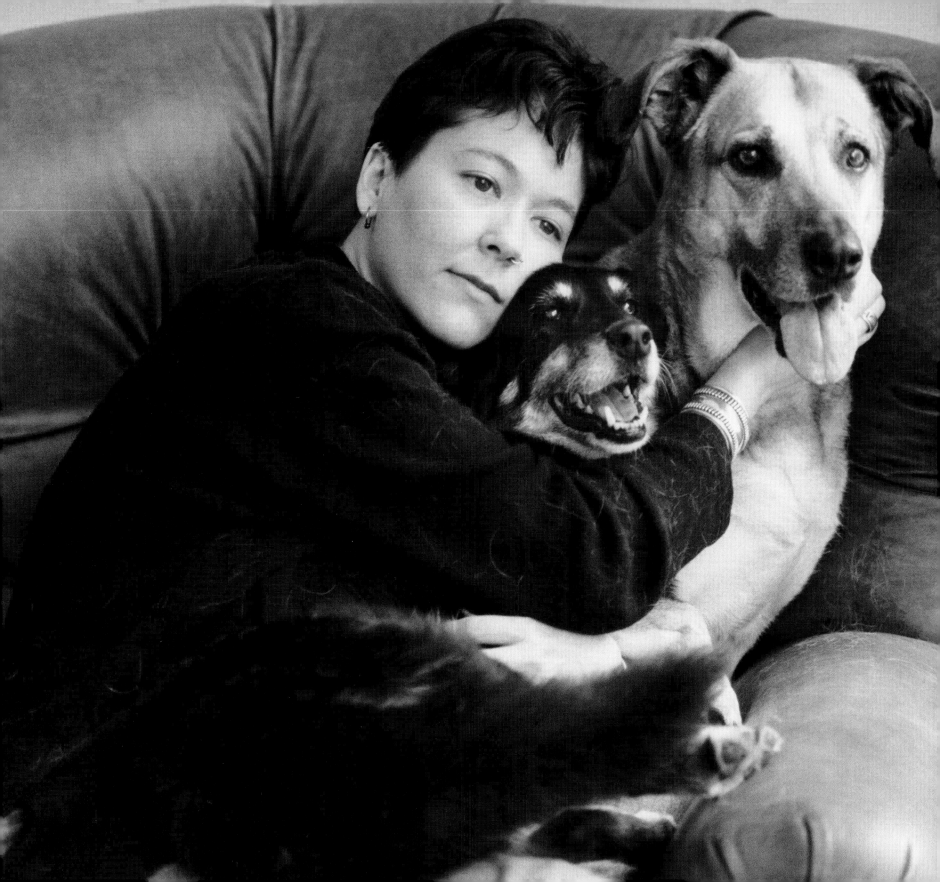

Cathy, Vagabond and Dazy

"*If you've never known, accepted and returned the love of a dog, there's a place in your heart still unopened,***"** *says Cathy with a catch in her voice. Listen to her tell you exactly what she means . . .*

I grew up in the country owning my own ponies and always surrounded by animals. Once, when I was four, I got mad at something and ran away from home—straight to my dog's house, where my parents finally found me asleep hours later. Even today, when I need comfort or solace, I find it with my pets.

When I came to the city to attend college, animals were banned in my dorm. Nevertheless, I rescued a rabbit and managed to keep him in my room.

Vagabond came into my life in my junior year. It was a cold, dreary day—with the sky the color of oatmeal—when I noticed her huddled on the stone steps of an abandoned building, a young, bedraggled black dog with antennae ears and intensely intelligent eyes. My boyfriend at the time, knowing how easily I could become attached, told me to keep on walking. I paid no attention to him and sat down next to the dog, crooning softly. First she accepted my voice; then my touch. After a while, when I was chilled to the bone, I got up, walked a few feet away and turned back. "Are you coming with me," I asked—the dog, not the boyfriend. She heeled quickly to my side. He followed reluctantly.

I smuggled her into the dorm. Since it wouldn't do to have a smelly, dirty and *illegal* dog in my room, I bathed her in the shower while people were off in class, and dried her silky coat with my hair blower. I didn't intend to keep her. I posted fliers and advertised to find her owner. But nobody responded. Then the vet gave her a clean bill of health. Said all she needed were regular meals, a good home and someone to trust. Me!

Soon I couldn't imagine living without her. I gave her a May birthday—same as mine—and named her Vagabond, "the wanderer"—vowing that her homeless, wandering days were over. Best I could tell, she was a mix of German shepherd and corgi. Except for a few chewing incidents, she was quiet, disciplined and bright—which is probably why my dorm mates helped me keep her presence in my dorm room a secret. I sneaked her in and out for exercise at odd hours. She became a favorite at the corner bar, the sweetheart of my friends, the darling of local merchants and my companion at my part-time job. Occasionally, I even took her to class. The only person who seemed ignorant of Vags's existence was my house master. When she discovered us, I sent the dog to my mother's house. By the spring term, I'd decided to rent an apartment off-campus. When it came to a choice between the dorm or the dog, Vagabond won hands-down.

For the last twelve years, Vagabond has been my confidante, my playmate, my soulmate and best friend. I'm not exaggerating! I don't have a single human being in my life who's shown the same constancy. She's gone to extraordinary lengths to stay by my side. There was the time I let her sleep late at some friends' where we were visiting, and I went off to work at a horse farm a half hour's drive away. Later that morning, Vagabond showed up at the farm. I figured my friends had dropped her off. It turned out that she'd found her way on her own, somehow managing to retrace the route from having traveled there at other times in the car with me.

Usually she follows my command to stay. But once I left her untied in front of a restaurant, and she got bored waiting for me. When I came out, she was gone. I searched the neighborhood in a panic, only to find her patiently waiting on the stoop at my apartment—the one place I hadn't thought to look.

When a lukewarm marriage I'd gotten into erupted into a violent parting, Vags and I ended up briefly living in my car. As I tried to piece my life together, I often had to leave her with others. I felt really guilty—as if I'd abandoned her—even though she was safe and well cared for by my friends. If she was fine, I was a mess. I felt awful that I'd let us be separated at a time that was as stressful for her as it was for me. After a few chaotic months, I retrieved her to accompany me on a five-day road trip over a holiday. That's when I realized how much of me was missing without her—and found *us* an apartment. We haven't been apart since. I know a blessing when I've got it!

Dazy joined us three years ago. She was a neglected five-year-old German shepherd–Great Dane mix in need of a temporary foster home. It was immediately apparent that if I took her in, my home would become permanent. But I couldn't say no.

While I can always count on Vags to comfort me with kisses and snuggles, Dazy makes me laugh. She is the dog of a thousand expressions, most often playing the clown. And she definitely has a mind of her own. Tell her that dogs do *not* belong on the bed pillow and she might just open an eye and groan. I've got to work to get her down to the floor.

Certainly other people are passionate about their pets, but you might well ask why I consider my dogs my *best* friends. Because I can always depend on them. Every day, no matter how good or bad my life is, they're here for me. Usually underfoot. They greet my waking up and my return home with joyous abandon. They're always up for anything I want to do—a hug, a walk,

a ballgame, a trek with the horses. Even a bath—so long as I'm the one bathing and they can lie by the tub and keep me company.

With dogs around, you can't mope or push the world away. You've got to get up, feed them, walk them and groom them. And believe me, I'm thankful for that. They've saved me from some dark, dark days. Not by doing anything dramatic, mind you. Just by the simple magic of making me smile and feel happy to be awake and alive.

Don't get me wrong. There are people in my life whom I love and enjoy—like my fabulous boyfriend. I hope we'll share our lives together. There's the catch: the word "hope." With Vagabond and Dazy I don't have to *wonder* about the future because I *know*, without a doubt, they'll be around as long as they live, providing me with a stability that I don't often find elsewhere. My relationship with Vags is the best long-term friendship I've ever had. Never a fight. Never a question of loyalty or betrayal. Or of being loved or respected or appreciated. It's the same with Dazy—only she hasn't been around as long.

I figure, from the way they dote on me, they must think I'm pretty wonderful and exciting, too. What more could you ask from a best friend than to always make you feel good about yourself?

Rick and John

It is unseasonably warm for the end of February, the kind of exuberant day that coaxes your inner child out to play. Not far from a rest stop on a Pennsylvania interstate, two college guys, hitchhiking on a midterm break, chase each other up a gravel pile like boyish competitors in a Little League game hustling to snare a fly ball. "King of the hill," one shouts when he reaches the top first. They laugh wildly at their silliness, at the perfect weather, at their youth, their freedom, at everything life offers them in that frozen moment; and at the promises that lie ahead. Then, exhausted and exhilarated, they crawl into the backseat of a Chevy Nova where the two tired girls who have stopped on the road to pick them up are waiting to drive on. Within minutes, the heat and the motion of the car lull them to sleep.

The excursion had been Rick's idea. He'd been having romantic troubles with a girlfriend in Massachusetts and felt compelled to see her. John, his best friend and roommate, came along to watch over him. The two have been tight as a square knot since the moment John wandered into Rick's dorm room at the University of Chicago. John still recalls his first impression with perfect clarity. "Rick was playing a Clapton tune on his guitar in a way that struck me as completely original and confident. I played folk guitar myself and was probably pretty stoned. I said to him in awe, 'That's the best guitar playing I've ever heard that wasn't on a record.' Not long after that, we had one of those what's-your-major conversations, and, without a pause, he said he

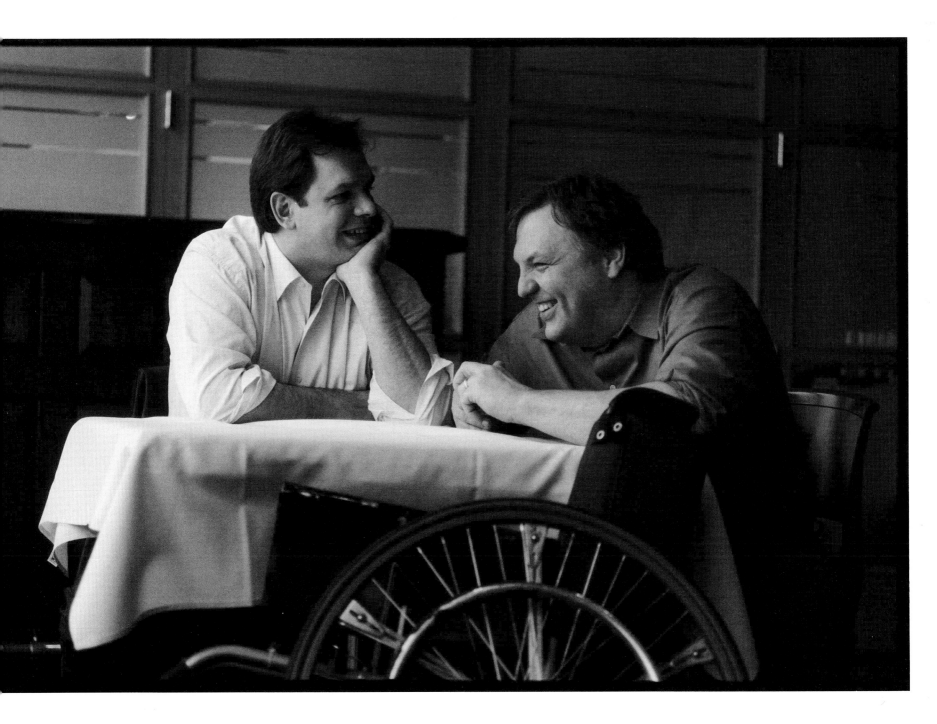

was a *poet*. Here I am, this goofy Midwestern public school guy—just beginning to understand that the world was infinitely bigger than I thought—and I'd never heard anybody say such a thing about himself. It was like, Where did you get permission? Show me your license. I sensed in Rick a kind of visceral intensity about life—and I wanted more of it. I started tagging after him, like the third grader who finds a sixth grader kind enough not to ignore him."

Rick blushes. "If you ask me to put my finger on my attraction to John, this is the guy with the *soul* of a poet. An over-the-top romantic. No one I know is more passionate or intense."

Initially they were bonded by their music—they were the golden boys of the guitar—and they decided to room together. "People gravitated toward us," John says. "Our room was called 'The Ranch.' We would sit and play, face-to-face, knee-to-knee, almost touching our foreheads, and you could have heard a pin drop. There was a rapture about us that partly came from our performing and partly from something bigger, a kind of spiritual resonance we gave off."

"It was a magical time," Rick explains. "We had this group of intellectually brilliant people coming of age together and embarking on a journey into the world of ideas. John and I were dangling our feet over the edge of the existential abyss. We had this powerful empathic dimension to our relationship—where someone becomes part of the other self that you carry around with you to view your own self. It's what intimate friendships are about, this process of mutual discovery and self-discovery."

John sums it up more simply. "Everything we were doing was so exciting—the music, the intense philosophical discussions about mind-body duality and fear of death. I always felt kind of loud and brash and crude, and had the sense that Rick was taking care of me, sort of telling me when I was overdoing

it. And, in return, I was the tough guy taking care of him in a different way. It was about not being alone."

The crashing noise of the car hitting the guardrail jolts everybody awake. The driver, who's fallen asleep at the wheel, is flung from the vehicle as it somersaults down the embankment. She dies instantly. John is pinned inside the car, crushed in a fetal position with his guitar between his legs and the long lens of the camera around his neck pressing into his broken ribs. The other girl lies moaning on the ground not far from where the car has landed. Rick, dazed but miraculously unhurt, crawls from the wreckage and makes his way up to the highway, where a semi-truck has pulled over to the side of the road and radioed for help.

Imprisoned inside the smoldering car, John smells gasoline fumes and fears he'll be burned alive. He is keenly aware that he cannot feel his legs. He can see them all right, but it feels as if they no longer exist. By tonight he will learn that his spinal cord has been severed and the race he ran up the gravel pile was the last time he would travel on his own limbs. He feels doubly helpless as he watches Rick through a crack in the window, scared, alone and ignored by everyone because he has no visible injuries.

It takes ages to pry John out of the car and finally move him into an ambulance. Rick has been holding tight to his hand for what seems like hours. John pries himself loose from Rick's grip, smiles weakly and wiggles his fingers in a strumming motion as if to say bravely, "Well, at least I can still play guitar."

John and Rick survived the accident with different kinds of scars. The survival of their friendship would require a longer healing period than their wounds.

From the hospital, John went to a rehabilitation center to learn how to live as a paraplegic, but Rick was too paralyzed with guilt to visit him there. How could he have emerged physically almost unscathed from an accident that was surely his

fault, because he'd instigated the trip to solve his stupid romantic problem? In his despondency, he shoved a bed into a crawlspace in the dorm room he and John once shared, and essentially holed up there for the rest of the term.

Lying in bed with nothing to do but think, John evolved a cosmic view of the accident. It seemed to him, "We each were assigned the role we deserved so we would eventually understand what we meant to each other. In the grand plan, I had been the loud one, the physical caretaker, and Rick was the spiritual caretaker. So the accident played out for me as a physical experience and for him as an emotional experience. We both got the jobs we were expert at. He made sure I got out alive, and now his part was to live with the guilt. My work was to get on with the whole business of reinventing my life. I am now in a wheelchair. This is the way I live. The accident wasn't a turning point that left us with dark demons. It was the thing that actually set us on our way."

Rick nods in agreement. "It was part of the shit you use as fertilizer in the process of living."

But now there was some hard ground between them. John, edgy and defensive, returned to the University of Chicago in his wheelchair, naively hoping that he and Rick would resume their old patterns. But there were no rabbits left to pull out of the hat to make that magic time reappear. One of them was consumed with anger and defiance; the other, wracked with remorse. Moreover, it was 1977, years before the Americans with Disabilities Act. The snowbound campus was extremely inaccessible, steps everywhere and no ramps. "There were all these issues between us about helping and not helping, whether Rick was going to push me or I was going to wheel myself," John recalls. "People acted like the accident was about me, and I wanted to signal it was about *us*. That if I'm independent and he's independent, we can both be okay."

Two eloquent men, who could ratttle on about every grand idea in the universe, couldn't talk about what really mattered: their brush with death and what was happening inside them as a result.

"It was a very confusing time that took years to sort out, although we never did lose our sense of connectedness," Rick says. "In a relationship you learn how to dance with each other's boundaries. It takes a long while to be able to step on each other's feet and go, 'Ooops, sorry. On to the next thing.'"

To get on to the next thing, it became evident they needed to separate physically and emotionally. John went off alone to a college in Oregon where he doggedly pushed himself up the rocky road to self-sufficiency, hell-bent on proving he could conquer anything. He succeeded magnificently and parlayed a volunteer position at a radical campus radio station into a prized job as a correspondent for National Public Radio in Washington; in his wheelchair, he quite literally covered the world, doing remotes from Africa, Israel, Iraq and Afghanistan. In 1992 he moved from radio to television and joined NBC News.

Rick made his mark in the business world. After graduation, he formed a band, then worked for a while on Wall Street until he was recruited in 1994 to run a burgeoning high-tech imaging company in Seattle, which he recently took public.

In the difficult years they spent apart, John and Rick stayed loosely in touch by phone, rarely seeing each other. The one subject they continued to avoid was the accident. Then one night, seventeen years after John lost the use of his legs, he was overcome with a pressing need to air their taboo subject. "I was sitting in a hotel in London on my way to Somalia and, for some reason, this upcoming trip brought me back to the accident," he says. "I was really worried what might happen to me in

Somalia—maybe I wouldn't return—and I had this chilling thought that I'd been such a jerk all this time doing my John program that I'd never really thanked Rick for saving my life. So I called him. I told him how I'd missed him all these years and I thanked him for keeping me alive." Many heavy things, long buried, spilled out; and they both ended up sobbing. The ice of silence finally melted.

Two years later, reliving that emotional exchange over drinks in Seattle, Rick tells John, "You didn't really call me to say thank you for saving my life. That was unnecessary anyway. You called to say, 'I'm afraid for *my* life again and I love you and this is how I'll express it because I don't want to tell you I'm afraid.'"

No one else in the world but Rick could have understood the meaning beneath John's words. "The difference between friends, acquaintances and best friends," Rick goes on, "is that deeper level of knowing, a deeper level of confidence and trust and familiarity that defies description. There's a comfort that you can come and go and you don't pay tolls. The kind of safety that Thelma and Louise feel as they sit next to each other and drive over the cliff. We give that to each other."

"It's always hard to convey to people why this friendship exists," John says, looking resolutely at Rick. "It's not because of the accident. We were having this amazing college experience, although until the accident I didn't know where the friendship would go. The accident actually ensured that our friendship would be permanent. It helped us understand how the past is a place where one can find richer meaning in a way that helps with the future. We already shared this great passion in everything we did and what we cared about. It was that passion that led us to think we could pack some suitcases, grab our guitars and get into a car on a warm weekend in February, discussing *Faust* on the way. And when I was in the car bleeding, the first question I asked myself was, Is the passion still with us? It's an implicit question I still ask whenever we open a conversation, and for Rick and me, the answer is always yes."

Lucia, Maria and Angella

The Ahn sisters—successful, sexy and slim as clarinets—are the embodiment of togetherness. They live in a cozy New York apartment, complete with a beautiful garden. When they're not at home, their busy schedule performing chamber music concerts keeps them entwined on the road an average of three weeks out of every month. The rest of the time, they rehearse together four to six hours a day. Yet when you meet them, the first thing they each want to do is establish their own turf.

"Living together has helped us learn that we can be very close and at the same time remain our own persons," Angella says. "We were really scared of losing our individuality."

They've been struggling with how to balance their attachment to each other since they were little girls in Korea, where they initially stood out because of the Western first names their parents insisted on giving them. At age seven, Lucia decided she wanted to play piano. Within a year, her sisters were clamoring for their own music lessons.

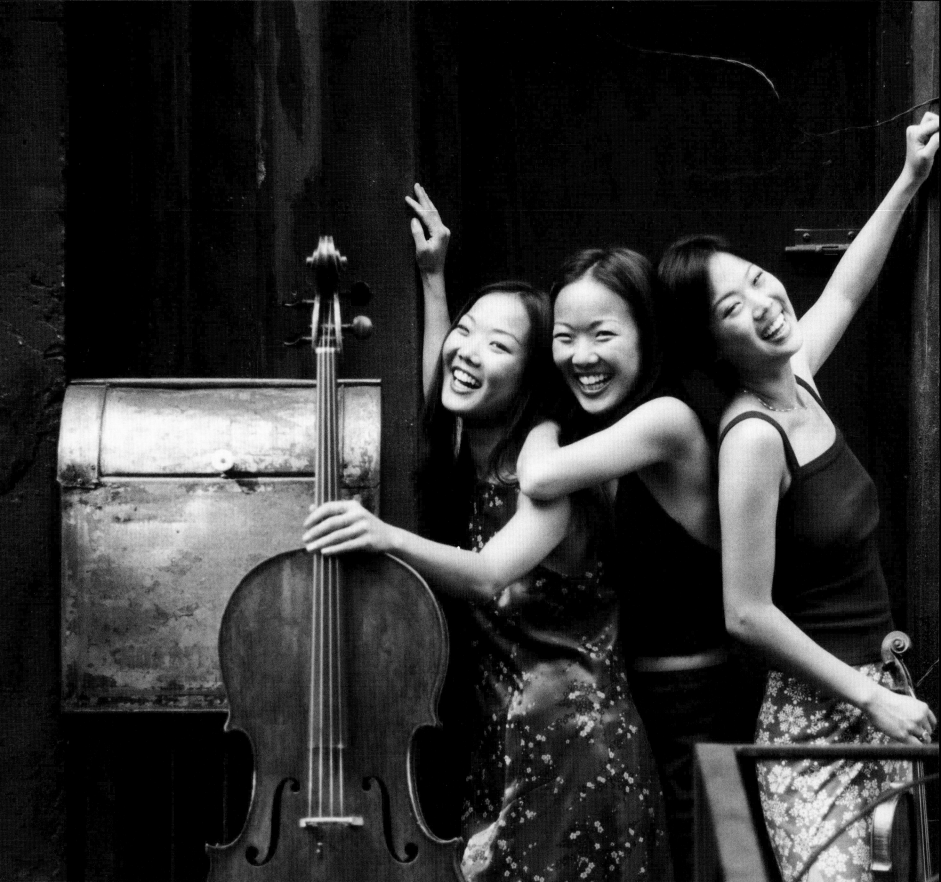

"It was natural for us to be jealous of her," Angella explains. "When one of us does something or gets something, the others must always have something—not identical but of equal value."

Their mother wisely insisted they take up different instruments, and she continued their musical education when she brought them to America in 1981, after her marriage dissolved. The girls fully expected to have solo careers until they attended college at the Juilliard School in New York and began doing concerts together as a trio.

A piano trio is the perfect medium for them because unlike most chamber ensembles, which depend on a seamless blending of sounds, the piano, cello and violin are intentionally distinct. Moreover, their repertoire—chosen democratically by a majority vote of any pair—gives them ample opportunities to shine as soloists.

While all three have skin like polished bronze and raisin-dark eyes that almost disappear when they smile, they are quick to point out how they've each dyed their hair a different color. You'll soon learn that Maria, currently a redhead, is the daydreamer, the fashion maven and the artistic director of the trio. Angella, with the pitch-black tresses, is the business brains and the slob. And Lucia, because she has the disposition of an angel, gets stuck with the role of mediator when her sisters stubbornly lock horns. If Lucia lived alone, her diet would consist entirely of burnt toast with jelly. She couldn't whip up an omelet if her life depended on it.

At age twenty-six, Angella, the violinist, is the baby in the birth order—and the mother when it comes to nurturing. She also handles the finances. "But I won't give a cent to Maria until all the bills are paid," she says, "because she's the worst with money."

"Angella is the best nurse among us," Lucia, the twenty-eight-year-old pianist, says admiringly. "When you're sick, you want her to take care of you."

"And I'm the best driver," boasts her twin, Maria, the trio's cellist.

"Are you kidding?" her sisters groan. "The other day you went through a red light, plus a stop sign."

Still, it was Maria who took the wheel when the girls were marooned in their van during a violent snowstorm in the midst of a tour in South Dakota. Angella, frozen with fear, stopped driving. The deserted highway had become

an ice field with zero visibility. "Since my sisters were panicked, I knew that only I could handle this," Maria says, provoking gales of laughter. "We had to get to the next town, so I drove forever at ten miles an hour while they kept screaming, 'We're going to die. We're going to freeze.' See what I do for you guys!"

"That night, Maria was totally focused. When she needs it, she definitely has that first-child quality," says Lucia of her twin sister—who is all of ten minutes older. "I think she had to get out of our mom first because she has absolutely no patience."

"The reason we get along so well," Maria declares, "is because we are different in so many wacky, crazy ways that we keep each other entertained. We would definitely get bored if we were more similar."

"We can be in the middle of nowhere," Angella explains, "and we have the best time driving around in our little minivan, giggling and singing. Of course, there are days we just get cranky. Even nasty. But because we're sisters we can take it out on each other and we understand."

"We forgive each other quickly. And then we laugh about it," Lucia says. "Being sisters makes our friendship definitely stronger."

"And our expectations of each other definitely higher," Angella suggests. "You know how even with your really good friends, there are little moments when you hold back. The three of us don't ever have to do that—"

"Because we can show each other our weaknesses," Maria says, finishing her sister's sentence—which they do continually.

"One reason we're such upbeat and happy people is be-cause we're sharing constantly, whether it's our music or our life," Lucia says sweetly.

"It would be no fun having all the things you wanted by yourself," Maria notes. "There are so many times onstage when I look at my sisters and we get just the right color or feeling in the music—"

"And," Lucia goes on, "there are a thousand people just holding their breath watching this intimate friendship of ours—"

"And it's so beautiful I almost want to cry," Angella finishes. "We have a lot of those cheesy moments. Oh yeah. We're all really sappy. We constantly talk about how grateful we are to have each other. And to have our careers together."

Lucia: "Like last month we were in Europe on a promotional tour for our new album. The record company got us three beautiful rooms in the hotel. We always have our own rooms because we like sharing emotions—but not sharing space. Sometimes you have to be alone."

"This is what we always do," Angella takes over. "We have our separate rooms, but twice a day we meet in one room—"

"To have a little discussion," Maria breaks in. "Usually about how amazing our lives are."

"Right." Angella nods. "And about how lucky we are. Every single night, after every concert, before we go to sleep, we must get together for ten minutes and just say, 'Wasn't that wonderful?'"

"We need to have that moment to share our happiness," says Maria.

"We're weird," Angella says, making sport of their intense friendship. "We're just a bunch of sickos!"

Allen and Gayle

When a straight single man and woman develop a bare-your-soul, share-a-room-on-vacation, call-in-the-middle-of-the-night best friendship, there's a good chance that one night too much champagne will excite the old hormones. A knowing glance will pass between them and they will face a charged moment of do we or don't we? If they truly want to remain best friends, they'll probably decide—as Gayle and Allen have—that their friendship is too valuable to put at risk for a night in bed.

Gayle and Allen had been casual, wave-hello-in-the-hall, high school friends. She got him through biology when he was too squeamish to dissect the frog. They lost touch after graduation and reconnected accidentally several years later, after Allen bumped into Gayle's husband at a poker game. Allen happened to be dating a woman who lived in their apartment complex and when they married, the four of them, plus another couple, became the "Gang of Six." "We spent every weekend together for nearly twenty years," Gayle says, "went skiing, to the beach, to the Bahamas, to Las Vegas."

The six unexpectedly shrank to four when Allen and his wife separated in 1994. He handled his despair by crawling into a shell that even Gayle had trouble cracking. She persisted in reaching out to him and occasionally he responded, like the time he sought Gayle's advice over a long letter he'd written to his wife when it looked like they might reconcile. "I withdrew," he

says, "out of a combination of male ego and a sense of failure. It was the toughest time of my life, and I needed to get myself fixed in my head. I would call on Gayle to keep up with things, but I didn't want to fall on her."

And then she suddenly fell on him. One day, two years after Allen's marriage dissolved, Gayle's husband came home from the office and announced he was moving out. The perfect couple was kaput! "It came right out of the blue," Gayle says. "I totally lost it. I called my best girlfriend, absolutely hysterical, and she must have called Allen because I don't think it was three minutes later that my doorbell rang and he was standing there."

Both of them get weepy remembering that moment. "Gayle had been my friend for so long," Allen says tenderly. "She was like a part of me. I really understood what she was getting ready to go through. And it was a horrible time. I just wanted to be a shoulder for her to lean on, to get her to talk; but more important, to be a good listener."

Need is a powerful fuel for friendship and there's no question that Gayle and Allen needed each other when their married worlds collapsed. "We'd been friends for twenty-five years," Allen says. "We have a history. We watched each other's children grow up. But our friendship never would have gone to the depth it has if it weren't for the circumstances of our divorces. That gave it the opportunity to really flourish."

Gayle absentmindedly strokes Allen's hand while he speaks. "He was my lifeline when my husband left. There's no question I would not have made it through without him. He had such empathy for what I was going through. It wouldn't matter where I was, or what time of day, or what I needed, he would drop everything and be there for me. Every morning he called to see how I was. Sometimes—in the middle of a workday—he'd phone, and he could tell if I was going through some bad stuff. Right away he'd leave work in Dallas and drive to Fort Worth, where we both live. That's an hour over and an hour back. I felt so nurtured by him."

Gayle has a best girlfriend, too, but her relationship with Allen often feels closer. "I can't tell you what the difference is between them, but when Allen puts his arms around me, there's just a difference. I can say anything to him, even things I wouldn't tell a girlfriend. I feel an unconditional love behind his words.

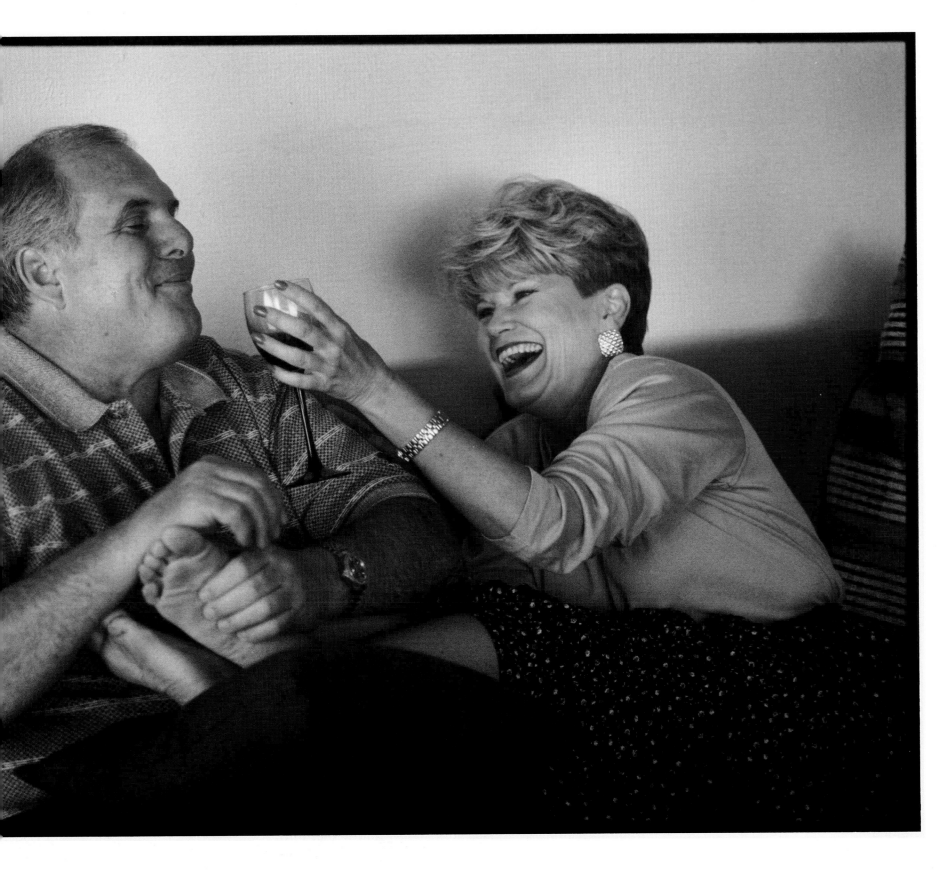

I really like that he gives me a male perspective on things. If I'm having a problem with someone I'm dating or an issue with my ex-husband, because he's a man he can give me better answers to my questions."

Allen also has an intimate male buddy, but he can't compare to Gayle. "I can talk to him to some extent about my feelings," Allen says, "but I'm not overflowing, like I am with Gayle. I can be completely uninhibited with what I say to her. I never worry about her judging me. I can even cry. Gayle always kids me that no matter where I am, she's a little bird sitting on my shoulder, and I do feel her pecking there, asking, 'What are you wanting? What are you needing?' She has a very calming effect on me. Men friends are more forceful or abrupt. They shoot from the hip. Give you the blunt answer. Gayle's advice is more rounded. Instead of angles, it's curves. And her touch is very comforting, like someone's touching your heart and your head at the same time."

They've traveled together and shared a room—but never the same bed—and they change clothes in the bathroom. "The first time we went away," Gayle says with a cute smile, "Allen asked if I minded him walking around in his underwear and I didn't care."

"Well, it was boxers," he explains a bit sheepishly as he massages Gayle's feet. "Most people don't understand how we can be best friends and not have sex come into it. I guess it is rare to have a male-female friendship as intense as ours without it being sexually based."

Especially for a couple who grew up in the sex-stereotyping era before coed dorms.

"For me, it's almost the way I've always felt about cocaine," Gayle says. "I don't ever want to try it because I don't want to risk what might happen. If Allen and I had sex, we could lose what we have. Our friendship would never be the same. And I would rather have a lifetime of Allen as my friend than anything else in the world."

While Gayle is still looking for a Mr. Wonderful in her life, Allen is currently in a relationship that could get serious. They're just beginning to deal with the reality of a significant other who could be jealous of their friendship. A husband or wife is much more likely to tolerate time spent with a same-sex friend than with an opposite-sex friend. It would be one thing for Allen to say, "I'm going out to have a drink with my friend Jim," and quite another to say, "I'm stopping at Gayle's house for a glass of wine. I need to talk to her."

So what would he do if pressed to choose between his lover and his best friend? "Let's just say this," he replies. "Our friendship is better than anything else in the world." Gayle does worry that their relationship won't be the same if Allen marries, but she's not afraid of ever losing him. Or that he would betray her, like her husband did. And if she should find someone to marry, she's clear that Allen would have to be accepted as part of the package—or the guy would get his walking papers.

Although both Gayle and Allen are committed to maintaining their nonsexual friendship, they once came close to crossing the line.

"It was the first Thanksgiving after I filed for divorce," Gayle says. "Holidays are hard anyway. The day before, I was cooking dinner for my family—you know how you look when you've been cooking all day—and the doorbell rang. There stood Allen. I couldn't think of anybody else I'd rather have had at my front door. It was like he sensed what I was going through. He gave me a hug and this thing passed between us that we both felt. I can't describe it, but he knew and I knew."

"Maybe I hugged her a little harder for a moment," Allen says, "and that was it. In a blink," he snaps his fingers, "it passed. What we have is an example of true friendship at its highest level. Why threaten that?"

Betty and Orianna

"Lo-ove me, Lo-ove me. Say that you love me." Orianna stands in the middle of her bedroom passionately singing along with the soundtrack from the *Romeo + Juliet* movie blasting from her stereo. Her glasses, damp with perspiration, slide down her nose, but she's too engrossed in her performance to notice. "Squeeze me. Please me. Say that you'll need me." She jumps around with wild abandon, swinging her arms in the air and nearly dislodging one of the hundred or so pictures of Leonardo DiCaprio—the current love of her life—that she's plastered all over the walls.

Betty, her absolutely "bestest friend in the whole world," sits on the bed, rocking back and forth to the beat, joyfully laughing and clapping her hands. Like kids at a playground, Betty and Orianna are momentarily wrapped in the invisible gauze of their sheer delight in each other's company.

Would Orianna like to sing on Broadway? You bet! But just acting would be fine, too. She takes acting lessons, has appeared in several school plays, and at the slightest provocation she'll recite gravely one of Juliet's speeches from the film she's seen countless times in order to moon over her heartthrob DiCaprio. "*Not proud you have,*" she emotes dramatically, "*but thankful that you have: Proud can I never be of what I hate; But thankful even for hate that is meant love.*"

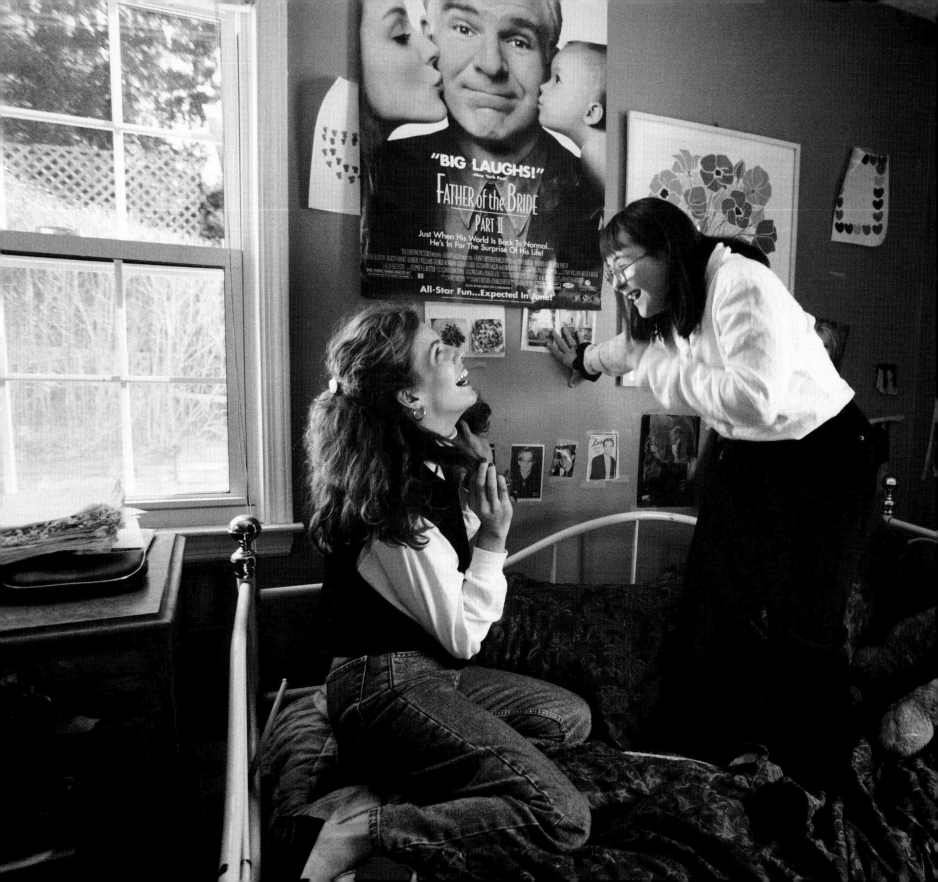

"Isn't she amazing?" Betty marvels. "Isn't she too much!"

But, of course, they both know that Orianna's name will never be up in lights, and that her passion for Leonardo DiCaprio is as close as she'll ever get to a real love affair, because Orianna has Down's syndrome, an untreatable genetic defect that limits its carrier's mental development. While she has the body and the hormones of a chubby teenager, her mind will never advance beyond the level of a precocious child. Betty, on the other hand, has no genetic abnormality other than the ray of sunshine embedded in her heart that causes her to exude a cheerful sweetness with her every breath.

They are an odd pair, these two best friends—a married thirty-year-old schoolteacher and a sixteen-year-old girl with Down's syndrome—but they are truly best friends. "When I'm with Orianna, everything is just real simple and extra-special," explains Betty. "It's easier and lighter. No negatives whatsoever. She won't say no or whine, or complain. She goes along with everything and is so eager to try anything. She's just a delight and we have so much fun. We just crack up. She's totally devoted. She gives you everything. 'Oh Betty, I can't stand it, I love you so much,' she'll say. That's her favorite line, 'Oh Betty, I can't stand it, I love you so much.'"

Betty has known Orianna since she was born, having baby-sat for the two older children in the family. She remembers Orianna at eight months. "We would have to roll her body over a big ball. Because of her condition, she didn't have any muscle strength." As Orianna grew up, Betty was always around. She accompanied the family on vacations as a mother's helper; later she would move into the house for a few weeks at a time when Orianna's parents traveled abroad. Gradually, what began as a job evolved into a genuine friendship.

Long after Betty's baby-sitting assignment had ended, when she'd graduated from college and taken a teaching posi-

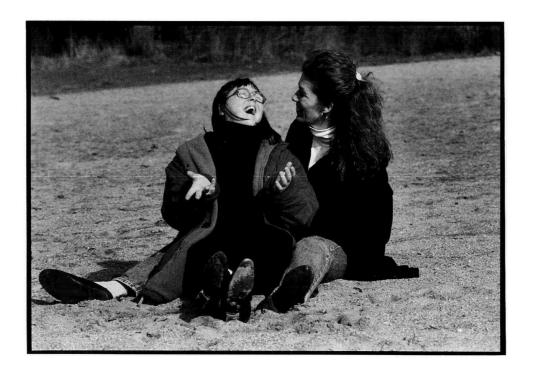

tion, the young woman spent nearly every Saturday hanging out with Orianna—by choice. "For nearly three years my boyfriend was far away," Betty explains, "and I knew I'd better do something to keep busy—or I'd go nuts. Everyone was asking, 'Why do you want to spend Saturdays with Orianna when she has Down's syndrome and she's twelve years old? What kind of person are you?' But I never wanted to do anything else. I knew, no matter what, if anything was going wrong in my life, it would be enlightening to be with Ori. We'd have a good time and laugh and Orianna would give me a nice rub and touch my hair. It was such a sweet feeling. We spoil each other with hugs and kisses. With Orianna, you don't have to give too much. She doesn't want a lot."

They had a routine. Pick up Orianna at eleven. Go somewhere for lunch. Drive around in the car with the windows down, the stereo cranked up, singing at the top of their lungs. Just acting crazy.

"We always love to share our song, 'One Sweet Day,'" Orianna pipes up. "That's our song. Mariah Carey, Boyz II Men. It comes on the radio when we're driving. I wrote to Mariah Carey to tell her. She hasn't written back yet."

In nice weather they would go to the beach and swim. On other days they'd run errands, visit friends, or bake cookies and brownies. Orianna would copy dessert recipes out of magazines and try out the simpler ones.

"I'm a chocaholic," she giggles. "And I love movies."

Next to *Romeo + Juliet*, Orianna's all-time favorite film is *Father of the Bride*. That's probably because of the way Betty included Orianna in all her wedding plans. Ori went along with Betty to pick out her dress, to check out the chapel, to choose the place for the reception and to order the wedding cake. "She was a part of it all," Betty says. "It was natural. She's my best friend. Wherever we were going, I'd say to my sister, 'Let's go get Ori. She just loves this kind of stuff.' She

even tried on wedding dresses." And at the wedding, where a beaming Orianna walked down the aisle as a junior bridesmaid, Betty asked the band to play "One Sweet Day" so that she and Orianna could dance together to their song.

"Being with Orianna," Betty says, "I always think to myself, How could I ever worry about having problems? I look at the world through Orianna's eyes, and what I see is uplifting and easy and happy. There's no stress. I don't worry about somebody being mad at me—or am I going to have enough money to go on a vacation. With her, you don't look forward. You don't have your mind set in the future. It's like you're living in the present, and this is the best."

Orianna gives Betty the opportunity to temporarily shed her responsible adult skin and indulge in the spontaneity that maturity does such a good job of burying. "I never treat Ori like someone with a disability," she says. "I guess I sort of escape with her. I can be really immature and foolish." And with Betty, Orianna gets to briefly forget that she's disabled or different. By nature, Orianna is outgoing and sociable. She has many friends like herself at school. But there is no one in her life to match Betty.

"She's very nice and funny and pretty and she's good to me," Orianna says in her carefully enunciated way of speaking. Then, spontaneously, she reaches over to Betty and throws her arms around her friend's neck. "You're the best, Betty," she whispers. "You're the *best*!"

Gay and Hotch

In the living room of Gay Talese's elegant town house on New York's Upper East Side, close by a pair of faded gold Queen Anne chairs, there are two large built-in bookcases flanking the entrance to a small, formal dining room. Gay's books—*Unto the Sons*, *The Kingdom and the Power*, *Honor Thy Father*, *Thy Neighbor's Wife*, *Fame and Obscurity* among them—occupy several shelves on the right side. On the left sits his extensive collection of the books written by his best friend, A. E. Hotchner, including *Papa Hemingway*, *Louisiana Purchase* and *Sophia*. Inside one of his books, Hotch has scrawled a few words that sum up the essence of their thirty years of intimate, supportive yet sometimes fractious friendship. "For Gay: My friend, confidant and co-conspirator, lo these many adventurous years."

They were introduced in 1965 by Gay's wife, Nan, a literary editor now at Doubleday. "She told me one day that there was this terrific book she was about to publish," Gay remembers. "She thought the author was very interesting and a lot of fun. 'He tells wonderful stories and plays tennis,' she said." That was sufficient to pique Gay's interest.

"I'd just left my job at the *New York Times* and begun to get interested in tennis. Hotch was, and is, a very good tennis player. We would play a lot of doubles, and through his exhortations and screaming advice, I learned where to move on the court. It wasn't exactly fun or joyful, but it was a means by which we came to tolerate each other. Not necessarily a means to understand each other."

Hotch chimes in with his recollection. "We were both going through a watershed period. Gay was freelancing for the first time and discombobulated in terms of his worktime. I was also unanchored. Until this book on

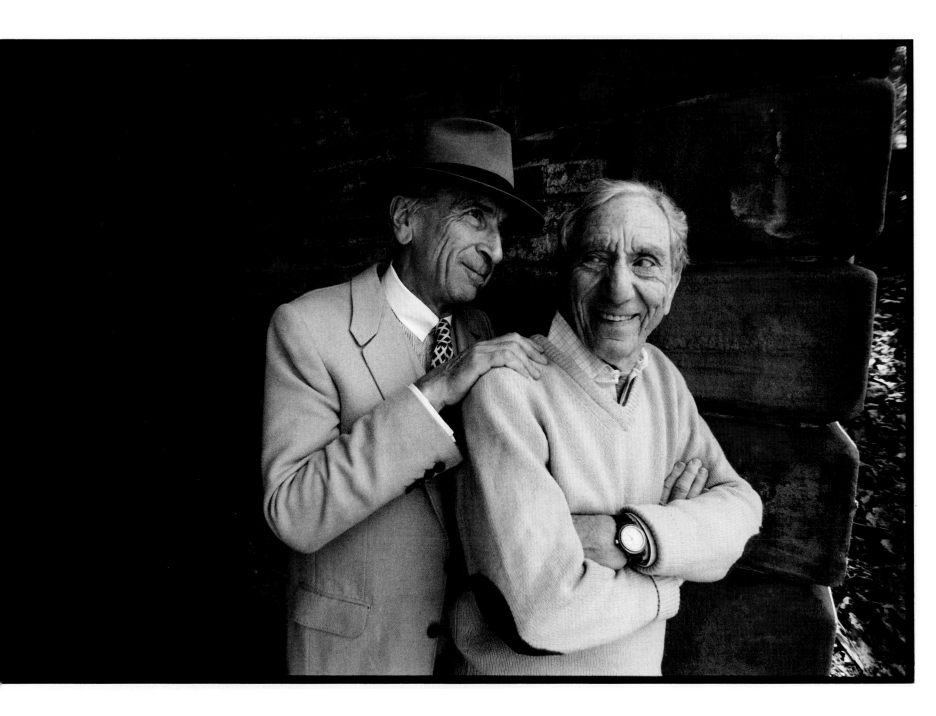

Hemingway, I'd been writing for magazines and television and had never done anything really literary before. And about eight or nine months earlier I'd left a marriage. So I meet Gay when I'm first starting to deal with literary recognition. It came as an absolutely startling shock to me that everyone thought this was going to be a special book. In a way, it was a time when we were both searching, both battling for a new life, and I think that that, more than tennis, is what brought us together."

Gay reflects for a moment. "Actually one of the things that connected us early on, and supported us through the upcoming years when we would have other fallings-out, was that we both came from an unhappy background. We were both kind of screwed up in our adolescences and didn't have a lot of friends or a sense of friendship. I'd had temporary acquaintances from my army years and my college years and the city room, but not many friends. There's the graduation process or the discharge process and then you move on because these aren't people you have much in common with anyway."

"Understand that my first introduction to Gay," Hotch interjects, "was through his having read my Hemingway manuscript, which is ostensibly about Hemingway—but really a memoir about my reactions to him. Gay picked up a lot about me from his very perceptive reading, and, out of that, we began to discuss my boyhood and his boyhood."

"Hotch and I shared this sense of disenchantment," Gay explains, "and perhaps loneliness. And maybe, too, a lack of fondness for people until we knew them well. And when you are mistrusting or defensive or shy, you don't collect a lot of people. When you do find a friend, you're going to hold on to him through thick or thin. And we've certainly been through thick and thin."

Clearly these are two men who, despite a broad range of social contacts, dole out their affection sparingly. It was easy for them to converge around their mutually sardonic way of seeing the world. Neither suffers fools gladly. "A trait Gay and I have in common is benign truculence," Hotch says with his ironic smile. "I also had very few friends; I was tentative about everybody. But Gay and I spoke the same language. We would put down people in the same way. That was good. We both have this ability to antagonize and we understand each other where somebody else might not."

"We shared a voice," Gay notes. "I respected Hotch. And I think he's fun. He's got a wicked sense of humor. We just got along well. We liked the same things: going to sporting events; watching football on television at my place on Sundays; hanging out in restaurants."

Hotch reminds him, "We were one of the first to regularly meet at Elaine's. It was just a skinny little restaurant then, nothing like she has today. We had a kind of literary salon at this one table where all of us would sit—David Halberstam, Tom Wolfe. Nobody had yet amounted to a hill of beans and we were all pulling oars in the same scull."

From the onset, sharing the agonies of their lonely work as writers turned out to be a particularly valued component of their friendship. In an article about his best friend, Hotch once wrote, "How many times have we met at his urgent call, because Gay's writer's wounds have been hemorrhaging."

"When you ask someone to read what you've written," Gay replies, "you're essentially saying, 'I need help.' Not many writers do that willingly. But I know when I need help, Hotch has always been there to give it to me."

"We can give each other a chapter to read," Hotch adds, "ask, 'Do you think this will work?' and be honest with our answers. We don't do that with anybody else."

Given their prickly personalities, it's not surprising that they often engage in loud, divisive arguments over such world-shaking issues as whether or not the Mafia can be considered civilized. The

very worst fight they ever had kept them apart for a year. Predictably, it was petty, and it stemmed from tennis.

"We met this very, very rich real estate guy from Chicago," Gay launches into the story, "who liked the same things we did—sports, good-looking women, tennis. He invited us out there from New York with our wives to his fiftieth birthday party, but I had a fight with Nan and we missed the plane and had to take a later flight."

Hotch takes over. "The next day we're all on the tennis court and a taxi pulls up. Gay is now arriving and he's in a foul mood. He changes into his tennis duds and the host sets us up to play with this father and son. The father is about five foot three, with a pot belly, shorts down to his knees and his socks folded over. The kid is about six foot two, with pimples, and it looks to Gay like we've been given this ignominious pairing. The wind is blowing like hell and they are just *wiping us out*. Gay is hitting his best serve and it's coming right back. The fact is that the little guy is the number one singles player in Illinois. And his son is number one at Princeton. To calm Gay down, I say something smart-ass like, 'Take it easy. The wind's the same on both sides of the net.' 'The hell it is,' he yells back. The score is now something like four–zip. We haven't won a game. We get into this big conflagration on the court, and Gay screams, 'I can't play with you. You think you're such a hotshot.' And he storms off. We yell a little more. The next thing I know, a cab pulls up and he and Nan throw in their bags and take off. They've been there about an hour and a half and they're gone. Later, back in New York, neither of us would give an inch over the incident, so for about a year we didn't speak."

Gay continues. "Then one Sunday night Nan and I and our daughters are having dinner in a neighborhood restaurant and I see Hotch in the back of the room eating alone. After we finish, I send the family home, and I walk over to his table. He doesn't know what the hell I'm doing. Is this guy going to hit me with a bottle? But I said something like, 'All right. I've been a horse's ass for a year, and I'd like to forget about it.' And that's how we made up. In a restaurant. It was very moving.

"I think the strength of our friendship is that we can do this kind of thing. If Hotch were a person I did not have confidence in as a friend, I could not have walked off the court and made a scene in Chicago. You wouldn't act out in the most disreputable way with a person for whom you had passive feelings. I can take all kinds of liberties with Hotch that I wouldn't take with other friends, even though they sometimes cause rifts between us, because I don't care about embarrassing him. I know he will always be a constant in my life. A predictable presence on two minutes' notice if I need something."

"You could say we're comfortable," Hotch observes. "Gay has an intensity, a concentration and a kind of wisdom that's invaluable in a friendship. If I have a problem, it becomes his and that's reciprocal. You wouldn't even consider some of our problems as problems, but they are to us. That pebble-under-the-saddle kind of thing that nobody else would feel, but we blow it out of all proportion. Usually in those situations, one of us can calm the other down."

Gay leans back into the sofa and fixes his eyes on Hotch. "What we've got here is really a boyhood friendship carried on inside the shells of a couple of senile guys. It's pretty remarkable. You see these two old geezers here, but within us we have this playful, youthful spirit."

"Just a couple of fraternity boys," Hotch suggests.

"Yes," grins Gay. "A couple of frat boys. That's us!"

Neither of these immensely successful writers finds any reason to edit that line.

Greta and Satya

On the wall above Greta's bed hangs a handmade plaque created for an English class in which her assignment was to write about a person who embodied her definition of a hero—her best friend, Satya.

With the difficult start of an unfair childhood, this girl came out smiling. That is because caring, believing and trying to make the best of her life, she sees past the reality outside right into the warmth of the heart . . . She is sure of herself, a true independent, who despite all her human faults never follows but always leads the way. She is truly special. My hero.

Satya reacts to Greta's praise with a loud whoop of "Wow! I mean wow!" And she gushes in response, "Greta's really intelligent and beautiful and she understands things. Even if she has no idea what the hell you're talking about, she'll tell you she does to make you feel better. We totally honor, trust and respect each other."

When you are a teenage girl struggling mightily with who you are and where you fit in the world, what could be more meaningful than a best friend who may live three thousand miles away but who sees into your soul like she's just next door? Certainly every fourteen-year-old needs galpals for shopping, gossiping and sharing the lunch table at school. But a *best friend* is much more

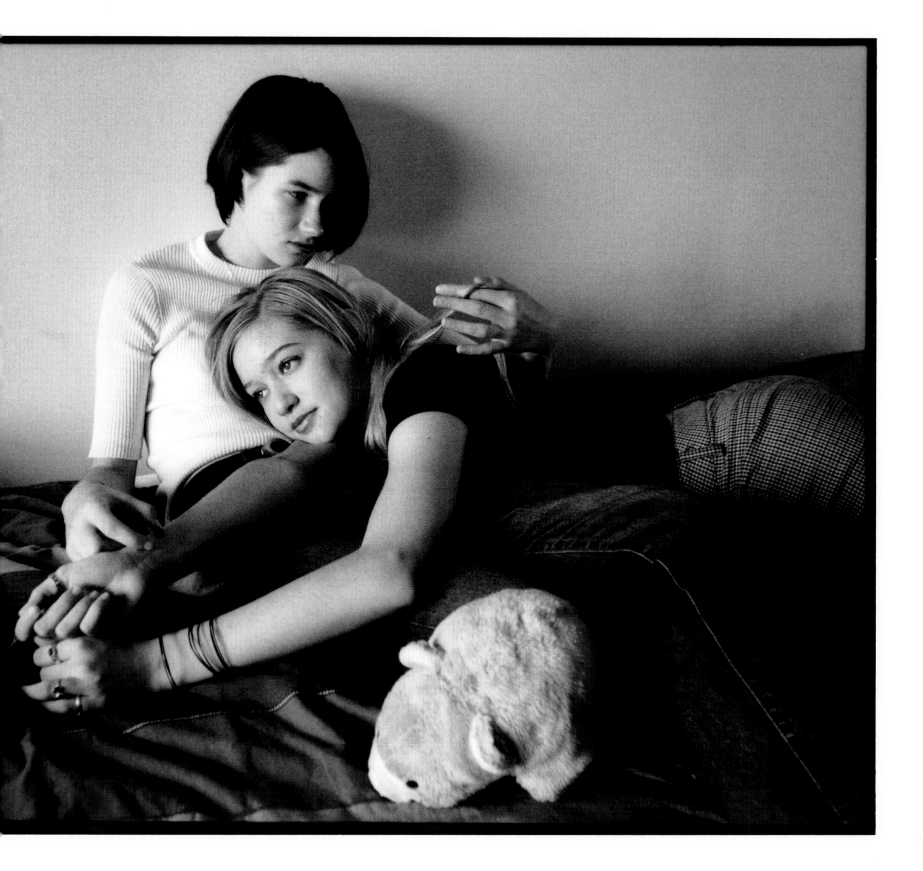

than that. She's the one person who understands you completely and loves you for being the person you think you really are. That's what makes Greta and Satya soul mates, even though—except for a month or two in the summer—they live on opposite sides of the country and need their mothers' permission to talk more than fifteen minutes on the phone.

"When you're doing all this searching," Satya says, "and trying to find your identity and grow up, it's so great to know I can call Greta and she'll be, like, 'I'm going through this thing,' and it's just the same as me. Or when I was having bad problems with my dad and I couldn't tell my mother and felt so helpless, I talked to Greta a lot and I knew I wasn't alone. We would cry and it would be okay just to get things out. It felt so good to have this person who was just there for me."

Greta continues. "I felt all I could do was let her know that she has me and I'm proud of her and I'll always love her. And like, now we're both going to be freshmen and we're scared. The thing is that me and Satya have this mutual trust. You never know who to trust when you're a teenager and I totally trust Satya. We're very secure with each other."

Satya nods in agreement. "That's a big thing. It's unspoken between us. We just know."

Oddly enough, the vast distance between them works to strengthen their friendship. "Because we're not always together we never get sick of each other and we don't waste time fighting," Greta explains. "We each have good friends at home and we can tell them this or that, but we can tell each other *everything*! And because Satya's not in my school, I never worry she'll tell someone."

"We really cherish the time we're together," Satya says. "Being far apart makes it more special."

They met when they were four years old. Greta came every summer with her parents to stay at a bed-and-breakfast owned by Satya's grandfather in the quaint New Jersey seashore town of Cape May. Two little girls with long brown hair and imaginations on the same wave length, they both loved to play Barbies and make believe. "We'd pretend we owned a bar and take out little shot glasses that we'd fill with apple juice, seltzer and olives," Satya remembers. "Greta would say, 'Give me one of those things on the rocks.' We always felt like family. We'd tell people we were cousins." As the years passed they developed little traditions like taking their picture every summer at the boardwalk arcade photo booth and going to the supermarket to buy peaches for Satya to cut up and sprinkle with sugar and milk and serve to Greta as a special treat.

Theirs has always been a summer relationship, sustained by telephone calls and letters during the winter and unaffected by their very different lifestyles. Greta, a Catholic, somewhat sheltered and protected, attends private school and lives with her mother and father in a beautiful high-rise duplex with a magnificent view of the New York skyline. Satya, a free spirit, goes to an alternative school and is raised by a wonderful mom she describes as "kind of a pagan." Satya and her mother share a communal home with three women in Seattle, where they have lived since Satya was eight. That never prevented her vacation visit with Greta in Cape May until this past summer, when she got an internship with a magazine. Satya wants to be a writer and won a grant to publish her own 'zine at school. At first it seemed the internship would cause her to cancel her annual trip. "I called Greta to tell her I couldn't come and she screamed, 'Noooo!' We had this long conversation and we both cried, and I hung up and said to my mom, 'I gotta go. I have to see Greta.' We've been really needing each other this year, going through a lot of stuff. So my mom borrowed the money for me to come for a few weeks."

"I got this message on my answering machine," Greta says.

"Satya said, 'I missed you so much I got a plane ticket,' and I was screaming. I was so happy."

"We always call each other on bad or special occasions," Satya says. "Like when Versace died."

"Or when I got my period the first time," Greta says. "I called Satya before I told my mother."

Of course the moment they fell into each other's arms it was like they'd seen each other yesterday. "It was so funny," Satya says. "Last year when I came we were both wearing these huge baggy jeans. This year Greta comes wearing the same sunglasses I have on, and we're both in a tank top and fitted jeans. We're, like, 'Can you *believe* it?!'" They immediately set off for the supermarket to run up and down the aisles and buy their favorite foods—candy and cereal and bread and, of course, peaches and milk. Then they rushed home to try on all of each other's clothes and get down to some serious yada-yada-yada.

They talk about their bodies, their zits and boys: "We give each other lots of advice," Satya says.

"Yeah, but you have better experiences with boys than I do," Greta declares. "If she likes someone, she says, 'I love you,' and they're, like, 'I love you, too.' If I like a boy and I'm honest, they get scared."

And they talk about sex, too. "It's not a big thing, because we haven't had it yet," Satya says.

"And we're proud of it," Greta adds.

"But if we do, we'll definitely talk about it," Satya says. "I'll tell you first."

"It's a deal," Greta answers. And, giggling, they shake hands to seal their bargain.

They can be awfully silly together. "Me and Satya know we're soooo weird." And they can also be very serious, as when asked to describe what makes them best friends. They sit facing each other in exactly the same position, knees to chest with their arms encircling their legs. Shyly staring at her feet, Greta begins. "Well, you're not like a sister [which neither of them has] or just any old friend, you're truly my best friend. I love you. I just don't know what else to say."

"Oooh," Satya sighs, and being the more confident of the pair, she locks eyes with Greta. "I love how we're so similar and so different and how you really understand and how we never have to lie to each other."

"I don't worry about losing you," Greta says, "because you're in me and I'm inside you. Qualities or situations that I don't have are the things you have and we fill in for each other."

"Definitely. It's like another half," Satya agrees.

"That's the thing about best friends," Greta continues. "Each one has a quality the other might not have and we fit together like a jigsaw puzzle."

"You bet," Satya whispers, and they throw their arms around each other, hugging and kissing and drying their tears, quite overwhelmed by the power of their feelings.

The moment passes and suddenly they are kids again. "You know that we're going to be in the nursing home together," Greta says.

"Which one?" Satya asks.

"I hear there's a really nice one in Switzerland," Greta answers. "We should probably be in separate rooms, but maybe we can have a curtain between us instead of a wall."

Three

Pamala, Wren and Angela

Sista' Angie B., Brother Wren and Lamb of God have a friendship of Elysian harmony and oceanic depth, made all the more profound by the faith they fervently share.

"We all come from Christian households," Wren explains, "so we had that as a commonality. And it was a wonderful foundation for building our friendship."

"God asks that we be servants to each other, and we understand that," says Lamb of God, or Pamala, as she's called by everybody except Wren—whose given name is so original he has no need of another handle.

"Without God, we're just flash and style. He provides the substance," Angela says with her perfect diction. "My life is so blessed by these phenomenal people who give me godly counsel, who share my hopes, my fears, my deepest concerns, my joys—and my faith."

"We three are very urgent people," Wren declares in his sonorous, honey-coated voice. "We laugh heartily. We grab life. We're interested in espousing joy. We even cry in an elegiac fashion. So our church experiences are very high. Very high."

Surely this is not your garden-variety, ego-centered Hollywood friendship. These are down-home, gospel-bred Christians who just happen to make their livings in show business. "Acting is what we do. It's not who we are," Pamala explains.

"All too often, show-business people either look to be validated or they lose sight of themselves," Wren ruminates—as he's wont to do. "They begin to kowtow and defer to the person who's got the high profile of the moment." He nods in the direction of stage and screen star Angela Bassett, whom he alone refers to as "Sista' Angie B." "But our support is based on a meritocracy. We would never put upon each other."

"Never. Ever," Pamala emotes dramatically. "None of us would ever say to another, 'I know you're working on this or that film. Is there something in it for me?' And we'd never ask Angela, 'Can you get me in, girl?' If she chooses, that's very different."

They will offer, recommend and accept from each other, but they will not request favors. The filling of each other's needs is so automatic that the giving routinely obviates the asking.

"Presumption resides nowhere in our relationship," Wren says. "Just this week my wife and youngest daughter were out of town, and my eldest daughter was taking her first school picture. Her Auntie Angela, in her inimitable way, was there at seven-thirty in the morning to do her hair."

Angela flashes her dazzling smile. Suddenly it seems as if all the lights have been flicked on in the movie-set trailer where her friends have dropped by for a visit. "They just give, give, give to me," she says sweetly, "and they don't take anything but my love. And that's free. These are people I don't have to hold back with. I tell them e-v-e-r-y-thing!"

"We know it *all*," Wren says grandly. "And we've been burdened terribly."

Pamala pokes him in the ribs. "It's wonderful that with all the kudos and accolades that have been showered upon Angela," she says, "we have been able to maintain a sincere friendship, genuinely devoid of celebrity stuff. There's a simplicity and a modesty about her. She's very easy to be with."

"Celebrity is not meaningful to her at all," Wren says. "She is a person who just wants to work and brings to it a tremendous sense of dignity and discipline. She is very present and has a wonderful quietness that balances our gusto and brio. Insanity is not native to her psychological disposition."

Angela takes the compliment by lowering her expressive almond-shaped eyes. "I have noticed that when celebrity comes, you're unprepared for how people relate to you," she says thoughtfully. "If you're sensitive, you do notice the insincerity. But these two keep the bullcrap at bay. Talk about having friends you can count on to be a protective fence around you!"

They could go on for hours extolling each other's virtues. You'd think they'd been friends since childhood—but it only seems that way. Angela grew up in St. Petersburg, Florida, Pamala was raised in Philadelphia, and Wren is fourth-generation Los Angeles. After Angela earned her master's degree at the Yale School of Drama, she moved to New York to launch her career. Pamala was another struggling young actress there.

"We met on April twelfth, 1983," Pamala says, giving the moment historical weight. "Angela invited me to a birthday party she was giving for a mutual friend, and we discovered that we lived around the corner from each other. We clicked right away. Angela is really good people. Very down to earth. A Southern girl with a wonderful value system. And she's very well-balanced."

"I instantly fell in love with Pamala," Angela interjects. "She is the life of the party. When she starts to shimmy, she's the most electric, sensual thing you've ever seen."

Their connection actually deepened after Angela moved to California. In 1992 Pamala came out to do a play during the time that Angela was under consideration for the role of Tina Turner in *What's Love Got to Do With It.* Angela pressed her to audition for the film as well, and she landed a part as one of the backup singers, The Ikettes. They moved in together until Pamala could find a place of her own. "It was the first time I had a room-mate," Angela says, "and I cried when she left. She was such a comfort to me when we were making the movie, which was the hardest thing I've ever, ever had to do in my life. Sometimes the set was utter chaos, and Pamala just kept my spirit moving."

Wren entered Angela's life in 1987. "I went to see her in a play," he says, "and I was completely and absolutely arrested by her brilliance. Her gift was mesmerizing. She just stopped time. I met her after the show, and we were like kindred spirits leaping from breast to breast. We've literally been inseparable from that moment on. I remember the day that she brought Pamala to the home my wife and I had just purchased. It is an old Federalist house with great character—much like the individuals who came to visit. It was immediate and electric between the three of us. We soon developed into gravity-like friends. We are really cisterns of all that is good in the others."

"It's not like we dialed request-a-friend to find each other," Pamala says, with all her gospel-mama fire. "We do have similar interests."

"We're all steeped theatre people," Wren elaborates. "That's with an R-E, not an E-R."

Their repertoire of favorite activities includes lots of stage plays and films. And more meals together than they could begin to count. "We all like to eat," Pamala says. And they like to *talk*.

More about ideas than about people. They will fly across the country to attend each other's premieres. They celebrate each other's triumphs—Wren escorted Angela, her mother and her sister to the Oscars in 1995 when she'd been nominated for Best Actress. And they share life's milestones—births, christenings, birthdays, anniversaries. They have performed together for money—Wren, for example, had a role in another of Angela's popular films, *Waiting to Exhale*—and also for charity; in particular, fund-raising events that benefit young, needy actors and dancers.

"Another *extraordinary* moment for the three of us," says Wren, emphasizing his favorite word, "was to be in the front row of the sixty-five-hundred-seat, open-air Greek Theater in Los Angeles for the Tina Turner concert. They lifted Tina fifty feet above the audience in a crane. And up above us, with a wink and a gesture, she acknowledged Angela. Obviously it was Angela's individual achievement. But we shared it in a way that was collective." That's how they are. Whatever happens to one of them belongs to all three.

Wren is the acknowledged group leader, and at thirty-four, the baby of the bunch. Angela and Pamala—hard to believe—are closer to forty. When Angela was house hunting, it was Wren who made a list of properties for her to visit. He annotates her scripts "because I know her instrument well, and I can delete little things that don't fit her mouth." And he directed every facet of her wedding, which he describes as "elegant simplicity." He served as best man. Pamala gave the wedding shower and stood as matron of honor, a role Angela had played at her marriage a year earlier. "I'll never forget how Angela drove over in her Range Rover to take me to the church," Pamala says.

Fortunately, their spouses also like each other and are uniformly accepting of this tight-knit friendship that sometimes in-

cludes them—but often does not. "People wonder why we are always together and what's it about," Wren says.

"We understand it, but the outside world doesn't," Pamala chimes in.

And Angela adds, "My husband, Courtney, isn't threatened in any way. He respects and applauds us."

One of their most treasured traditions is New Year's Eve. "It's all about conversing, interacting and sharing," Pamala says. "And Wren holds court. He does that so well."

Wren jumps to his cue. "But the most salient characteristic of New Year's is our wonderful, collective midnight circle prayer."

"We pray for our families, for the world—and for ourselves," Angela says. "Without sounding corny, it wasn't luck that brought us together. It was divine providence."

"There is destiny associated with this depth of friendship," Wren says. "God absolutely knew that we needed each other. Needed to take the others higher. And now those needs are met.

"The word 'friends' does not aptly describe what we have. Even 'best friends,' which is considered the highest form of friendship, isn't accurate. We are brother and sisters. Without the family baggage. Without the familial envy, jealousy and petty behavior that can transpire in a household. We don't have parents treating one more fairly than the other. So we can just come together and purely love the things we love about one another. I really have no need for anything else in my life but my Father in Heaven, my blood family—and my family. My sisters here."

Angela and Pamala raise their arms and exuberantly shout, "Amen, brother! Amen!"

Anna and Regina

Regina was a spirited, happy-go-lucky young girl when Hitler began his crazed mission to annihilate the Jewish people. Now in her late seventies, she can vividly recall the day the Nazis marched through her Polish town, rounding up Jews to make bullets and bombs for their war at the local munitions factory they'd occupied. She was playing games outdoors with her girlfriends when they were swept up in a crowd running wildly to escape the German soldiers. But flight was useless; every one of them was captured and imprisioned in a work camp.

Anna, a shy girl with a thin face framed in a halo of golden curls, had just celebrated her sixteenth birthday when officials in her Polish town announced that all Jews above the age of fifteen—except for mothers and their little children—were to report to register for work.

"I went with my father," Anna remembers, "expecting to go home afterward. But they put us in different trucks—the young ones separate from the old ones—and that was the end of liberty. I never saw any of my family again."

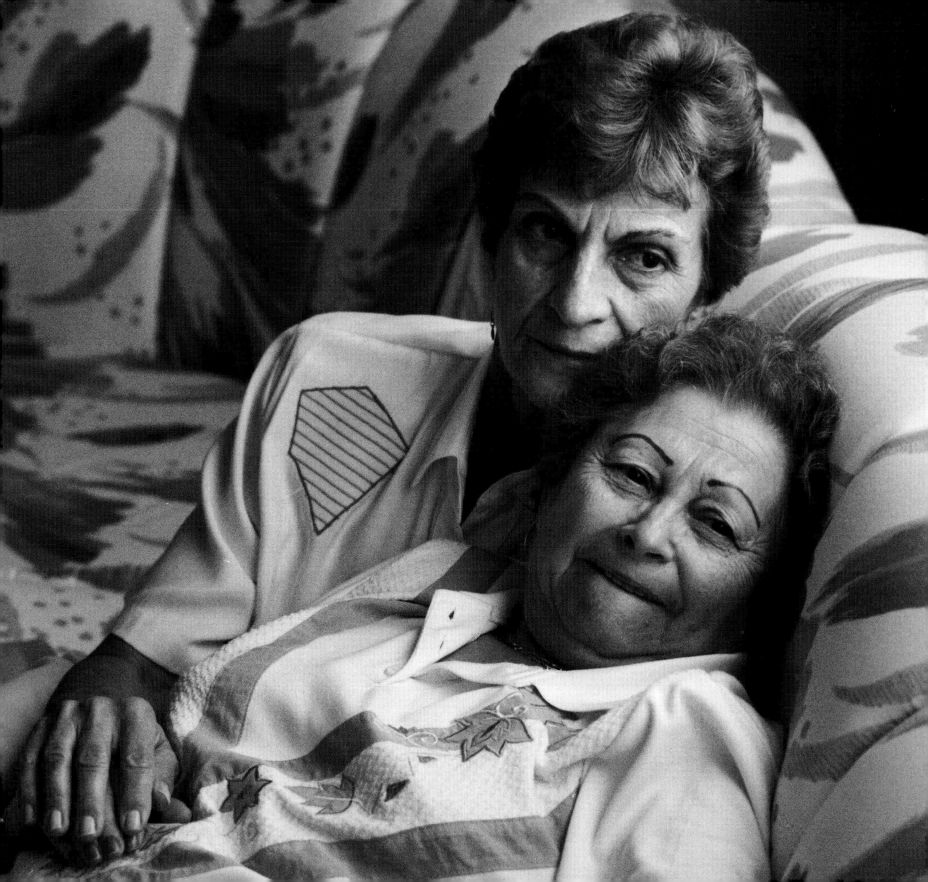

"How I became friendly with Anna I really don't know," Regina says. "Whenever a new transport arrived, we'd all sneak out to have a look. Maybe a father, a sister, somebody we know is on it. That day I noticed Anna. We started to talk for a minute. I was thinking to myself, She is very pleasant, and she had beautiful curls."

Anna laughs softly, "She was in love with my hair."

They barely had a chance to get to know each other. Anna, who was four years older than Regina, worked alternating day and night shifts in the munitions factory, while the younger girl herded the camp's calves back and forth to pasture.

"But when we had a chance," Regina says, "we would communicate a little. We were pals. I would see her going by, and I would wave hello and smile."

"A smile with no future," Anna says bitterly. "We didn't know from the next ten minutes what was going to be."

Merely enduring the present was difficult enough with its routine beatings and guards hurling insults: "You are filthy, you Jewish whores." Regina was luckier with the beatings than Anna; she was whipped only once, when the Nazis caught her stealing food from the dogs. "I had permission every morning to take some soup to feed the dogs," she explains, "and they got me because I ate a dog's food. My two potatoes and his two potatoes. I was their dog."

But in brief stolen moments, their little friendship flourished. "Sometimes," Regina recalls, "I would sneak into Anna's barracks and she would say to me, 'Now get out. Get out. Get out.' Always frightened and very careful. That was Anna. She is a quiet girl, keeping to herself. Me, I am friends with the whole wide world. I don't know why, but I just liked her."

One day, without warning—it was always without warning—the girls were shipped off to work in another munitions factory. Their main contact was a furtive smile exchanged whenever the camp was summoned to the yard for yet another body count to check whether any prisoners had escaped. A few months later, Anna was moved again—this time without Regina—to a massive concentration camp where the guards cut off her golden curls and issued her a threadbare coat and a pair of clogs to fend off the bitter cold. Her meager food ration consisted of watery soup with a tidbit of bread.

On a particularly raw winter afternoon, Anna heard a rumor that a transport was arriving from the camp where she'd last been with Regina, and she managed to hide near the washroom to see if perhaps her friend was on it.

Regina recalls, "I am arriving at the camp and looking around, too. I am always looking for my mother. I didn't know then that she was already dead. And all of a sudden, I scream, 'Oh my God, it's Anna!' She says, 'Shhhh. Quiet. Don't say nothing.' I was holding this piece of bread . . ."

"You had a loaf of bread," Anna corrects her.

"Okay," Regina agrees. "When I saw Anna, without even thinking, I threw my bread to her. I was lucky they didn't see me. If they catch you for something like that, they shoot you on the spot. So a couple of days go by. I was *so* hungry. They give us no food. Everything was unbearable. The dirt. The lice. Somehow, Anna sneaks into my bunk and says, 'Here's your bread.'

"'What are you talking, Anna?' I whisper. 'What did they do to you?' Her face was all sunken in. Her eyes like empty bowls. I start to cry. 'Please don't give me the bread. Keep it. You need it more.' And she said, 'No, Regina. I am here a couple of weeks, and I am used to always being hungry. But you just came. You are going to be very, very, very, very hungry.' She put down the bread and left. It was like she was giving me life.

"If I talk from today to tomorrow to Purim, I cannot talk out what it was like in those camps," Regina says, weeping. "I was just a girl. What did I know of anything? What did Anna know? She was young, pretty, full of life. And what did they do to us? Took our families to the gas chamber. And that's where we were headed, too."

But the Germans never got to complete their massacre. On May 1, 1945, the Allied forces liberated the camp where Anna and Regina had been scheduled for extermination. Instead of dying in a gas chamber, they wound up in an army hospital and nearly died of typhus. They lost track of each other in the chaotic world of the DP camps, and soon became too busy building new lives to worry about finding an old friend. Within a few years they'd both gotten married, had children and sailed off to America, part of the vast wave of postwar immigrants.

Four years after the war ended, on a balmy spring day ideal for a stroll, Regina and her husband decided to explore the Boston neighborhood where they'd been placed by the Jewish agency that handled resettlement for concentration camp survivors.

"All of sudden, coming down the street pushing a stroller, I see Anna," Regina says, breaking into a huge smile. "We start yelling and screaming. Kissing each other. 'Oh, oh, oh my God, Anna, is that really you?'"

"Who could believe from Germany, from those camps, we would meet each other again in Boston, in the United States," Anna says, shaking her head, still in wonder. "It was like a miracle."

"And right away we became very close," says Regina. "Best girlfriends. We learned to play cards like American madams. We would take turns making New Year's parties. Holidays we'd be together. Anna would do beautiful dinners. Always she would come and help me. If I needed to go someplace, she would take my kids. I would call her fifteen times a day, 'Are you coming? Are you doing?' Friends like that you don't find often."

Births, weddings, graduations, illnesses, deaths. They celebrated and grieved with each other. "You can't explain our closeness," Anna says in her reserved way. "We have no families. We have only each other."

"If I could have a sister, I could not love her more than Anna," Regina says. "We are very different. She is serious. I am

never serious. But I adore her all the time. I could be mad at anybody, but I could not be mad at Anna. I will die loving her."

"We have other friends who are Holocaust survivors, but it's not the same," Anna points out. "We didn't know them then. We weren't together *then*."

It was Regina's idea to revisit their past. In 1995 she persuaded Anna to return with her to Europe for the fiftieth anniversary of their death camp's liberation. By that time they'd both moved to Florida. Anna's husband had died and Regina's had been rendered speechless by a stroke. Two old women, bound by unspeakable experiences, they joined 1,300 other survivors for a memorial ceremony at Ravensbrueck. Holding hands in the hot sun, Anna, thin and stoop-shouldered, and Regina, small and plump, sat on chairs in the camp's main square. The same square where half a century before they'd stood shuddering in fear during the daily roll calls during which Nazi guards would casually beat to death anyone who stepped out of line. Anyone caught doing something as foolish as tossing a friend a crust of bread.

"We were crying and kissing each other," Anna says, her eyes watering at the memory of that moment and of all the memories, good and bad, the two of them have shared. "Imagine being here fifty years later. Imagine having fifty years of friendship when according to Hitler we were supposed to be dead."

Thankfully, the Lord had other plans.

Glenn and Storm

To the preppies at his new school, Glenn Davis was a swaggering redneck from the wrong side of the tracks with the good fortune to be a gifted athlete. His prowess had caught the attention of Coach Davis (no relation), who recruited him to the private academy he entered in tenth grade.

"It was my mom's decision," Glenn remembers. "There was no way *I* wanted to be bussed twenty miles each way every day, but she wanted me to go to a good school. I think the coach pulled some strings, because I know my mother couldn't afford the tuition."

Coach Davis had a son named George, whom everybody called Storm. He was the same age as Glenn and also a star athlete, but that was all the boys had in common. In contrast to Glenn's rowdy nature, Storm was a quiet sort of kid. But on the field he was a fierce competitor. Before they even clashed on the first day of football practice, Glenn had marked him as an arch-rival. "All I ever heard," Glenn says, "was Storm Davis this and that. Back in my old high school, I'd been the main man. Now I'm on his territory, and when you come into another dog's yard, you better have your teeth showing, especially since we were the two best athletes on the team—and I wanted to be top dog. To get there, Storm was the one I had to beat. I felt I had a lot to prove to gain acceptance. Storm had nothing to prove at all. Everything about him was perfect. My parents divorced when I was young and I never had a solid family. I was already starting to look at his dad as a father figure, and I wanted the affection that I saw between them. Yeah, I was jealous."

Sports is the petri dish of choice for cultivating male friendships, even those that have their roots in a rivalry like this one. When spring rolled around and Storm and Glenn traded pads and pigskin for bat and glove, they also grudgingly traded resentment for appreciation. "Football had held more of an adversary aspect for us," Glenn says, "but in baseball we started seeing how we could function together as part of a team. We became a great one-two combination. The Dynamic Duo. Our strengths complemented each other.

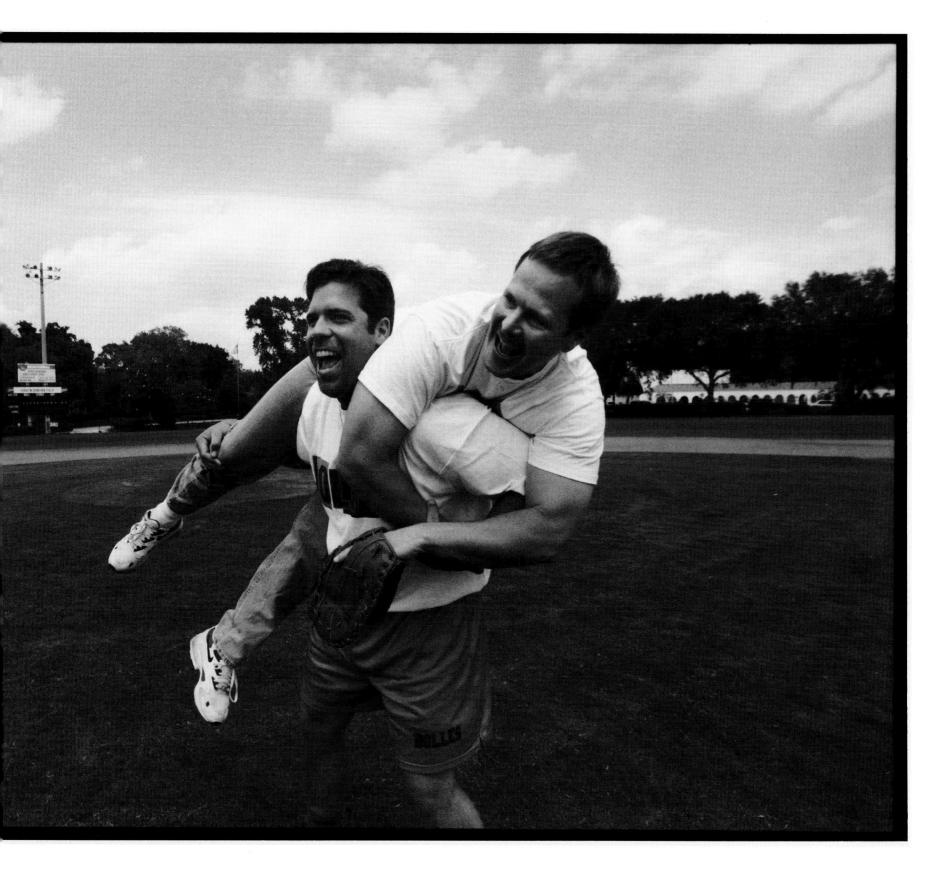

Storm had this God-given gift of being able to throw the seams off the ball. Every pitch was pinpoint perfect. On the other hand, I could hit the ball a really long ways."

"Quite honestly," Storm says, "Glenn was a godsend. I really think my successful career in major-league baseball was due to the fact that Glenn made me a better player. He was that guy I needed in my life at that time to push me. I knew how hard he worked and I wanted to keep pace with him. I couldn't slough off. Every day at the end of practice it was always just the two of us in the batting cage until the sun went down."

In his junior year in high school, Glenn avoided his troubled home by spending several nights a week with Storm and his family, who, in effect, became his surrogate parents. "I had a lot of hostility in me," Glenn says quietly. "I suffered in many ways from my parents' divorce, so I was very attracted to what I saw in Storm's house. The love they all gave me broke down a lot of barriers. With Storm, I could talk about really personal things." At night in the bedroom, when the boys had exhausted sports talk, they'd drift into deeper best-friend talk—family, girls, college, the future. Even God. "Storm had a strong faith in God, more of a relationship than a religious thing," Glenn continues. "I could see how that brought stability to his life. Like, he was living his life and loving God. I was real curious about that. Damn, I thought, this is interesting."

Glenn also filled a need in Storm's seemingly ideal life. "I didn't have many friends at school," Storm explains. "When your father is the coach and the dean, it's like you've got this piece of paper on your back that says, 'Don't talk to me or I'll turn you in.' Glenn and I just became closer and closer, confiding in each other more and more. He'd tell me these stories about his family goings-on, and later I'd ask my dad, 'Can things really be like that in someone's house?' I truly came to respect him. Golly, here's this guy who not only has the common

struggles of a teenager to deal with—grades, school, athletics—but has all this stuff at home. I felt for him, and I'd have given anything to help him. Mostly, all I did was just listen. I didn't pretend to have any answers. I left that to the counselors."

"You used to let me drive your car," Glenn reminds him with an easy grin. "You didn't let anybody else do that."

Their high school graduation was bittersweet. Storm had been drafted by the Baltimore Orioles, while Glenn decided to go on to college. When Storm took off, Glenn moved in with the Davises and slept in his best friend's room until he left for freshman orientation. The following Christmas, when they were both home for the holidays, Storm's girlfriend found him crying one night after they'd all been out together. "What's the matter?" she asked. Storm replied, "I miss Glenn when I'm off playing ball and I wish I could be with him more." He pauses in his recollection. "I knew in my heart when we said good-bye that night, it would never again be like it was in high school."

"The game that brought us together was now separating us," Glenn says wryly. "Professional sports aren't all the glamour they seem. For players, it can be a lonely world with a high demand on your time and your life. It's hard to stay in contact."

For the next eight or nine years, Storm's and Glenn's paths rarely crossed except for phone calls and an occasional winter visit. After a few years of college, Glenn joined Storm in the majors, but they landed in different leagues. Glenn played first base in the National League (mainly with the Houston Astros) and Storm pitched in the American League (primarily with the Orioles). They did manage to attend each other's weddings. Storm was Glenn's best man, and they still joke about how Glenn's wife forgot the ring and during the ceremony, Storm, always Mr. Cool, simply removed his ring and slipped it to her to put on Glenn's finger.

Then, in 1992, they finally got to realize their dream of

playing professional ball together when, for one season, Glenn wound up on the roster of the Baltimore Orioles. Sadly, it wasn't destined to be a repeat of their high school glory days. Off the field, it was great. They lived in same neighborhood. Their kids got to play with each other. They rode back and forth to the ballpark and prayed together in the baseball chapel. But the rest was torture. Storm was not having his greatest year on the mound, and Glenn was still recovering from a career-threatening injury that he had sustained the previous season.

"We never got to have any fun playing together," Glenn says, trying to describe their daily stress. "I was being crucified by the media. I was the highest paid player on the team—getting more money than Cal Ripken—and here I was, damaged, and couldn't perform. When you get hurt, it's like you have the plague. You become the invisible man. You don't exist until you get back on the team. It's outta sight, outta mind. No time for sympathy." Even from your best friend.

"I'd come from back from a road trip," Storm says, "and Glenn would be in the training room getting therapy. I'd ask, 'Feeling any better, buddy?' He'd say, 'Not a whole lot.' I'd say, 'I'm praying for you. Hang in there.' Even though I really felt for him, I couldn't let myself get too involved. I'd had two mediocre years and wanted to prove to everybody I wasn't washed up. I had to keep my focus and concentration on my game."

"I knew in his heart he was with me," Glenn recalls, "but he had to take care of his responsibilities. We never got to enjoy the year like we wanted to."

By 1995, they'd both retired from baseball. Storm packed away his two World Series rings and settled in his hometown of Jacksonville, Florida, where he now coaches at a private school. Glenn took his two All-Star rings to Columbus, Georgia, near

his wife's people, where they've established a residential program for at-risk children. Both men are heavily involved with their families and their community, but neither is big on phone calls or e-mail, so their interaction continues to be limited. As is often the case with men, their level of contact or no-contact has little deleterious effect on their friendship.

"The unique thing between Storm and me," Glenn says, "is this deep core inside us. No matter if we see each other the day after tomorrow, next year or in ten years, things don't change. We both hate chattering and catching up. Fortunately, when I do connect with Storm, I don't have to go through that little ritual of connecting. He'll put his arm around me and give me that little smile and it doesn't matter if we didn't phone or write. We know where we stand. The trust and acceptance we've established are the foundation of our existence. That's the beauty of our relationship, and it gives us both a sense of peace."

"In baseball, everyone is kept at arm's length," Storm picks up. "Because there's so much transition from year to year, you don't develop our kind of friendship. But Glenn is like a comfortable T-shirt. Our friendship runs so deep that from my body language or the look in my eyes, he understands me. Nobody else in the world can do that, except maybe my wife. I don't have to act around him. Be this big-deal former big-league player. Hey, we went to high school together. He knows what I'm about. I can't imagine what it's like for people to go through life and not have a friend like Glenn."

Back in their glory days, people often assumed Storm and Glenn were brothers because they had the same last name. After a while, they got so weary explaining they stopped bothering to correct them. Because it didn't matter. In their hearts, Storm Earl Davis and Glenn Earl Davis really *are* brothers.

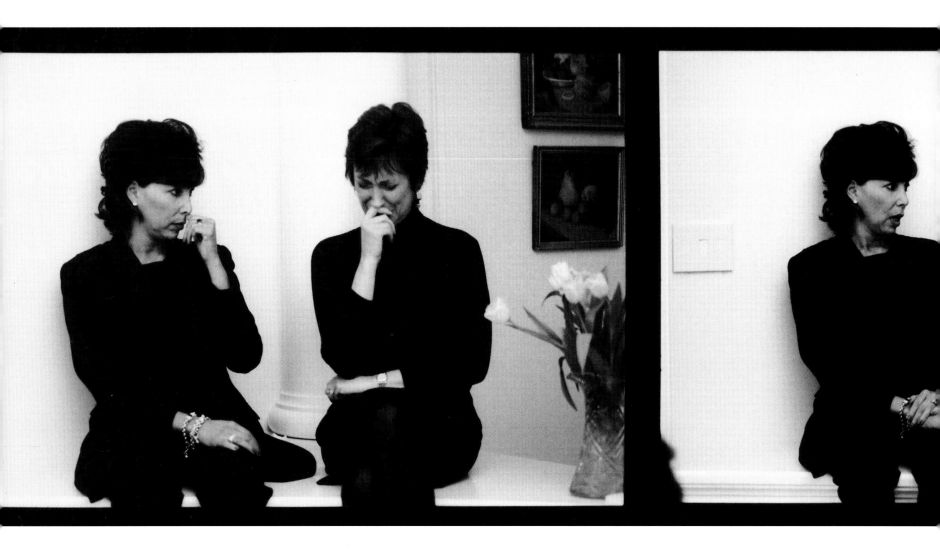

Phyllis and Deborah

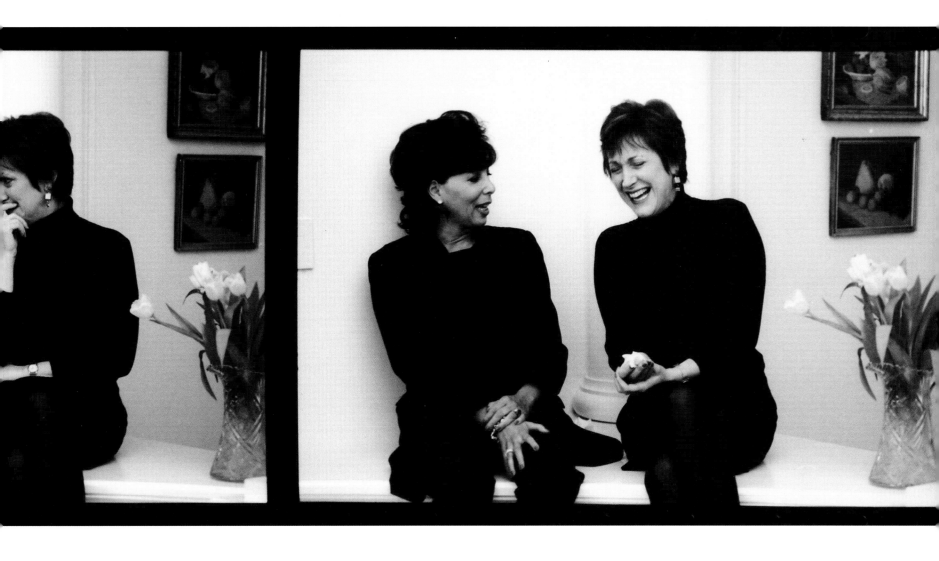

Y ou can't imagine you won't be girlfriends forever. If someone mentions the words "best friend," her name pops into your mind. You've shared the most revealing and embarrassing moments, divulged unspeakable secrets, laughed yourselves silly, swabbed away each other's tears. What could possibly destroy such a perfect friendship?

Then, one day, she suddenly stops speaking to you. She won't talk about why and refuses to discuss whatever went wrong. She just doesn't want to be your friend any longer.

Do you think it unthinkable that such a thing could happen to you and your best friend? Well, so did Phyllis and Deborah.

Part One: The Good Old Days

Deborah, sitting alone, begins her version of their story: "We met in high school. Phyllis was in the popular crowd and I wasn't. I was in the advanced classes, and hanging around with Phyllis meant being with the popular kids, and that's very important to a teenager." By the spring of tenth grade—in 1967—they'd become such close pals that Deborah invited Phyllis to her Sweet Sixteen party. "I can still see her in that paper dress she wore, acid green, hot pink and purple. There's nothing ordinary about Phyllis. She was, and still is, always on the cutting edge of fashion. Always full of the enjoyment of life. You were never bored with her. We had a blast!"

For three years they were inextricable, tooling around their Long Island town in Phyllis's 1958 Oldsmobile. "We called it the Pink Panthermobile. She could get to my house in four minutes flat." Nearly every day they had dinner at one or the other's home, depending on whose mother was cooking the better meal. They shared everything—their fears, their dreams, their sexual explorations, their clothes. Once Phyllis borrowed Deborah's bathing suit, and when the falsies accidentally fell out and floated to the surface of the pool, she didn't hesitate to shriek at the hunky lifeguard, "They're not mine! They're Deborah's!"

"I just remember a lot of screaming laughter," says Phyllis, telling her story without Deborah's presence. "I liked being with Deborah's parents. I was very comfortable in their home, which was very different from mine. At that age you go for the whole package. I can't tell you what drew us together. We were always very different. But I can tell you why I stayed. Because Deborah loved me—and I needed to be loved. She was very open, and I think she admired aspects of me she didn't have in herself. We

trusted each other. Deborah is a serious person, but she was a great partner to be silly with, and my goal in life is to enjoy the child in me."

By the end of their first year in college, having drifted in opposite directions, they ceased calling and writing. Deborah attended a liberal, experimental college and immersed herself in radical politics. "I went away to a junior college in Boston," Phyllis recalls, "with my false eyelashes, go-go boots and miniskirts. I was leading a very structured life and Deborah was barefoot with loose hair. She had a boyfriend and lost her virginity. I remember fixating on the fact that she'd seen him naked. She had trouble relating to me, and I had trouble relating to her, because we weren't interested in the same things."

Four years later, when Phyllis was living in a chic Manhattan apartment and Deborah was writing for an artsy magazine, they bumped into each other in a neighborhood restaurant. "There was all this silly schoolgirl screaming," Phyllis says, "and we picked up right where we'd left off." Deborah was still very much the bohemian and Phyllis had remained the queen of trendy. "She had lots of Lucite in her apartment," Deborah says, laughing, "and my decorating consisted of an Indian-print bedspread over my desk, which was a door resting on two filing cabinets. Even though we were different, we obviously cared and filled a need in each other. And we both recognized that there's only so long you can laugh and reminisce about the past. You've got to build in the present."

Accumulating new experiences came easily as their lives naturally progressed. There was Phyllis's wedding and the birth of her daughter, Morgan. She paid Deborah, by now a student at Yale Law School, the ultimate compliment by choosing her to be Morgan's godmother.

Phyllis's willingness to entrust her daughter to Deborah underscored—for both of them—the depth of their friendship.

"I was very moved and very honored," Deborah says. "She wasn't choosing her brother or her sister. She named me. It was all about trust and respect." Certainly there was never any shortage in that department for Phyllis, who proudly wore the Yale sweatshirt her friend gave her. Nevertheless, Deborah's years at Yale only emphasized the disparity of their worlds.

"There were times when it was difficult for me because she was married and had financial security and I didn't," Deborah says. "I remember her thirtieth birthday. Phyllis's husband threw her a party at a fancy restaurant in New York. Here I was, an impoverished law student, and everybody else was a fabulously dressed New Yorker who gave her expensive presents. I gave her earrings with flashing lights that cost twelve dollars in a boutique in New Haven. But Phyllis fussed over them like they came from Tiffany's."

By the time Deborah finally got engaged seven years later, Phyllis was divorced. Although her own life was in a slow meltdown, that didn't keep her from reveling in Deborah's happiness. It was Phyllis who took her friend shopping for a wedding gown and brought along a bottle of champagne so they could uncork it in the store the moment Deborah found the perfect gown. "Phyllis always had a knack for knowing how to celebrate life," Deborah says. "She was my matron of honor. I didn't have a big wedding. Phyllis was the entire bridal party. She was *it*." And it was Phyllis who whipped out her camera and insisted on taking nude pictures of Deborah when, at age thirty-nine, she became pregnant. "She wanted me to always know what my body looked like then."

There is no shortage of delicious memories on either side. "What kept us connected," Phyllis thinks, "is that our relationship had so many layers. We'd been vulnerable together. That was our common thread. We'd seen each other's foibles and secrets and we were still there for each other."

What on earth could ever destroy such a powerful friendship?

Part Two: The Rift

Deborah could only speculate about what devastated Phyllis to the point of cutting off their relationship, because Phyllis refused to discuss why she was upset. Deborah only knew that after the baby naming for her son and a weekend that Phyllis spent visiting her about a month later, she never saw her best friend again. "We said good-bye at the station," she says, "and I remember feeling it hadn't been a good visit. I was a very nervous new mother and I'd been kind of uptight. I called her several times and left messages. But she didn't return my calls. Finally I got her and she said she'd thought about this very seriously and she couldn't be my friend anymore, and she wouldn't tell me why. I was dumbfounded. I didn't know what to say. We spoke for a few more awkward minutes and that was it."

Seven years passed. Very lonely and painful years for both of them. Once Phyllis sent her a card saying: *I don't know whether you still think about me. Someday I hope to get the courage to call you.* Deborah wrote back: *Of course I think about you. I will always be here for you. I miss you and I'm here when you're ready.*

"And I did miss her terribly," Deborah says tearfully. "So many times I wished I could call and talk to her. I always felt Phyllis represented unconditional love. You expect that from your mother and your husband, and you're disappointed when it's not there. But to get it from a friend, what a gift that is! To have had this wonderful friendship and then to lose it and not even understand why, it's just been awful."

Part Three: The Reconciliation

Morgan, Phyllis's daughter, was responsible for bringing her mother and godmother together. She attempted to connect with Deborah through the Internet, and one night they found themselves chatting online. That set the reunion in motion. Both

women were ready. Time had done its job, softening the sharp edges of Phyllis's indignation without erasing the emptiness they both felt at the absence of a best friend.

Phyllis arrived first. When Deborah walked through the door, they collapsed into each other's arms, sobbing uncontrollably.

"Why didn't I wear waterproof mascara?" Deborah moans.

"Well, I did!" Phyllis exclaims.

"That's why I've missed you," Deborah sputters. "You'd have never let me come without waterproof mascara. My first problem today was what am I going to wear. The second was that the only person I could ever call to ask what to wear was you." Now they are laughing so hard that they start to cry again.

"I'm sorry. I'm sorry," Phyllis says. "I know it's been hard for you. I'm sorry." She pauses. "I'm getting married."

"Nooooo. Tell me about it."

"A fellow adoptee. The straightest Republican you ever met!"

"How could you marry a Republican?" Deborah gasps, giggling.

They've both brought family pictures, which they spread on a table, trying to compress seven lost years into a few paper images. They skip and jump around the details of their lives until they can no longer avoid the tough stuff underneath.

"It was really hard for me," Deborah says, and the tears begin to flow again. "So much has happened in my life that I wish I could have shared with you. The best way I can describe it is like how I miss my father. He's dead and I can't pick up the phone and talk to him. All these years I haven't been able to pick up the phone and call you. It's been very painful, because you're not dead. You're here on this earth but not for me."

"I know," Phyllis says. "This voice haunts me constantly. You are still in my will, you know. I never took you out. Every year at Rosh Hashanah I promise myself I'm going to call you

and mend fences. I'm going to do it. And it just doesn't get done."

"And I'm angry, too," Deborah continues. "When you had Morgan and I had nothing—no husband, no child—it wasn't always easy to join in your happiness without thinking of what I didn't have. But I did it, because how could we be friends otherwise?"

"That was always very generous of you, and I knew it," Phyllis acknowledges.

"And when I did get a husband and child, I couldn't have the pleasure of sharing and celebrating that with you." Deborah is sobbing hard. "I never got to have you enjoying what I finally had. You denied me that pleasure by going out of my life. And right now I'm not sure I want to know why. If it's big and horrible I definitely don't want to know, and if it's small and inconsequential I don't know how I'll feel sacrificing all these years for something petty. I'm not a very forgiving person."

"Same with me," Phyllis says. "I'm very bottom-line. I couldn't tell you what the problem was because it wasn't fixable. Some of it wasn't even my business. But even if hurt is a nanosecond long, it can be a deep wound. Then comes the anger. And you really pissed me off. I just decided I'll be the bad one and end it. If I told you about it then, I'd have been more incendiary and you'd have been full of denial. No good could have come of it. But I do think you're entitled to know, so why don't I just tell you."

And out pours a pent-up litany of hurts and slights that piled up around the time of Deborah's son's birth until they felt to Phyllis like a mountain blocking the future path of their friendship. There were no major betrayals. No thefts. No awful lies. But to even the strongest friendship, the prick of rejection can be lethal. And Phyllis felt rebuffed. First because she'd been passed over for godmother in favor of two family members. "I

understood why," she says, "but you could have prepared me. And then later you kept introducing me to all these academic friends of yours saying we have nothing in common, we're just old friends. Well, that destroyed me." She goes on to talk about the visit they'd had a month later. How she'd come down so eager to bond with her best friend's baby and share the wisdom of her own motherhood, and how angrily and rigidly Deborah reacted to everything she suggested. "I was really, really hurt, about the baby naming, about 'we have nothing in common,' about how resentful you were of whatever I had to offer, and I decided I just didn't want to be around you."

Deborah has listened without interrupting, heaving great sighs. "I'm so sorry," she begins. "I never meant to hurt you. What I meant by 'we have nothing in common' was not something superficial like 'this is my friend from the office' or 'we play bridge together.' It came from my heart that this is my friend Phyllis and what we have together is each other. Our friendship. That's what we have in common. I've always celebrated our differences, and our friendship is remarkable for existing despite them." She dabs at her tears. "Oh look at me. I feel just awful. People shouldn't carry that around for all these years. As for the weekend visit, I was a new mother. I was very unsure of myself and I thought you were really being bossy, telling me what to do."

"I certainly might have been," Phyllis admits.

"And I hated you knowing what to do and me not knowing. You knew better than I did what to do for my baby, and I rebelled against it."

"I'm certain I came across sounding like a know-it-all," Phyllis says. "You aren't the first person who's told me that."

They sit silently for a moment, drained. The dreaded incident has been disgorged and the earth did not open and swallow them up. They have survived to learn the lesson of true friendship; that it is a strange amalgam of contrasting properties, part as strong as steel and part as fragile as the petals of a daisy.

"I want you at my wedding," Phyllis blurts out. "I hated planning the list and not having your name on it. For me the issues are gone now. What's new is what we've become in seven years, and we have a lot to catch up on."

"Ahhhh boy," Deborah says happily. "I'm ready to fall right over."

"Remember when you rented that cottage on an island and I came up with Morgan? It was just the three of us with nothing to do while it poured and poured. We all ran outside in the rain and danced naked, like Isadora Duncan. That was the greatest. I still love you, Deborah. I've never stopped telling anecdotes about you."

"Me neither," Deborah answers. "In mine you always have the label 'my best friend, Phyllis.' Always have and always will."

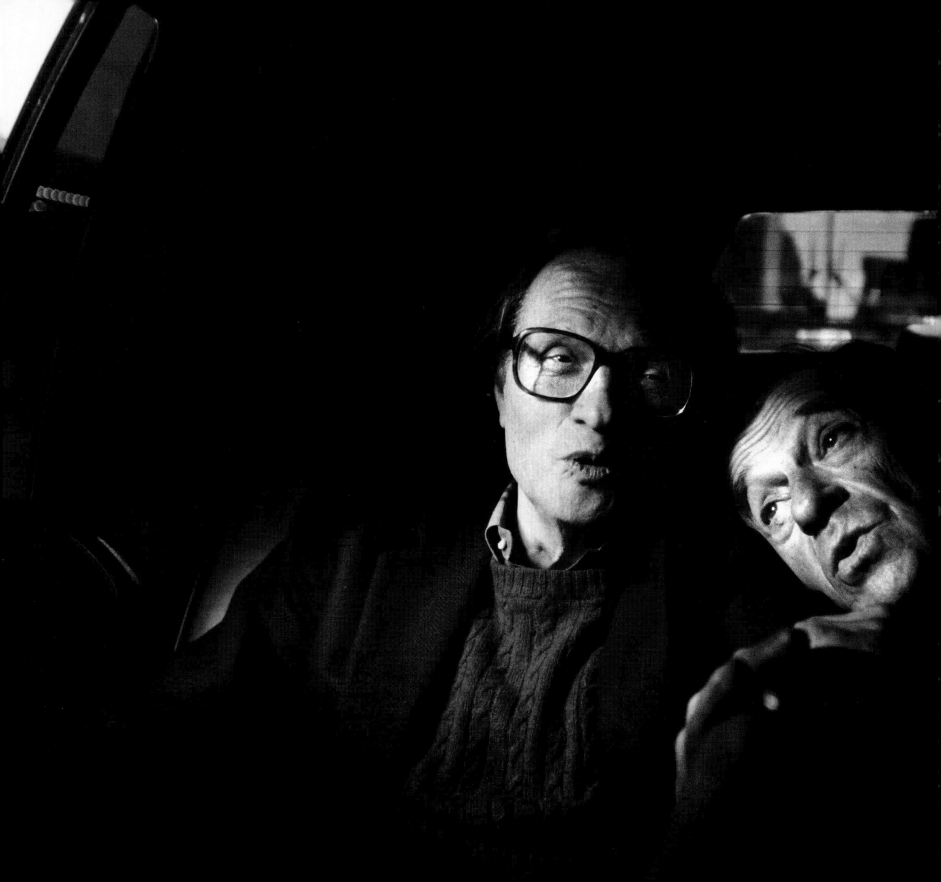

Larry and Herb

Winter 1943. Two skinny nine-year-olds with slicked-down hair and care-less grins slouch in the principal's office at PS 128 in Brooklyn awaiting the arrival of their mothers, who have been called to school *because this is serious business.*

Zeke the Greek, a.k.a. Larry Zeiger, has been charged with talking in the hall. Again. He will go on to make a big-time career out of talking.

Herb Cohen, sometimes called Handsomo, will mature into a successful business negotiator and bestselling how-to author. He, too, has broken *the rules.* His crime: going up the down staircase—or was it down the up staircase? Zeke screws his face into a do-you-believe-this-crap smirk and Handsomo mouths a wisecrack in return. Although the two have never met, they instinctively recognize each other as soul brothers and fellow smart-asses. In no time at all, they'd become best friends.

Scenes from Their Childhood

From age nine to age twenty-three—in the uneasy years of a boy's life when hav-ing a best friend is more critical to happiness than clear skin, pocket money, hitting a winning home run or getting to first base with a girl—Larry and Herbie misspent their youth as bosom buddies. One lived in a house on Eighty-first Street; the other in

an apartment on Eighty-third, and they saw each other all day, every day.

HERB: We weren't exactly bad kids, like the wiseguys on the other side of Ocean Parkway. We were more what you called Attitude Problems. In those days, if you chewed gum or hummed in class, you were an Attitude Problem. I guess the worst thing we ever did was steal the furniture for our clubhouse.

LARRY: It was more like interior decoration.

HERB: Yeah. Anyway, there were apartments that had furniture in the lobby. Now, to sneak in at night, break the windows and destroy property, that was unseemly. Almost criminal. So we'd go in during the day with our sleeves rolled up, wearing hats we borrowed from a guy who drove a bus, and we'd ring the super's bell and say, "Upholstery. Landlord called about getting the furniture upholstered. Can you help us out with it?" He'd hold the door and we'd tell him we'd have it back in about three weeks. We liked to think of it as "converting"—not stealing.

LARRY: We were looking for adventure. School did not challenge us. I did not do well in school.

HERB: Larry is the only person I know who exaggerates his grades downward.

LARRY: So we'd hang on the corner every afternoon. We were both sports nuts. Herbie was a Yankee fan. [Larry is the only person who still calls him Herbie.] I was a Dodger fan, and we loved to argue sports. We were both very knowledgeable. We'd listen to all the games, then read the accounts in every single newspaper. Even the *Daily Worker*. Maltz, the guy who owned the newsstand, would yell at us because we never bought anything. I'd tell him, "What?! You can't sell it 'cause I read it? Am I reading out the print?"

HERB: When Larry got really bored, he'd announce the cars that went by. He'd cup his hand like a microphone and in this deep voice he'd say, "Here comes a '51 Hudson. Forty-seven dollars. White walls. Moving slowly." Larry used to crack me up because he was crazy. He was always crazy funny, and I was his biggest fan.

LARRY: We always played well off each other. In eighth grade the drama department decided to put on this big variety show. There were all these talented people in the class and they didn't know what to do with Herbie and me, so we're assigned to pull the curtain. I'll go to one side, Herbie to the other, and we'll pull.

Now it's the day before opening and the teacher says they got a problem. Can we fill time between the acts while they're changing the sets? So we dress up as bums. Our mothers made outfits with patches and—*ta-ta-ta-ta!*—we run out onstage to open the show. I say, "Hello, Spark." Herbie says, "Hello, Plug," and the audience falls down laughing. The curtain pullers became the hit of the show. We improvised gags, and people would be in their seats yelling, "We want Spark and Plug! We want Spark and Plug!" The people in the show with real talent hated us, but everybody else loved us. Even the girls liked us, and until that time, they didn't like us much at all.

HERB: We share all these things in common. What Larry remembers, I remember. We think the same things are funny. We spent most of our childhood laughing. Saw the same games; went to the same political rallies.

LARRY: We were big liberal Democrats. Adlai was our guy. We loved him.

HERB: You have no idea how many of the same memories we have. One of the things about a best friend is that you share experiences with him like with no other person. That's what

makes us so close. The commonality. We shared all this at the most important formative years of our lives. In my eyes Larry is always sixteen. He looks at me and sees me at the same age. Even though we're sixty-four now, to each other we're forever young. Everything that's happened to us since we were kids is irrelevant. Even if he worked in a grocery store instead of becoming famous, we'd still have this common bond.

SCENES FROM SEVEN MARRIAGES

Larry's wives—six at last count—come and go, but Herb has been married to the same woman for over thirty-five years. On Herb's first date with Ellen, he took her to a basketball game and Larry was there. They've been a threesome ever since.

HERB: The night we consummated our marriage, I have my arm around Ellen, and I'm holding her tenderly, and she says to me, "Darling, who do you love the most?" I think for a while and I say, "Larry number one and you number two." The woman got pissed off. I tried to explain to her, "Look, I just met you. Larry I've known for a long time. You'll move up over the years. You could get to be number one—if you behave yourself." She's kind of tied for number one now.

LARRY: If you look at the pictures at his kid's bar mitzvah, you'd think the boy was raised by two gay guys, without a mother, 'cause every picture is Herbie and me and you can't find any of Herbie and Ellen.

HERB: I like the one of you and me dancing.

LARRY: I always dance with Herbie. At my sixtieth birthday party I danced with him. At all my weddings I danced with him. And I slept with him, too. This was a classic. I'm in Miami on business and this guy who's got this fancy place on Fisher Island offers it to me *free*. I persuade Herbie to come for a night. I tell him it's got a big suite with a Jacuzzi. Huge bathroom. Everything is perfect. So Herbie arrives and it turns out there's only one bed. That's the first time we slept together since we were kids and his family took a summer place in Morristown, New Jersey.

SCENES FROM THE PRESENT

Today Larry and Herbie live in apartments on opposite sides of the Potomac River, just about as far apart as when they were kids. "I can see him from my balcony," Herb says. "If he were to do anything with anyone on that balcony, I'd get on the phone right away and call him." They talk on the phone at the very least once a day, no matter where they are. "He could be in Paris," Larry says, "and I'll call him and ask Ellen, 'Can Herbie come out to play?'—just like I used to do."

Larry and Herbie puff up the steps of the Jewish Community Center in the Bensonhurst section of Brooklyn; half a century ago, when they weren't hanging on the corner, they were here playing basketball. "Turn right," Larry barks in his trademark baritone. "We gotta go down the hall and down the stairs. I bet the gym is still in the basement. Lookit this place. Except for all the Russians who moved here, nothing's changed." They find the court as if they'd been there yesterday, shoot a few baskets and wonder why the gym looks so much smaller than it used to. Then Herb announces he needs to use the john. The director of the center insists that his famous visitors use the staff bathroom—which turns out to be little more than a closet with a chipped sink and a toilet. Herb takes the key and, without missing a beat, Larry follows him in. Standing side by side, they unzip, pass water and walk out arm in arm. This friendship still has no boundaries.

Larry and Herbie. They have weathered the best and the worst together, including their mutual heart attacks, Larry's bypass surgery and Herb's valve replacement. People who know both of them suggest that Larry is lucky to have had Herb all these years as a voice of stability in his tumultuous life.

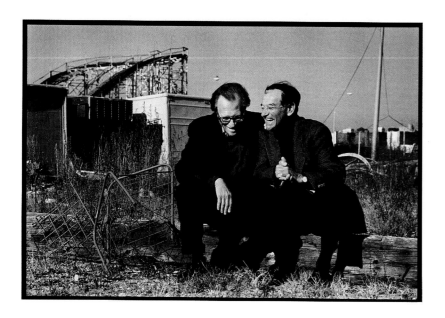

"I don't see that," Herb says. "Knowing Larry has enriched *my* life. What I do know is that I liked him and was his friend at a time when he wasn't Larry King. My relationship can't be questioned."

"We've always been there for each other," Larry says. "For instance, if Herbie were O.J. and asked me to drive the Bronco for him, I would do it. I think we tell each other everything." Suddenly he gets very serious. "What we have is so special, it's almost not describable. I can only tell you that Herbie is the one person, other than family, that I would want to die before."

For a moment, they stare silently at each other, sobered by Larry's words and sobered by the reality that there will be a day when they won't be able to call each other to come over to play.

LARRY: Well, it would be nice to be buried together.

HERB: Yeah. In Cody, Wyoming, so the kids wouldn't feel guilty about not having to come to visit the cemetery.

LARRY: Plots are cheap there. And they don't deface Jewish graves because they don't know what a Jew is. And it would be nice if somebody would come there to bring the news to us.

HERB: Nice if every week they'd bring the Sunday *Times* and a bagel.

LARRY: I'd like that. The *Times* and a bagel. And Herbie next to me.

John and Catherine

Friends are people invited into our lives by choice. Family, on the other hand, are people we're stuck with. Yet sometimes the line blurs and a beloved relative evolves into a treasured friend. That's what happened with John and his grandmother Catherine, unlikely candidates for friendship given that she was sixty years old when he was born. "I truly never felt the age difference. Not at all," John says of the woman he considered his best friend. "I always felt totally at ease with her. I had a great love for her and she had a great love for me. She made me feel special."

Bonding them was their common passion for gardening, which would eventually lead John to establish his own landscape business. They loved doing things together—visits to the arboretum and the flower show, planting in the backyard, making pies in Catherine's delicious-smelling kitchen when his parents took him to visit, bus trips to the zoo and the museums. She was the teacher and he the avid student. Even as a child, John sensed a kindred spirit in his grandmother. "She was a gentle, warm, sensitive person, and I'm just like her in

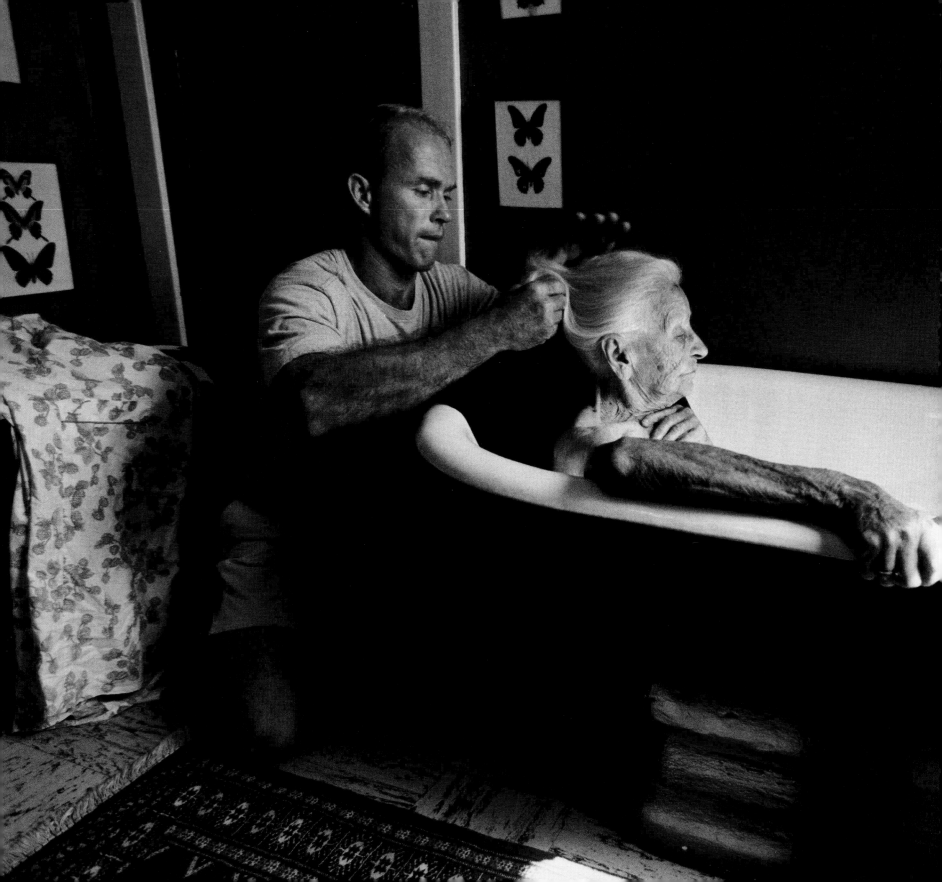

that way. We were both into givingness." John was pretty much a loner growing up and Catherine served as his confidante. "To me, true friendship is all about trust and comfort," he says. "Somebody who loves you for who you are. That was Grandmom. She had this wonderful way of nurturing that made me feel safe. We could be comfortable together in a chicken coop. In my teens when I was insulted by friends, the way kids are, I could call her with my problems and she would answer in a nice, soothing way. She was very intuitive and could always tell just how I was feeling."

The one thing John never discussed with Catherine was his homosexuality, although he made no attempt to cover it up. It wasn't that he feared her disapproval. He simply felt this was something she couldn't understand. "I just thought, Here is a smart woman who will never hurt or criticize me. I'm her boy and she'll love me whatever I choose to do."

So it was with little trepidation that one rainy weekend when John was thirty and Catherine ninety, he drove to her home, brewed them a pot of coffee on the old stove and, as they sat in the cozy kitchen redolent of rich memories, asked, "Grandmom, what do you think about me moving in? This was always such a wonderful house and it's getting rundown. You could really use some help. Think of all the flowers we could grow."

Catherine's big smile conveyed her delight. "I only wish I could get outside to help you," she sighed.

"I didn't do this out of any sense of family obligation," John explains. "I wanted to get back to my roots. I needed a home and someone to talk to. Grandmom always used to say, 'He's a home boy,' and that is still who I am. She instilled that in me. The warmth of company at the end of the day. The smell of fresh flowers on the table and coffee in the morning. So fresh, like her smell, like a baby, when I'd give her a little kiss."

Within days, John had settled into his aunt's old room and begun painstakingly renovating the old homestead. Often he'd carry his ancient grandmother upstairs to watch him scrape and paint the walls in the careful way she'd taught him long ago.

In the mornings, John would rise first, start the coffee and go into the dining room, where he'd set up her bed because she couldn't climb the stairs. "She

was so little and frail," he remembers, his eyes misting from the picture in his mind. "I'd put my arms behind her back to help her up and dangle her legs over the edge of the bed. I'd comb her long white hair and rinse a facecloth in warm water. She'd take it and wipe her eyes. 'This is what they call a pussycat wash,' she'd say. She was *so* cute. Then I'd hand her a mug of hot coffee and her oatmeal with raisins and bananas cut up in it. She was an itty-bitty thing but a terrific eater. And very healthy. Never took a pill."

He even changed her diapers. "She was always so appreciative of what I did for her and apologized for making a mess. I remember the first time I had to change her. She was so funny. 'Don't look or get any fresh ideas,' she said. Afterward I'd put a clean housedress on her and an apron. She always liked to wear an apron."

On bath days, John would gently carry Catherine upstairs to the big old tub and fold some towels behind her bony back for a little padding. "She didn't want a bath every day. Said I'd wear her skin out. I can still see her propped in the tub, the sun shining in through the big window. She'd say, 'Oh, this feels so good. It's nice being up here.' That was sweet. It touched me. Like the times we'd sit in the garden and she'd pat my leg or run her hand through my hair, those little weathered fingers that had worked so hard for so many years. We didn't always talk. We could just sit together and be happy."

At night after John returned from his landscaping business, they'd watch a little TV. He'd make her a bedtime snack and tuck her in. "I'd always give her a couple of kisses on the cheek or forehead and I'd say, 'Sweet dreams.'"

This routine continued for eight years until Catherine's death from a fall at age ninety-eight ended their thirty-eight-year friendship. "I guess I gave up a lot to be with her, but I never thought about it," John says. "The time went really fast. She was such a delight. A little old sweet doll! Grandmom taught me to open my life and be loving. How the values that are important are the simple things. She was a true best friend."

Suzanne
and Carol

Few friendships trace their origins to a genuine case of hate at first sight—which perfectly describes Carol's initial reaction to Suzanne.

"To me, she was this blonde, blue-eyed WASP, tied to the right people in the old network, who'd had everything handed to her on a silver platter. Including the job that I'd applied for—and should have been mine." Carol talks on while sipping herbal tea in the sunny kitchen of her best friend. "And she saw me as this typical militant black woman with a chip on her shoulder. And an attitude problem. We were both direct and outspoken. Believe me, it was ugly."

Suzanne and Carol started out on the wrong foot. The perfect fit for each other's negative stereotypes—the successful white woman versus the angry black victim of discrimination, flung together at the management level of a large insurance company. It was hardly a situation destined to encourage workplace harmony, let alone friendship.

But in the context of the roiling mid-seventies, everything was possible. This was a time when the "me generation" flocked to personal-growth workshops. Feminists discovered their voices. And burned their bras. New affirmative action laws had companies scrambling to deal with people who used to fetch

coffee and now were ordering it fetched for them. One of Suzanne's first initiatives in her new job as head of employee relations was to hire a consultant to radically change the corporation's policies around issues of race, gender and class.

It quickly became apparent that Suzanne and Carol were prime targets for her coaching. If the consultant could get them to work together as a team, they could be a powerful force in moving this process forward. Instead of their butting heads, she wanted them to become allies. Reluctantly, they agreed to try. "To our credit," Suzanne says, "as much as we couldn't stand each other, we did have an integrity toward our work and a belief and passion in helping the organization change."

"Yeah," echoes Carol. "We had a personal animosity but a high professional regard. We never fought in public."

However, their private hostility continued to smolder. Periodically the consultant would meet privately with the two of them to throw water on the embers. "You have to work out the crap between you," she'd tell them.

"But it was hard," Suzanne says, and both women grimace at the memory of those bitter days. "The first time we all met, I don't remember whether Carol or I yelled at the other first, but within a few minutes we were out of control. The same thing happened the second time."

The third time, they cooled down. Slowly, the way dripping water wears a groove in stone, they began to understand how the fair employment principles they'd been intensely promoting for the good of the company also applied to their own lives. "The turning point for me," Suzanne says, "was around the competition issue. Kaleel, our consultant, pointed out that a competitor was someone you saw as a worthy opponent. We could use our competition as an energizing force or a destructive force. I'd always been a competitive person, but I never thought about how it was playing out between us. How we were both busy showing off our stuff; how as women we weren't socialized to compete; how powerful this could be if we could harness it."

"Kaleel believed that we wouldn't be having so many conflicts and still hanging in if we didn't care about each other," Carol adds. "At first that was hard to digest. Why would I care about this white woman who was threatening my job? Then Kaleel began to help us see that this race thing was bigger than the

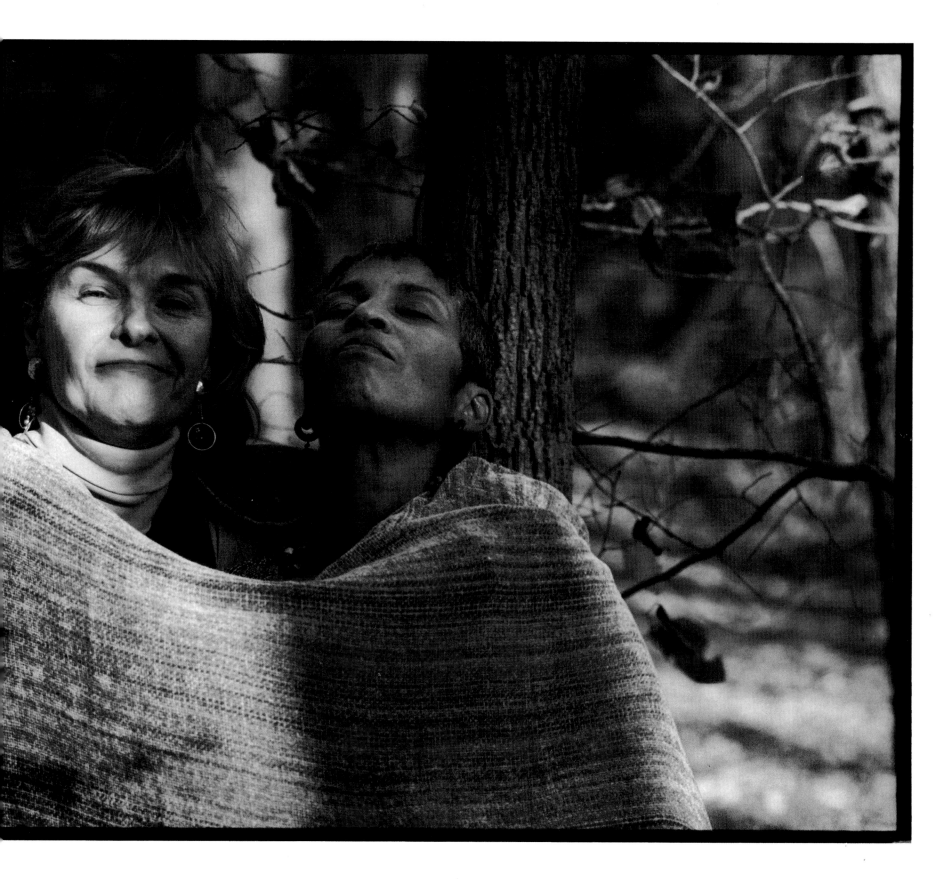

two of us, that I couldn't put everything happening in the world around race on Suzanne. And finally Kaleel brought up gender. *That* was a form of discrimination we both suffered in common. Then we started to go shopping together and really got into what looked good on each other. We were even fiercely competitive around dressing. Suzanne is conservative—with a flair—and I'm more flashy—with a flair."

"She could put a skirt around her neck and it would look fine," Suzanne interjects. "But we really did look good."

"We did, child, and we had good bodies, too." They both burst out laughing, and Carol continues, "So there were these little goings-on that had nothing to do with work. Sometimes we did stuff on the job that went beyond respect; we covered each other's backs. I started to recognize there were things Suzanne did differently from me, like I operate at more of a feeling level and Suzanne is more of a strategic thinker. We both knew something was shifting, but we didn't really talk about it."

Suzanne refills Carol's teacup and picks up the story. "Then one weekend we were at a black-white management workshop, and Carol was just exhausted from spilling her guts trying to teach these white men what the real story was. Everyone had left the room. She was sobbing and sobbing, and I was holding her. I can still remember that moment, thinking how I'd been looking at a lot of this work in terms of helping the organization and trying to understand race and gender in the logic of my mind, but not in my heart. Suddenly it reached my heart: This isn't *fair*. There's no reason Carol has to go through this."

"And I couldn't believe I was in Suzanne's arms and she was comforting me. It was human being to human being. Period. All the facades disappeared. I get chills when I think of it."

It had taken nearly two years for the loathing to evolve into a genuine liking that, given more time, would deepen into real friendship.

Their business trips led to personal trips—skiing or relaxing on a beach. They began to socialize and meet each other's friends and families. "We once gave this funky interracial party," Carol remembers. "It was a phenomenal success. When black people give parties, they don't invite just anybody. So for me to go before my friends with this white woman was a kind of silent admission that this friendship thing we had was for real."

In 1981, six years after their icy introduction, they both left the company. "We knew by then we'd always be friends, but we had no idea of where that would go," Carol says. They did not foresee the tender ways they'd support each other in the life passages that would carry them through their thirties and forties to the milestone fiftieth birthday they have just celebrated together. They would share the deaths of their fathers, Carol's marital problems and the births of Suzanne's two children. Their lifestyles diverged: Suzanne would become a volunteer social activist and part-time consultant; Carol would remain in the work world doing corporate diversity training. They would turn to each other for deep discussions on relationships, career changes, aging parents, spirituality and, of course, menopause. Suzanne would nurture Carol through an emotionally and financially wrenching divorce.

"When I hit hard times and other people weren't there, Suzanne was there," Carol says. "There are all kinds of ways for people to be there, but she was there in a way that allowed me to be who I was. She even loaned me money. These things mean something. I began to know this woman would be in my life forever. There would be hardly anything I wouldn't do for her because she was there at my darkest hour."

Through her friendship with Carol, Suzanne got the opportunity to live out her ideals. "She brought so much personal growth into my life, so much learning," Suzanne explains. "It started with race, but it ended with human attachment. I'll never

forget when somebody loaned us a condo in Hilton Head and on the way there we got lost. Carol was driving the rental car, and we stopped and she asked a policeman for directions. Rather than answer her, this jerk walked around the car to *my* side—and then purposely gave me the wrong directions. Or one time we went shopping in a store where I'd been a customer for twenty years and suddenly the owner was following us around. This happens to black people all the time, but it had never happened to me. It put the whole context of my white privilege on the line."

"It's real important to me to have a white friend who I can safely talk to about race," Carol explains. "It's a given that you can talk to other people of color, but Suzanne was the first white person in my life with whom I could sit down and say, 'This is what it's all about.' And there's a whole aspect of white life that I get to see for real through her. Like I never knew the name for a trivet! When you're white, you know that shit." They look at each other and howl at all the white social niceties that trivets represent.

Carol, who is childless, is "Aunt Carol" to Suzanne's kids, and for the last eight summers she has taken Suzanne's daughter along with her own niece on a week's vacation lovingly referred to as "Camp Carol."

Although they now live in different states, Carol and Suzanne always get together at the Christmas holidays. And they never, ever, forget each other's birthdays. "We may not send a gift on the day," Carol explains. "But we always exchange something eventually. Her birthday was two months ago, and I haven't found the right thing yet. We're still a little competitive around gift-giving. It's not about money or anything like that. It's finding something you *know* is her. It has to speak to you."

Perhaps because their friendship is something neither Suzanne nor Carol ever expected to have, it is especially precious to them.

"Suzanne has really taught me what friendship is about," Carol says. "This wasn't a friendship that grew out of something we had in common. It wasn't natural. It came from adversity. And because of that, I've thought long and hard about what it means. This is somebody I care about as a human being who happens to be white, who happens to have grown up with a different background. Yet I get unconditional acceptance about who I am from her and her husband and her kids. I think our friendship proves that if you really hang in there with somebody, you can work through the race crap and the gender crap and the class crap and the oppression and you can see the humanness."

"There are things Carol knows about me or I know about her that we'd never tell other people," Suzanne acknowledges. "We know what's sacred. After all that's happened between us, I can't imagine *anything* that would sever our friendship."

"What's great about us," Carol points out, "is that we're smart in different ways. We can be working on the same issue and I'll bring this to it." She draws an imaginary circle on the table. "And Suzanne will bring this." She draws another circle.

"And the way we put the circles together," Suzanne interjects, "that is powerful!"

"A best friend is like a completion," Carol finishes her thought. "She makes you better than you are."

Sue,
Gerri
and
Sharon

If you're not too tired, you could walk to the Melrose Diner from Philadelphia's Italian Market. Anybody in the neighborhood can give you directions, because the diner is an institution. At any hour of the day or night, you can slide onto a stool at the counter and order a full meal—but if you want a second cup of coffee, you gotta pay for it. The Melrose's chipped beef on toast is as good as it gets. The waitresses are about as sassy as the boss allows.

This is the story of three of those waitresses on the 7 A.M.–to–3 P.M. shift: Sue, Gerri and Sharon. They are ordinary women with ordinary lives. What *is* special about them is the friendship they've forged in the chrome-and-Formica palace where they spend most of their waking hours.

Gerri—the one with the perfectly drawn doe eyes, the orange fingernails and the turquoise scrunchie in her impeccable updo—is the mother hen and the oldest. She's fifty-four, has five kids and six grandchildren and has been waitressing off and on since her youngest was in diapers.

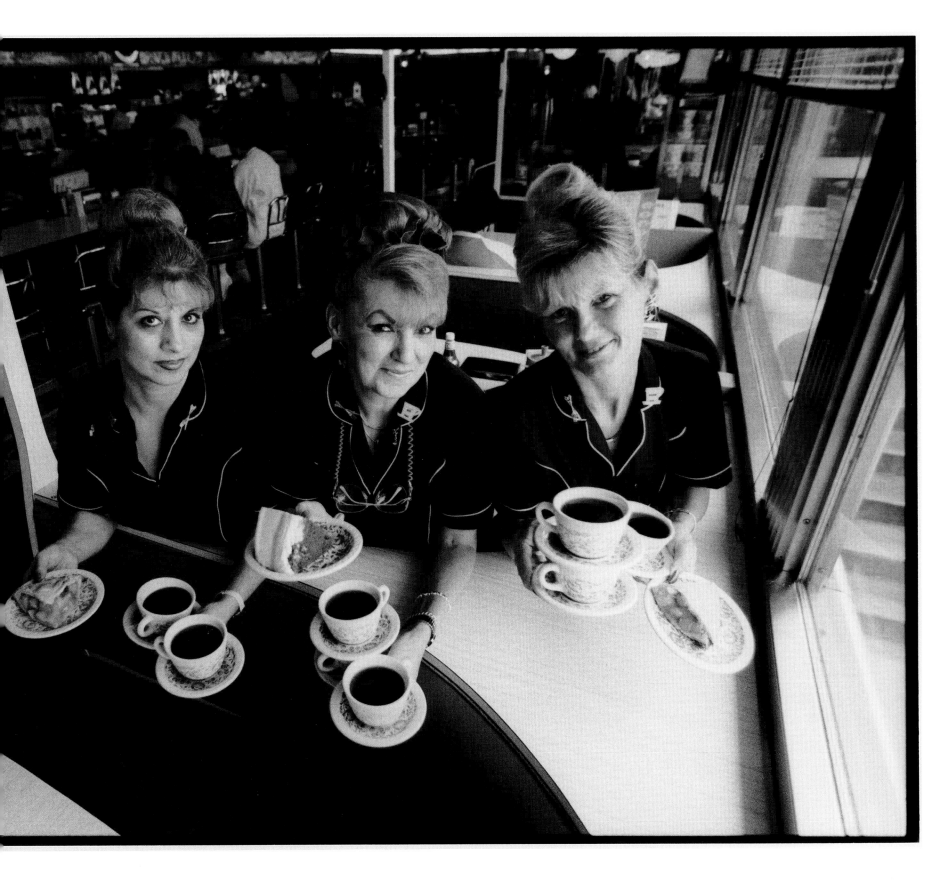

"I come to the Melrose, right. So the owner interviews me and I say, 'Excuse me, sir, I want to tell you I know nothing about waitressing. *Nothing.*' And he says, 'You're hired. You start tonight.' He liked me because I was honest." Sometimes Gerri daydreams about selling clothes instead of slinging hash. But hon, the hours in retail could kill you!

Like Sue, who's forty-seven and has two daughters, Gerri is divorced. Sue, of the red hair, the purple fingernails and the toothy smile, loves waitressing because she loves working with people. "I'm not the type to sit at home," she says. "Put me in an office typing all day, I'd go crazy. I need to be walking and talking."

Sharon, the forty-five-year-old narrow-boned baby of the bunch, flies into the diner every morning at two minutes before seven, wearing nothing on her fresh-scrubbed face but a smudge-of-lipstick smile. She keeps her skin smooth as lemon pie with regular facials. Her other weakness is a weekly manicure to preserve her dragon-lady, blood-red nails. The sweet mother of one son, Sharon never worked until a few years ago when her husband of twenty-three years—a city cop—dropped dead of a heart attack.

"Everybody was worried about me being on my own," she says. "I worked for my dad for a while. But when you're a daughter, you don't really work. So I got a job at Melrose."

Gerri immediately took Sharon under her wing. "We became friends from day one," Gerri says. "I always try to set the new girls straight. I explain to them, 'Keep everything to yourself. Do your job; leave your personal business at home.' You know what I mean? Right away, I thought Sharon was very nice. But I could tell she didn't have street smarts. I knew she'd make it, though, because she was very determined.

"I also felt a little responsible for her because I knew her brother. I used to wait on him when I was on night work. He'd come in late, after partying at the local clubs, and order his Sprite and his chicken cutlet. If you see him and Sharon together, they're one face."

When Sue was hired, she also received the Gerri "treatment"—because her cousin happened to be Gerri's boyfriend. And how's this for another coincidence? Long before these three ever met, the same obstetrician had delivered all their babies!

Within a couple of weeks on the job, the girls were tight as a box of Q-Tips. Soon they were trading the kind of tales usually reserved for a lifetime confidante. Sharon, naive and new to the dating scene, desperately needed some experienced heads to confide in. "I got involved with somebody who was very advanced for me," she says, blushing beet-red. "I wasn't sure what I should do and how to go about it. I never liked talking about nothing personal to nobody. But with these two, it's okay. Let's face it. We're with each other eight hours a day. Even more than with our own kids. At first we started out being work friends, but now we're much more. Now we're friend friends."

Sue butts in. "There are things you can't tell your family that you can tell a friend," she elaborates. "We definitely trust each other. We don't always take each other's advice, but at least we can console each other."

"Exactly," Gerri agrees. "And they know if they tell me something, that's as far as it goes. It stays right with me."

Yakkety, yakkety, yakkety. These three can chew the fat right down to the bone. Sometimes the boss has to move one of them from counter duty to the floor—like a teacher who separates chatterbox second-graders to opposite sides of the classroom.

"We work good together, but when the three of us are at one station—phew, the boss is really pressing his luck," Gerri admits, giggling.

They arrive each morning, fresh in their black uniforms with the white piping and in their white shoes, pick up their order books, down a quick cup of coffee and immediately catch up on what might have happened to each other since they talked for an hour last night before hitting the sack.

"Sometimes I feel like there's a phone growing out of my ear," Gerri says.

When they aren't gabbing to each other about men or kids or clothes, they're chitchatting with their customers—or talking about them. "Basically we know all their personalities," Gerri says. "The regulars come in sometimes two, three times a day, and they'll say their whole order exactly the same. It's like they're reciting a prayer: 'A bowl of oatmeal, a little bit of milk on the side. And just give me a half cup of coffee. I'll use the milk you give me for the rest.' We have one guy, I swear to God, he'll spread out his napkin on the table so nothing touches the counter, and he'll line up fifty butters. Then he'll make a little mountain out of his chicken livers and stick crackers in it. They're so predictable."

Sharing inside jokes with friends on the job who know exactly what you mean helps take the drudgery out of the routine. "Any job is less boring when you're with people you like," says Sue. "And we can depend on each other. When they're here, I know my back is covered. When they're off, I know it's going to be a long day."

Trusted best friends on the job are also guaranteed insulation against petty workplace gossip. "When you work with a bunch of girls, most likely there's going to be cattiness and jealousy," Gerri says. "But nobody in the diner would say anything derogatory about Sharon or Susie in front of me, because they know how close we are."

As if spending eight hours a day weren't enough time together, they also do things in their spare time. "Like last Thursday," Sharon says, "Gerri and me were off. She picked me up at nine-thirty and we had breakfast at another diner. Then we went shopping, got haircuts, had lunch at another diner and went to church. The priest gave us a special blessing. He must have known we needed it. When Sue got off work, we all went walking. We do that a lot. Then we went shopping again. We love to shop."

"That was the day Sharon was looking for shoes to match this one top she has," Gerri says. "She finds the perfect pair. Only it's a nine and a half. Her size is seven and a half. So she buys the nine and a half. We were cracking up."

In her defense, Sharon pipes up, "Well, they were imports—so they look small."

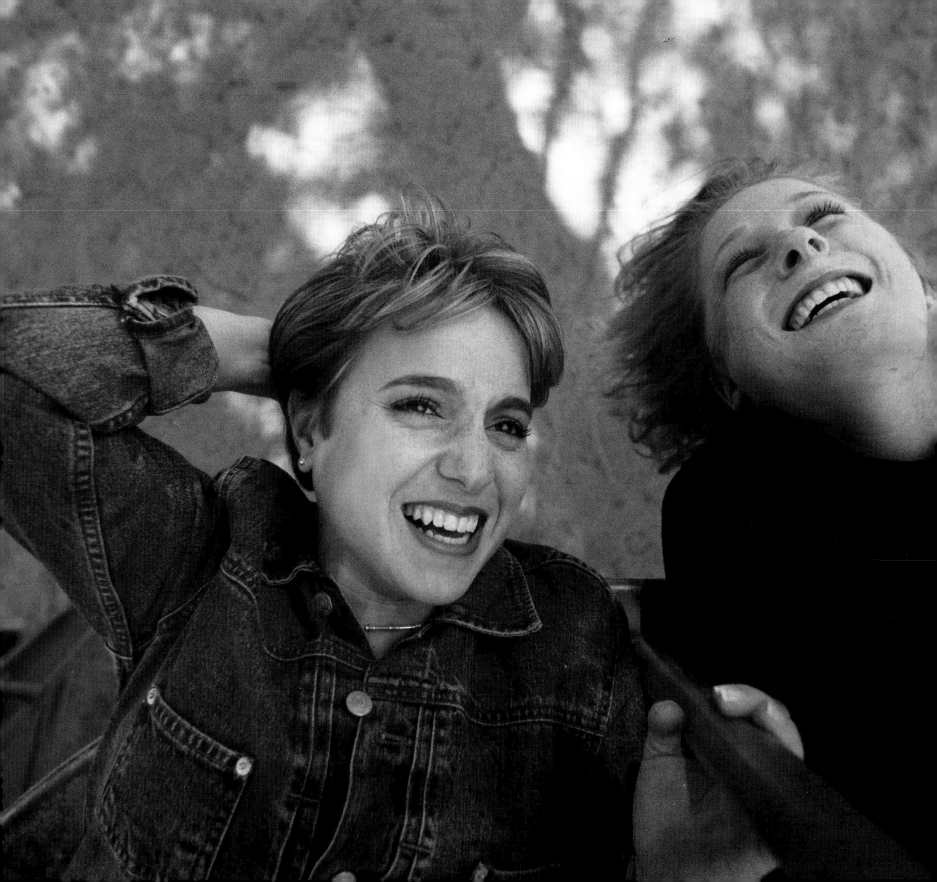

Kerri and Sunshine

In every Olympic competition there is always a heart-pounding moment of athletic heroism that shoots out of the television screen. At the 1996 Atlanta games, that flash came when gymnast Kerri Strug, after injuring her ankle in the middle of her routine, continued on and vaulted flawlessly through the air to a remarkable landing on one foot, clinching the gold medal for the United States team. For the world, it was a supreme achievement; for Kerri, it was a supreme disappointment. Because of her damaged ankle, she'd no longer be able to compete in the individual events where for so long she'd dreamed of winning medals. "I was heartbroken," she says. "I'd trained so long and hard with an idea of how my Olympic experience would be. And when it didn't go according to my plan, I thought the world was over."

Only one person who rushed down from the stands could console her. That was her best friend, Sunshine. "My parents were upset that I was upset; they didn't have a wide view on what was happening," Kerri goes on. "My teammates were mad because I had stolen the show. They didn't want to talk to me. But Sunshine was like this neutral figure, kind of a mediator. When my dream was cut off, she knew how to comfort me and how to handle the situation."

While Sunshine was close enough to Kerri to soothe her shattered hopes, she also had just enough distance from the situation to sense the excitement Kerri had generated in the American public. Maybe her best friend wouldn't attain her original goal, but clearly something else quite wonderful was possible. "You could feel the buzz around her," Sunshine says. "It was huge. I tried to make Kerri feel better by helping her focus on the positives and see that there would be other kinds of opportunities."

Sunshine has been bringing perspective and balance to Kerri's life since they met as youngsters in a Fort Worth gym. Kerri, a diminutive nine-year-old, had traveled from Tucson to train with twelve-year-old Sunshine's coach. When she began spending two weeks every other month—and summers as well—in Fort Worth, Sunshine's mother invited her to live with them. The girls became as glued as a stamp to a letter. They sat in the same chair, giggled at the same things and slept in the same bed, although Kerri could have easily had her own room. It made no difference that Sunshine was three years older. "My mom used to say that Kerri was ten going on twenty-one. I remember when she first unpacked her suitcase. The shoes had individual bags, everything was neatly folded to a tee and she'd done it all herself. I think I was also a little immature, so the age difference never affected us."

Nor was there ever any sense of competition. "Kerri was already this great gymnast at ten that I was struggling to become at thirteen. I was never envious because we weren't on the same track," says Sunshine, whose given name is Staci. (When she was born, her father told her mother, "I don't care what you name her, I'm going to call her Sunshine." She's been Sunshine ever since.) While both girls were high-level gymnasts, Sunshine was never an Olympic contender—although she *would* win a gymnastic scholarship to UCLA. On the other hand, by age thirteen

Kerri had left her home and relocated to Houston to train with famed coach Bela Karolyi in preparation for the Barcelona summer games in 1992. Whenever possible, Sunshine would come to important meets like the Nationals and the Olympic trials to cheer her on.

"Sunshine was serious, but gymnastics wasn't her life," Kerri says. "She went to a normal school and had a boyfriend while I was training eight hours a day."

"Kerri led a very regimented life," Sunshine interjects. "Nothing but school and the gym, and contact only with the same few people every day."

"But I think gymnastics is one reason we're best friends," Kerri says. "It helps Sunshine to completely understand where I'm coming from. Other kids would get annoyed when I wasn't available because of gymnastics, but I didn't have to be with Sunshine, or see her, to know she's there and she supports me. Then, after Bela retired, I moved around to a lot of different cities trying to find another coach. With each place, it was some new saga. It's hard to find good friends when you're traveling like that."

But Kerri could always pick up the phone and vent to Sunshine at the end of an exhausting day. Although they were leading very different lives, they both made a huge effort to nurture their friendship long-distance. "Wherever I was, we could always call and talk," Kerri goes on. "Like when she had boyfriend problems, or I had bad injuries and eating problems. She's kind of like my psychiatrist, always there to help me through. I have a lot of people who come into my life when it's good, but they don't want to stick around when things are bad."

Their only rough patch was a six-month stretch when Sunshine started college. Between leaving her family in Texas and adjusting to her new life in Los Angeles, she withdrew into

a private funk. Meanwhile Kerri was mired in some training crisis of her own. "My mom was a great and good friend at that point in my life," Sunshine says, "but I realized I needed someone near my age who understands me—like Kerri. So I sent her a card I found that said, 'My crayons have melted,' and I wrote inside that no matter how far apart we were, we'd always be best friends, that I'd be here for her always, and that I was ready for us to become closer again."

The minute Kerri finished reading the card, she picked up the phone in Oklahoma City and called Sunshine in California. "We knew we needed each other and were just being stupid," she says. "Right away we were back to how it was before."

Because Kerri's existence had been confined for so long to the narrow world of floor mats, gym horses and balance beams, she almost didn't know how to behave when her Olympic performance in Atlanta catapulted her into the national spotlight. Fortunately, Sunshine was there to prep her and to share, as a girlfriend, the excitement of becoming an overnight celebrity. "It was fun to do all those interviews and talk shows with someone I really cared about," Kerri says. "Sunshine's been in the real world a lot longer, so she's able to help me with the transition to being a normal person. There are so many things I haven't a clue about. Like when she graduated college and got a job with Smith Barney in New York, I had no idea what Smith Barney was. And after the Olympics, I was really overwhelmed. We went shopping together and I didn't know what to buy. All I'd ever wanted was leotards."

"She had to fill out some form about her favorite television shows for America Online," Sunshine remembers, "and she didn't know what to put down. She never watched TV. So I said, 'You're coming over. My boyfriend will make us pizza and we'll watch television and I'll tell you what to write.' I was just ecstatic that I was there to support her. And I got to do so

many things I'd never have done. We met Sylvester Stallone, went to a dinner for Magic Johnson and were on the set of the TV show *Copland.* But I never worried all this attention would go to Kerri's head. One thing she's always been is very levelheaded. Except one time when we were at a talk show on CNN and the President called her. She was so excited. 'Can you believe it? I just talked to the President of the United States!'"

Sunshine's playfulness gives Kerri the chance to be the teenager she never had time to be. After Kerri enrolled at UCLA, Sunshine, then a senior, took her to her first fraternity party (and then told her she'd never meet anybody great that way), showed her the hot spots, introduced her to sorority life and hooked her on frozen yogurt. "She's like a big sister watching out that people don't take advantage of me," Kerri says gratefully. "Also, she shows me how to focus my energies. She's a much more even-tempered person than I am. I stress over everything. Sunshine just stresses over things you need to stress about and relaxes the rest of the time. She can handle a lot of things at once, whereas I've usually done just one thing at a time, and I realize you can't go through life that way. She has taught me so much. She's really shaped my life."

Sunshine is quick to point out that Kerri gives to her as much as she gets. "We really laugh a lot and get to be like little girls when we're together. Kerri has accomplished everything I've ever wanted, so I get to live through her vicariously. She's also a great role model, someone I can admire and look up to, even though I don't have to put her on a pedestal because she's my best friend."

"What's important to me," Kerri says, "is that Sunshine was there for me before all this Olympic stuff happened. Some people want to be around you for all the wrong reasons. But with Sunshine it's not that way. Sunshine likes me just because I'm me."

Jeff and Vance

REGINALD A. JORDAN
VAN J. JOYCE
FRANCIS X. KANE
ALBERT KAPLAN
EDWARD J. KAPUSTA
RONALD J. KELLEY
GERALD J. KELLY, JR.
THOMAS P. KEOGH
MICHAEL J. K
THOMAS J. KI
GOLSBY KIM
LARRY V. KIN
RONALD C. K
STEVEN KIRBY
HERBERT A. KI
BERNARD F. KIS
HARRY T. KITE, JR.
JAMES J. KLINE
ROBERT T. KOEHLER
STEPHEN B. KIRSO

Basic training. Fort Bragg, North Carolina. 1967. Get up at 4 A.M. and hit the road. Run miles and miles and miles until you drop. Then pull yourself up and keep going. You're in the army now, boys. Next stop, Vietnam.

It was on those daily, grueling predawn runs at Fort Bragg that Jeff and Vance first paired up. "You get punished if you pay attention to anybody who falls behind," Jeff recalls, "so you start buddying up with guys who are at your same level of ability. I trusted Vance early on, felt I could depend on him. In the service, trust is everything. I saw what kind of person he was in his training and work habits, and you want to exist with the best people."

Jeff reminded Vance of his brother back home. "There was something about him," Vance says, "some magnetism. He was cocky and direct and straightforward. I never did fit in with the guys my color from New York and the big cities. But it was different with Jeff. He never made fun of my stutter. I didn't feel threatened."

From the beginning, race was never a factor. Vance, a lanky nineteen-year-old black Southerner, didn't harbor any prejudice against white folks. Until the army, his world had been so segregated that he just didn't know any.

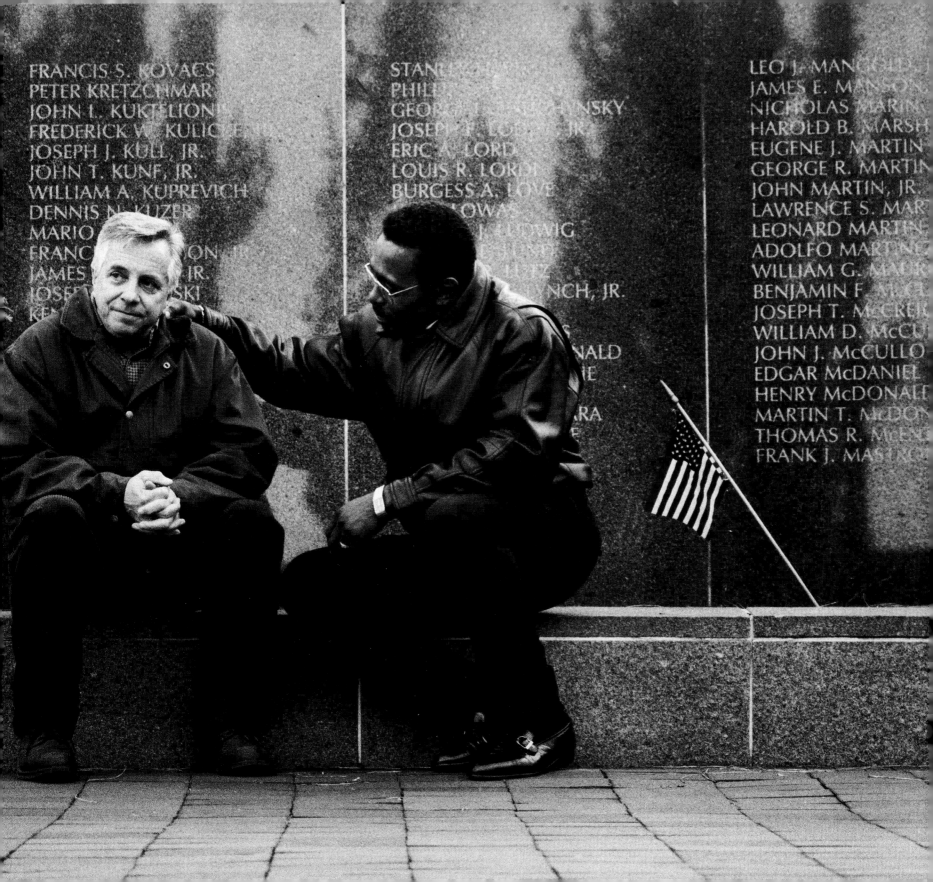

Jeff, a short twenty-three-year-old married drummer from up North, considered himself color-blind because he'd been playing alongside black musicians for years.

Their burgeoning friendship would have ended when they finished basic training had they not, by pure chance, been among a handful of GIs from their platoon told to report to Fort Rucker, Alabama. With a little aggressive maneuvering on Jeff's part, they wound up as cooks in the mess hall. For the next three months they lived and worked side by side. Having each other to rely on was the single thing that made their miserable life bearable.

"May as well tell," Vance says with a sly grin. "Don't want to be modest. We were *good*! We didn't know anything about cooking, but we learned. We set our bedroom up like it was our little home. I'd put on the music and do my artwork. I found that I could share embarrassing stuff about myself with Jeff, and I wasn't scared he'd take it and use it against me. We did all kinds of things together, though he never did teach me how to play pool. Jeff was always drumming things in the kitchen. He'd be imitating Dr. King singing 'Free at last. Great God almighty, I'm free at last.' Then I'd say something, and we could put all the racial tensions behind us. We were in our own world. The environment on the post was real hostile, so to have a friend meant everything."

When they finally got their marching orders, it turned out they were both flying from Fort Dix, not far from where Jeff lived, so he invited Vance to spend the last two weeks of their leave at his home before they shipped off to 'Nam. Days later, a tractor trailer driven by Vance's brother deposited him in front of Jeff's door. "It was a great experience spending time with his mom and dad and wife," Vance says fondly. "I felt like part of the family. I had my own room, something I sure never had at home. Me, a kid who graduated from the last segregated class in my community, sleeping in a white folks' bedroom! Jeff and I,

we were breaking new ground and didn't even know it." But they never really had enough time to cultivate the fertile soil of their growing friendship.

Whatever glamorous ideas of war they still clung to began to dissipate the moment their military transport touched ground in Vietnam. Jeff describes their arrival: "You're brought up with movies starring these older guys, John Wayne and Lee Marvin, landing on beaches with thousands of men running around. When the tailgate dropped on our plane, there were mostly kids—nineteen, twenty years old. All they could talk about was their proms—that was the last big thing that had happened to them. None of us really had a life yet. We walked out into this intense heat, it had to be a hundred and thirty degrees, and the stench of human waste was all over the place, because people went to the bathroom anywhere. There were no beds; you just laid down in the mud to sleep."

The Vietnam War wasn't hell; it was chaos. "The noise was awful," Vance says. "Generators running all the time and the base always being rocketed by incoming artillery rounds. One day you're playing football on a field and the next it's full of dead people. You lived in fear of being shot or caught in a booby trap. It was constant vigilance. You could never let down your guard."

They were separated almost immediately. Vance took whiskey for his new companion. Jeff deteriorated into a wild animal. "I became subhuman. Some days I'd wear a top hat I'd found or I'd paint a bull's-eye on my chest or half my face black and half red, or I'd wear a string of ears or fingers around my waist. We were in combat all the time; it was crazy."

After several months, Vance learned that Jeff's unit was camped about ten miles from him. He hiked through the jungle, ducking enemy snipers, to find him. He might as well not have taken the risk. Jeff was not glad to see him. "Right away, I could

sense a difference in him, a distance," Vance says. "The place just messes with your head."

"I think we just stood and looked at each other," Jeff recalls. "It's hard to understand, but everything there was so weird and so intense. It was like I had put him out of my mind, and here he shows up in my face. And maybe he'll be killed. I didn't want a friend now, because he could get hurt or die and I would lose him. I couldn't take that kind of pain. It was too much."

They never saw each other again until twenty-eight years later.

When Vance's tour of duty ended, he came home with a serious alcohol addiction and a bad attitude. Very gradually, he cured himself of both problems. Over the next several years, he patched up his marriage, bought a house, adopted a baby and worked his way through school as a janitor and cook to ultimately earn three degrees. The first, from a junior college, was in law enforcement; the second was in religion and the third, a master's in divinity, trained him for the profession he practices today—the United Methodist ministry. All the while, the one constant thread in his life was the stories he told his wife about his buddy, Jeff, the only real friend he'd ever had.

"Stuff about him just stayed with me," Vance says. "He was always teaching me. By working with him and accomplishing the things we did, he was a great help in my discovering myself. Even when I fell in love with Minnie, remembering how Jeff was with his wife sort of helped me to be a husband. I made some acquaintances over the years, but nobody who mattered to me like Jeff."

Meanwhile, Jeff returned from Vietnam with an evil temper and a constant guilt over the fact that he'd survived. "I got back," he remembers, "and my wife's standing there with a baby I'd never seen. It freaked me out—this love stuff again. I got a job real quick. Then we have another baby who I adore and I'm just starting to get around to not worrying about killing people—when all of a sudden, my wife dies. Woof, heart attack. She's gone, and there's two kids hanging on to my legs and I have to tell them they got no mother. I had nobody. What few friends I had were married, and once my wife died, I was no longer a married person. I had no buddies to come over and have coffee. My parents were great, but they can't lay there with me at night comforting two kids who don't want to lose anybody else."

For four years Jeff worked two jobs, electrician by day and musician at night—while learning how to be a single father, how to braid a daughter's hair and get a hot meal on the table every night. And then God sent him Maria. "An angel," he calls her. "She had this softness, this unbelievable softness, and a can't-hurt-me voice." He was thirty-five; she was twenty. They were married within a year. With Maria's encouragement, Jeff opened a sporting goods store in an abandoned garage and built it into a successful business. As the years went by, he'd pull out his picture albums from the war and talk about his buddy Vance. Maria noticed he was the only friend Jeff ever seemed to care about.

Left to their own devices, Jeff and Vance would probably have gone to their graves with nothing but faded memories of a prized friendship cut short by fate. But they had wives who wanted to put a face on those memories and surprise their husbands with that one gift money could not buy. Independently and without their husbands' knowledge, both Minnie and Maria set out to track down Jeff and Vance.

Maria traveled alone to the Vietnam Veterans Memorial in Washington to make certain Vance's name wasn't listed among the dead. She hounded her congressman, various veterans' organizations, army record bureaus, all to no avail. In the meantime, hundreds of miles away, Minnie worked her own hunt with no better luck. Eventually Maria narrowed her search to a few Southern states and began calling anybody listed in the phone

directories as V. Hunt. Two days before Christmas—a decade after she'd begun looking—she hit pay dirt. "Is this the Vance Hunt who was in Vietnam with my husband, Jeff Leonard?" she asked. And the stunned voice on the other end of the line shouted, "Yes!"

"I couldn't believe it," Vance says. "She was so excited and I was going berserk. She runs home, calls me back and hands the phone to Jeff without saying a word. We used to have this private saying, Jeff and me. He would kid me about how everything got caught in my hair. Dust. Lint. You know. And I told him I wore my hair cut short because it makes combat shots and beebee knots. So I said over the phone, 'Could you tell me if you know anyone who can deal with the problem of combat knots and beebee shots?'"

"I yelled, 'Holy shit!'" Jeff says, giving Vance a high five as they relive that call. "Holy damn. I thought you were *dead*. I couldn't believe it."

Between everybody's work schedules, it took them until July to arrange a visit. As the date grew closer, both men got more worried. "All kinds of doubts come into your mind," Jeff says. "I was scared. I'm thinking, Man, this is almost thirty years. We don't look the same. Are we gonna still hit it off? Maybe I have this false perception I had a great friend—and it wasn't true. Then there would be this void in my life. He's been my connection to reality."

Vance was just as concerned. "We took the train for fourteen hours. I must've chewed three packs of Levi tobacco and eaten a hundred breath mints. I've never been so nervous. I didn't want him to feel—because of my vocation, being clergy—that I was a fuddy-duddy. People run from the preacher and I didn't want that to happen with Jeff. Would he still like me? Would I be accepted as I was back then?"

The instant they saw each other, their fears evaporated. They hugged and cried. "Not like we did after Vietnam," Vance says. "These were tears of joy. They made us feel a full welcome. They put us up in their room. You can't get closer to someone than to have their bed and bathroom. In no time, we were like family."

The visits are now an annual reunion during which the past is rarely mentioned. They're too busy creating new memories from the present. Their phone bills are high. Vance sends Jeff audiotapes of his sermons. Jeff sends Vance Italian food packages. And the wives have become as close as their husbands. On a recent visit, the men finally decided they were emotionally strong enough to visit the Philadelphia Vietnam Veterans Memorial together, something they'd refused to do for years. "It was just too vivid a reminder of a loss of life that made no sense whatsoever," Vance explains.

Under a cold slate sky, on a windy day, they walked along the carved granite walls of the memorial and talked about the amazing survival of their friendship. "It means so much to have Jeff back in my life," Vance says. "It allows me to recall who and what I was thirty years ago. Through Jeff, I can see and know *me*. I have a trusted lifetime friend. A buddy."

"Having Vance back in my life is like a million pounds taken off my back," Jeff says. "It's like finding your kindergarten friend. Like a new life."

As they stroll pensively along, reading the names of those who weren't as lucky as they were, Jeff begins to quietly weep and Vance reaches down and takes his hand. "There are lives behind those names," he says, trying to express what they're both feeling. "There's mamas and daddies, sisters and brothers, daughters and . . . and . . . oh, shit, Jeff. I'm just so glad we made it . . . I'm so glad your name's not here."

Erica and Carol

*I*n a Michigan lawyer's office where the walls are decorated with baby pictures instead of the traditional framed diplomas, three strangers share a sofa and begin chatting. Erica, aged thirty, is trim and dark-haired, a legal secretary from Pennsylvania with an independent streak. She is here because, quite by chance, she picked up a book about surrogate mothers written by this attorney and called him. "I was deeply moved by the painful stories about his clients who couldn't conceive," she says. "I'd look at my two little angels sleeping in their cribs, and it just didn't seem fair to me that other people can't have that." That's when she decided to give the gift of a baby to a desperate couple who couldn't have their own.

Carol, fifty-one and old enough to be Erica's mother, has driven to Michigan from Ohio, along with her husband, Jim. She is a tall, big-boned woman with unruly blond curls and a hello-world toothy smile. A partial hysterectomy in her thirties left her infertile; marriage late in life has ruled out adoption. Agencies don't give babies to middle-aged couples. Their only option for children has become surrogacy. "The joke around my family," Carol says, "was that I was always a mother, but I just didn't have anything to mother. I mothered my parents, my nieces and nephews, the dogs. My brother had sheep and I mothered them. I have quite a maternal instinct."

Of the four couples Erica interviewed that afternoon, she selected Carol and Jim the only possibility. Their relationship should have been little more than a formal business arrangement in which, for a rather modest fee, one woman had contracted to carry a baby for another, fathered by the client's husband. Normally, surrogates and couples are discouraged from having much contact. But Erica and Carol would soon have none of that. "This was," says Erica, "love at first sight."

Or as Carol explains, "Not husband-and-wife love, but something that clicks between two women who are going to share a long, loving relationship. Erica and I recognized that right away. Besides, Jim and I had already decided that we wanted an ongoing connection with our surrogate mother. A picture at birthdays and letters at Christmas was not our idea of sharing this child."

"I felt the other couples were going to pack up and move in the middle of the night so I wouldn't come back to steal the baby," Erica goes on. "But Carol was open. She knew I wasn't there to make a business deal. I was doing this for a couple because I liked them. I could tell she trusted me and saw something the others weren't even willing to look for. Like when I mentioned I wanted to nurse the baby for three days, her reaction was, 'We'd be honored. That will make the baby so much healthier.'"

Carol continues, "When you're infertile and going into surrogacy, you're so sensitive that your nerve endings are sunburnt. You have unbelievable fears, and you're scared this woman might decide to wrench the baby out of your arms. Erica and I both had to trust each other. I just knew immediately that she was right for us. This woman is compassionate. Intelligent. Humorous. Cute. Streetwise but not jaded. All in all, a very nice gene pool. She's a marvelous woman, a marvelous mother, a marvelous friend."

Of course, Carol could only intuitively sense those qualities in the lawyer's office. But her first impressions settled into convictions as her attachment to Erica deepened over the many months it took for the repeated inseminations to work. "The more I got to know Erica, I couldn't think of anybody else to be the mother of our children," Carol says with her typical gusto. "When she finally conceived, you couldn't shut me up, and in my usual bossy way, I told Erica what

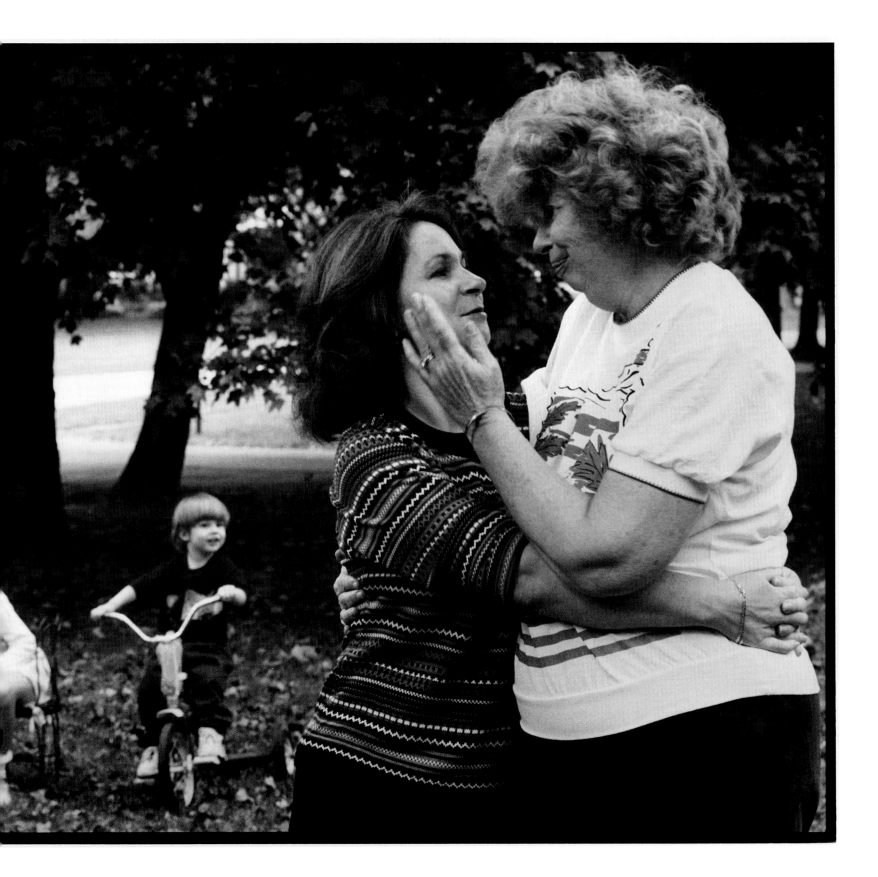

she should eat. I was so excited, I told the mailman, the mailman's wife, even the dog that barked at the mailman."

The moment Erica went into labor, her mother called Carol in Ohio. By the time she and Jim drove to the hospital in Pennsylvania, Nancy had already been born. "Erica handed the baby to my husband," Carol recalls, "which I thought was wonderful because it was his biological child."

"I couldn't give her to you," Erica reminds her. "You were crying too hard."

Three days later, Carol and Jim packed baby Nancy in their car and set off for home. "I didn't feel a bit sad when they left," Erica says. "I actually felt proud. Most surrogate mothers don't feel they've gotten a lot besides a check. I got as much from Carol as she believes she got from me. I think best friends have to complement each other and grow from the relationship, individually and together. We just keep moving up and over. Carol's helped me get past a lot of my insecurity and learn what I was made of. She helped me feel good about myself, feel that I'd accomplished something. Deep down we all want to believe we're worthy, and it's nice to have a friend who sees that in you. I can show Carol my ugly side and tell her things about myself I'm not proud of—things I've never told anyone. I know she won't be judgmental—like my mother would—or have less respect for me. Her attitude is always, 'If you felt it was the right thing to do at the time, then it was right to do it.'"

Carol retorts, "Yeah, I won't say, 'Boy, was that dumb!' I only wish Erica had my self-confidence. She should, because she's a wonderful person."

After Nancy's birth, her mothers talked on the phone every few days, then every few weeks. Carol had gotten involved in an induced lactation program that taught her how to nurse Erica's baby, and she had lots of questions. Many of their conversations ended with Carol offering, "If you need to see the baby, just call us." Three months later, the invitation to the christening came. "Do you know what they did?" Erica asks, still marveling at her friend's generosity. "They put me in the back of the church with them and handed me Nancy, and everybody who came up to them, came up to me, too."

Carol shrugs her shoulders in a what's-the-big-deal gesture. "I wanted our friends to meet this fabulous woman."

It probably took Carol all of fifteen minutes after holding Nancy in the hospital to realize she wanted Erica to have a second child for them. By the time Erica was ready to get pregnant again, the women had become so enmeshed that the Michigan lawyer simply Federal Expressed the contracts, a midwife supplied them with sterile syringes to perform the insemination at home, and in a few months their son, JT, was conceived.

Erica's second pregnancy for Carol provided an ideal opportunity to explain to Nancy why she has two mothers. According to Carol, "Nancy tells people that everybody gets to Earth from somebody's tummy. My babies came from Erica's tummy because my tummy can't do it. It's no big thing to her. She says she's lucky, because not everybody has two mothers." JT is still too young to understand.

As for Erica's two natural children, aged ten and fifteen, they think of Nancy and JT as their siblings, bless their "other family" in their prayers and view Carol as their second mom. In the ultimate confirmation of their abiding friendship, Erica, who is divorced, has legally designated her best friend as guardian of her own son and daughter should anything happen to her.

While it's not uncommon for special circumstances to create unlikely friendships, only a best friend can surmount the added obstacles of time, place and distance. Carol and Erica both believe passionately that having the babies brought them together—but that it's not what keeps them together. While their

backgrounds and lifestyles are very different and they have no shared childhood history to fall back on, they do share similar values. "If I'd met Erica in a social relationship, I'd have worked very hard to make this woman my friend," says Carol. "Absolutely. Very hard. It would be difficult to think of someone I respect more than Erica. We have a non-hiding relationship. We can be ourselves around each other. It would be easier for her to die and get out of the Columbia Record Club than it would be to get out of my friendship."

"We'd have been attracted to each other no matter how we met," Erica affirms. "Carol's more religious but we're both spiritual. When she seeks God's help on my behalf, I get strength from that, even though it's not part of my makeup. What matters is that basically the things that she thinks are right, I think are right, too. We had to recognize something special in each other to develop this friendship, because it's long-distance—we only see each other three or four times a year. Normally I don't have a lot of time for friends. Being a single mom, going to work and trying to get a college degree at night, taking care of my kids, getting them to their violin and singing lessons—these are real obstacles to friendship. I've been spoiled by Carol. She's taught me you don't have to be doing things for somebody to be their friend. You just have to share whatever they're happy about, and let them know you feel an empathy for whatever they're going through at a particular time."

Since they are mothers of the same children, their friendship raises empathy to a rare level. Could anyone be more supportive than a woman friend who truly mirrors the gamut of your feelings toward your son or daughter—from pride to joy, from worry to heart-stopping fear? For a brief period, Nancy experienced a series of what might have been life-threatening seizures. (She has since been cured.) Not even Carol's husband could give her the comfort and understanding that Nancy's other mother, who flew out to see her, provided. "We talked. We cried. We did a lot of hugging," Erica says, still choked up at the memory. "And after I went home, Carol called to say she felt better just for having had me there."

Their dream is someday soon to have Erica nearby all the time. "Erica and her children are eventually going to move here," Carol says with absolute certainty. "It *will* happen. We want our families to grow up together and know one another. Share holidays. Share traditions. Share love. Share everything. This woman gave me the gift of life. Not once, but twice. By my definition, *that's* a best friend."

Kevin and Michael

*K*evin Bacon struts and slithers on the stage of a cavernous warehouse that's been converted into a rock concert hall. Dressed in jeans and a T-shirt, his spiky hair unmoussed and uncombed, the edgy actor skillfully fingers a guitar and in a surprisingly good voice glides over the lyrics to "Brown Eyes," a ballad he's composed about his two children. While this could easily pass for a scene from a Kevin Bacon movie where he plays a rock star touring in a band he's formed with his older brother—it's not. This is the Bacons live and in person. Actor Kevin and Michael, an Emmy Award–winning composer, rocking and rolling around America, playing to packed houses of screaming fans who've forked over big bucks to see the Bacon brothers ham it up.

Nothing in the complicated rules of family life teaches brothers how to become best friends. Sometimes it happens. Just as often it doesn't. Blood may create brotherhood, but it doesn't guarantee friendship. Until a few years ago, Kevin and Michael would have described themselves as brothers who certainly liked each other well enough and got along without friction. Then they put together the band and something happened that neither of them ever anticipated. They became best friends.

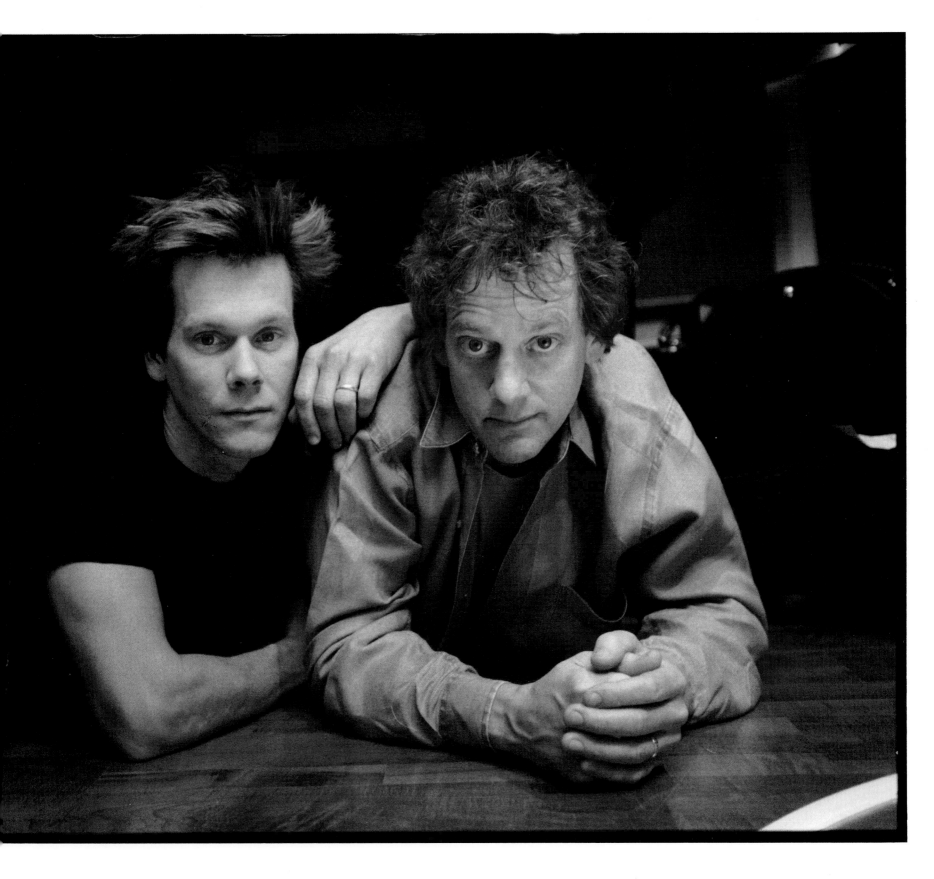

The nine-year gap between them precluded the possibility that the boys would pal around growing up. "Our whole family, my four sisters and myself, were pretty much established when Kevin came along," Michael explains. "Since our parents were older, he was almost our baby."

"I can't tell you how often people say to me, 'You must fight. You're brothers. I know you fight,'" Kevin declares, laughing. "But we just don't fight! I almost feel apologetic about it sometimes."

The good thing about being far apart in age was that they never vied against each other in school or in sports and never shared the same women. The disadvantage was that, except for their identical pale blue eyes, the color of denim washed too many times, they didn't have much in common. Even today, they have different tastes in movies, food and music. Michael favors a melodic, sweeter sound; Kevin likes things a little harder. And forget politics. "We don't even talk about politics," Kevin announces.

Michael shrugs his shoulders under his button-down oxford shirt and says, "I'm the family Republican."

If anything, Kevin grew up exhibiting a major case of hero worship for his big brother. "He was kind of a gold and shining knight on a white horse to me. Much more of a role model for me than my father, who is pretty eccentric and eighteen or twenty years older than any of my friends' fathers. He was never into sports like normal dads. He was into architecture and European history, whereas I was totally enamored by rock-and-roll musicians—the Beatles, the Stones, the Monkees. Guys with guitars were my heroes, and my older brother, who had a band, was one of them. Some of my first memories of him are of being five or six years old and hearing his band practice. I'd sit there listening on the steps of the basement—there wasn't any room for me *in* the basement—and it was like magic. My brother

bought me my first guitar and taught me how to play 'Hey Jude.' I never really played that well, and I still don't, but his doing that was definitely very important to me. Even though I'm sure I was a nuisance, Michael was always nice to me. After he finished college, when I was a teenager, he moved back home to Philadelphia, and I'd get real excited when he would have me over to his apartment for dinner or something."

They first began behaving more like peers when Kevin moved to New York after high school to try his luck at acting. At the time, Michael was living in Nashville, struggling to make his mark as a singer-songwriter. "Any chance I got," he recalls, "I'd come up to New York, sleep on the floor of his apartment, and we'd go out and goof around."

Then Kevin suddenly skyrocketed to fame on the big screen. Michael, who was strumming his guitar and singing his music before sparse college audiences, got his first taste of the bitter brew of sibling competition. "It was pretty terrible for me," Michael admits. "I was happy Kevin was doing well, but I had no work, no record contract, a wife and a kid. I felt my whole career was grinding to a halt. Kevin's emerging kind of kicked me in the butt. I decided that I wasn't going to spend my life as Kevin Bacon's older brother, playing for kids in schools. I knew I had to do music, but maybe not as a performer. I borrowed eight thousand dollars from my father and moved with my wife and son to New York. And, as it turned out, we rented an apartment upstairs from Kevin. He supported me in my career as much as he could. Baby-sat. Introduced me to people."

Slowly they formed a much tighter bond as brothers, but they were still far from bosom buddies. Family and work actually kept them at a distance. Michael got busy and successful writing and recording music for films and television. Kevin was off on location making movies. "We both had family and kids

and schoolwork and careers. Different wives. Different lives," Kevin says. "It was even tough to have dinner together. He eats way too late for me, like at nine, and I eat at six. Spending time with each other just took too much energy."

And that's the way they'd have gone along forever had it not been for the band. From time to time they'd dallied at writing commercial tunes together, and one day a friend suggested they try something onstage. It sounded like a hoot, so they tried out their act before an audience packed with friends at a little neighborhood bar in Connecticut. A week later, they played at a popular club in Philly, their hometown, to a crowd made up mostly of strangers that they quickly transformed into fans.

"I was terrified," Kevin says. "It was like jumping out of an airplane. But something clicked between us immediately. This stage relationship just happened. I looked at Michael and he looked over at me and we sort of smiled, and that was it. With Michael, I have this tremendous safety net, because I feel very naked when I play. There's no character between me and the audience to hide behind, but I know that next to me I have this musical rock who's always going to be able to pick up the pieces. There's a lot of history here. And it just gets better and better. It's so much fun, so much fun playing with Michael."

As they became more involved musically, the problem they'd once had making time for each other melted away, giving rise to an unexpectedly rewarding intimacy. "One of the things I realized after I had a child," says Michael, trying to define the shift that occurred, "is that love is one thing, but time is another. Time is what matters. Spending time with someone is what makes a relationship grow, and the band has changed that for us in a very drastic way. It was never ingrained in me to say to my wife, 'I'm going out with a friend.' But now we go on the road—like we went to California for six days, just us. There's no other way in the world we would get to be together

so much. And for me to watch my brother enjoying things that have always been so enjoyable to me and seeing him getting into what my life has been about for thirty years is an experience like nothing else."

"It's like the gigs are our excuse," Kevin continues. "Getting the chance to play together is our golf or our strip clubs or Saturday night poker or fishing trips. We don't do any of *those* things. We have the band. We talk every day about something band-related, and sometimes if we're having a conversation, something else will come up of a more personal nature. Our careers. Struggles. Family. Our father. Our sisters. Our wives. Fatherhood. We talk about fatherhood a lot."

"We're very much alike in our values, in terms of what we consider important in life," Michael adds. "Like what's the value of work. Your work does not become who you are to your family. Your work is something external and is treated that way."

"Yeah, we put our families first," Kevin says. "Even in something as egotistical as my life. I mean, I'm an actor. I'm a complete egomaniac, but when I approach work, it's about taking care of my family. We're both very traditional that way."

That traditional perspective once colored the way they viewed male friendship. But not anymore.

"Until now, there wouldn't be anybody I could think of as my one best, best friend," Kevin says. "Some of my friends are halves of couples. Some are friends from a long time ago who've sort of slipped out of my life, but when I see them, there's a certain bond that never goes away."

"But I think we're both closer to our wives as friends," Michael suggests.

Kevin agrees. "Honestly, I never feel that I'm as close to my male friends as I would like to be. I look at my wife, who has a handful of these very intimate, very intense friendships with women that she can immediately go to at any time. I wouldn't

say I have that. Except with my brother. And it's a good thing because you need to have someone other than your wife who you can talk to."

Michael sits thinking for a moment. "Here's something interesting," he says. "Before we started this band, I would never hug my brother. I just didn't do that. My father's way of hugging was to smack you on the back as hard as he could, and I'll tell you, it could take the wind out of you. But my brother is a huggy guy, and all of a sudden, I'm hugging him back."

Under the harsh glare of the spotlight, Kevin energetically swings his guitar above his head, ending a foot-stomping song about an encounter he once had in a redneck Southern bar. Michael alters the mood by swinging into "Adirondack Blues," a gentle tune where he puts aside his guitar and pulls a bow across the tender strings of a cello. In the closing bars, Kevin moves in closer and the brothers blend their voices into a lovely harmony that hangs softly in the air for a brief moment as the music fades. Kevin closes his eyes and grins in total contentment. He opens them and turns to Michael. "What else can I say. I love you like a brother. And I mean that NOT in a Hollywood way."

Michael flashes his wry smile. "You'd better!" And the crowd roars.

Valerie and Marnie

It's a warm day in June. Two brainy and beautiful college sophomores—Valerie from Harvard and Marnie from Princeton—are reporting for their first day of work as summer interns at the prestigious New York law firm of Sullivan & Cromwell. Marnie arrives first, formally presents herself to the receptionist and primly sits down to wait in the impressive lobby. Minutes later, the second intern breezes in. With a big smile on her face, she extends her hand across the desk and cheerily pipes, "Hi, I'm Valerie."

Marnie eyes her coworker warily. "My first impression of Val was that she was overzealous and too friendly," Marnie says, laughing. "I just didn't know how to take her."

In the course of that first day, Val discovered it was Marnie's birthday. "To me it was like, How could you start work on your birthday when you don't know anyone and pretend it doesn't matter that it's your birthday? So I invited her out for a drink."

"It was raining," Marnie remembers. "I had an umbrella. Val didn't, so we decided to share mine down to the subway. As we're walking, she linked her arm through mine. My friends were much too cool to do anything like that. But Val was just so incredibly warm, so outgoing and trusting, so willing to share from the get-go. At first, I was sort of taken aback, not sure if she was

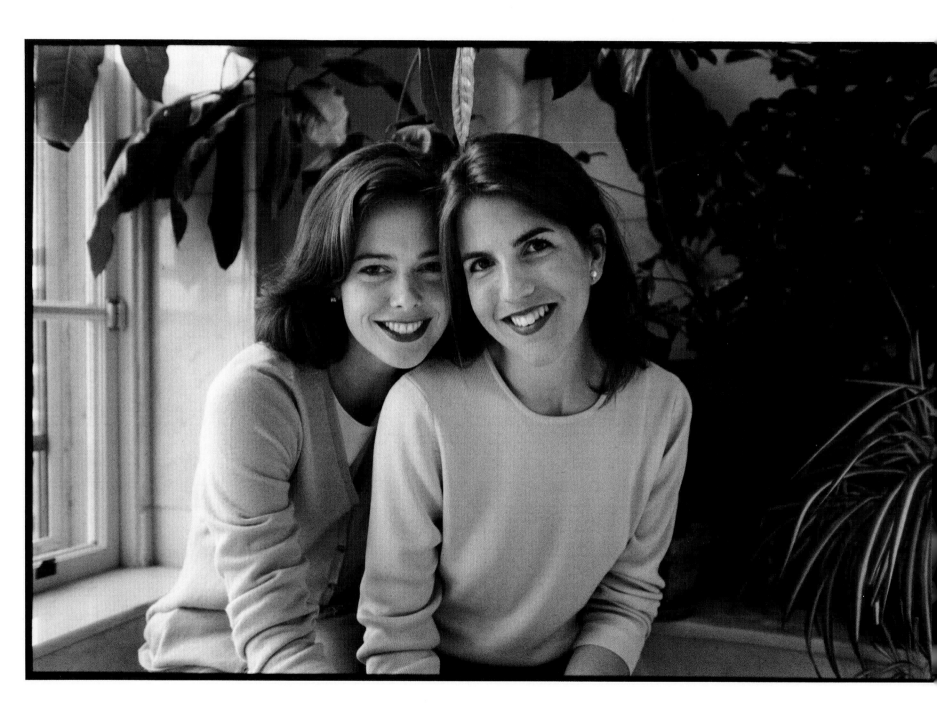

strange or just unusually wonderful. Thankfully it turned out to be the latter."

It took them just one day to like each other and one summer to establish what would grow into an unbreakable friendship. "I'd never felt the need for a best friend before," Valerie says. "I'd always had a posse of different friends who shared some particular interest with me. We either played sports or sang together or served in student government. Marnie was the first person with whom I shared many, many interests. We had the same kind of moral code and the same way of looking at things. Also, I'm very close with my brother and sister, so I'd never felt a need to go outside for more. But almost from the beginning, I thought of Marnie not so much as a friend but as someone who'd entered into my family. That distinction is very important to me."

What clinched their friendship was sharing an apartment in New York while Marnie attended law school and Valerie worked at Citibank. (She'd later get an MBA at the University of Pennsylvania's Wharton School.) Living with a friend can either destroy a relationship or establish a fondly remembered historical reference point for everything in the future.

"The decision to live together was a real leap of faith for both of us," Marnie says. "We hadn't gone to the same college or grown up as friends. As an only child, the thought of sharing space with someone was pretty nerve-racking. You can't hide your little idiosyncrasies or vulnerabilities. But if the connection is good, like ours, it really results in something special.

"You'd think because Val is so social and gregarious that she's not the best listener, but she will sit down and have more patience for your problems than you have for your own,"

Marnie goes on, mindlessly tucking her smooth, straight hair behind her ear.

Of course, Val leaps to return the compliment. "Marnie is such a solid person and so full of integrity. She's taught me so much about listening and picking up things when people are silent."

They are sanguine about the future of their friendship because of the way they've traversed so many life stages in the last eight years. "I see our friendship as just beginning. I know it will progress with our lives," Valerie says with her typical enthusiasm. "That's kind of exciting. It's not a childhood friendship where you're stuck in your childhood jokes, or a college friendship where your only context is that four-year experience. Marnie is the one friend I will go forward and share life with.

"When I think, Who will I know in old age? Know their children? Go to every birthday party and baptism? Know every story? The answer is Marnie. And I'm sure when I want to share something about my family, the one person I'll call right away will be Marnie.

"She's my best friend because she holds up a mirror to my face and tells me everything great about it. And everything that needs improvement. She helps me grow and change and supports me. She also challenges me as I go forward."

Marnie's scrubbed cheeks, untouched by blusher, turn bright red. "That's a show-stopper!" she says. "How can I gauge what Valerie is to me? Well, she loves me and supports me no matter what I say—and only criticizes me in the most constructive way. I trust her with everything. Valerie is the closest thing I ever had to a sister. I really can't imagine my adult life without her."

Could anyone define best girlfriends better?

Sister Mary and Riki

Sister Mary Scullion, a forty-five-year-old Irish Catholic nun from a working-class background, manages a residential program for the homeless by day and works with street people camped on steam vents by night. In her spartan room on the fourth floor of a halfway house for recovering male drug addicts, her entire wardrobe, both winter and summer, barely fills a narrow closet. She lives on an annual $9,000 stipend from her order, The Sisters of Mercy, which marks her as one of the wealthiest residents in the poverty-ridden neighborhood she calls home.

Frederica Wagman is the fifty-something author of four novels, mother of five children, grandmother of five and wife of a successful businessman. She resides in a spacious art-filled apartment high above a park in the toniest part of town. Her social life is a whirl of travel, theater and four-star restaurants. While materially she wants for nothing, she has had her share of pain, having lost a child in a car accident. Born and raised as a Jew, she eventually found a measure of spiritual peace by converting to Hinduism.

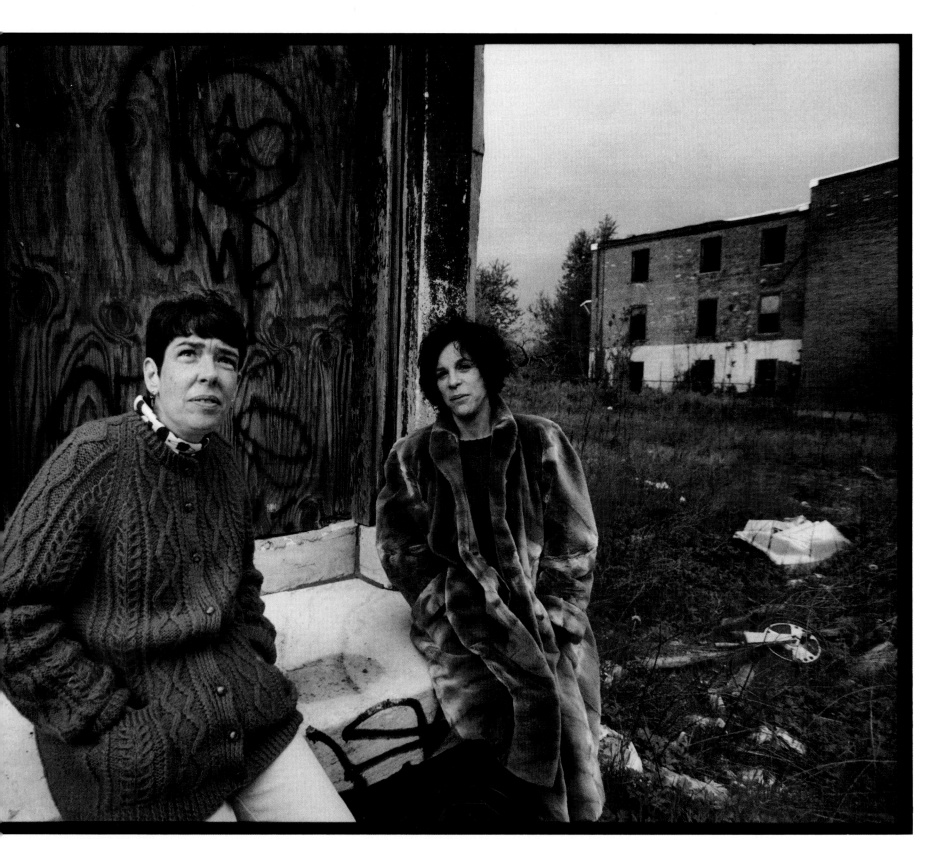

The beneficent forces that connected their disparate orbits were set in motion one bitterly cold night as Riki and her husband were walking home from a concert. "Out of the shadows jumped a bone-skinny woman with a shopping cart full of bags," Riki begins. "She hugged me and kissed me and disappeared. I recognized her as a once-beautiful old friend who had been about to go to law school when I lost touch with her. Somehow she'd become a street person! For weeks I looked for her everywhere, even though I had no idea what to do if I found her, because I was completely unfamiliar with anything about the homeless in the city. Finally someone told me to call Sister Mary for help."

Mary told Riki to simply look outside her window. "I went to my bedroom, looked below, and there on the sidewalk was my friend, huddled with her bags." Riki shudders. "The whole thing of it, me being warm and protected in this nice apartment, and this woman I cared for so much on the street, was just too much."

The next day, Riki marched over to Women of Hope, a residence Mary ran for former mental patients and alcoholics whom she'd rescued from the streets. "All of a sudden this small woman in a big fur coat comes trudging up to my office on the third floor," Mary remembers, "and everybody was staring at her. She wanted to know how to resolve the situation with her friend, and I said, 'Well, let's go talk to her.'" That visit marked their very first joint foray into the streets. And Riki's life was changed forever.

"You have to understand," Riki explains, "that I lived in a very different, protected world. I'd never seen anything like Women of Hope and its twenty-four residents. Each one was a jewel of a person who'd been saved by Mary and put in this wonderful, spiritual environment. I was transfixed. Blown away! I

immediately started going around with Mary in her street work to places that if my husband knew where I was, he'd have never let me out of the apartment. I had this huge Mercedes and we were out there picking up people from under bridges and in alleys. I was so afraid we'd get clubbed that I swapped cars with my daughter. You can't know how uncharacteristic of me this all was. I'm basically very shy, but I was just pulled into Mary's world."

Every night, after they'd distributed blankets and food and delivered people to shelters, Mary and Riki would stop at a diet ice cream parlor for coffee and conversation. Where most relationships start by wading into the pond of small talk, they dove head-first into the deep pool of ideas. Over fat-free ice cream, they explored philosophy and religion, matters of the heart and of the soul. "We had this instant rapport," Riki says thoughtfully. "You know how it is with certain people. You can get away with just being yourself. We really spoke the same language, which was pretty wild because we come from such divergent worlds."

At least a year passed before they ever got around to such mundane girl-talk subjects as a good haircut—Riki's, not Mary's, of course—and they still don't chat about clothes or shopping. "I rarely see something in the thrift shop and think, Oh, Riki will love this," Mary says, giggling. "Still, it almost seemed we were friends right from the beginning. Riki was a person I could be very open and honest with. I totally trust her and I've told her stuff I would never want anybody else to know. It's always been easy to share all kinds of things with her."

Critical to their friendship is the way they enlarge and expand each other's lives. "Mary's network was vast; mine was not," Riki explains. "I live a privileged, affluent existence. But

my world has great limitations, is much more superficial and selfish. Getting in touch with Mary, her work and who she is, really ripped all the edges away. She taught me to move beyond my small world, which for me was the best thing that could ever have happened. It was a whole new level of experiencing life that's been just unbelievable. I cared so much about her work and then about her. I guess that's what happens with dear, important friends. You care about each other."

For her part, Mary was drawn to Riki's sincerity and her pursuit of what was real and true. "I was automatically attracted to Riki because she had such deep feelings about this isolated woman who had once been her friend that she'd do anything to assist her. That level of concern and loyalty in friendship really spoke to me. Being able to share this problem about her friend freed us up to have these great conversations, and one thing just led to another. We finally decided that we must be twins who'd been separated at birth."

"Soon I wanted Mary to meet my husband," Riki breaks in, "and she wanted me to meet some friends of hers who happened to be priests. I thought they'd be really restrictive. But they are the least judgmental, most accepting people. I've found a certain spirit with Mary's friends that was new for me."

Before long they began spending holidays together—a Thanksgiving dinner at Project Home (Mary's newest endeavor in permanent housing for the homeless); an elegant New Year's Eve bash at Riki's apartment. Now they go on vacations together. A year ago Riki and her husband joined Mary in Ireland after she'd finished a retreat there. "We did Ireland my way," Mary banters. "They stayed at the convent! Then afterward I was their guest in London for five days."

"We were just laughing beyond belief the whole time," Riki says. "That's a really important part of us. The same things that strike Mary as funny usually strike me as funny, and we convulse. Sometimes at inappropriate moments, too! We wouldn't trade lives with each other, but there's definitely a place where our lives overlap."

"Yeah," says Mary. "We hang out a lot, but it's usually with some kind of goal."

They're frequently recommending and exchanging books. Mary's suggestions tend to be more spiritual in content and Riki's more literary. "We also share an enormous love for poetry," Riki points out, "and Mary reads my manuscripts, too. She's given me great advice because she's very clear about the things I'm vague about. Very solution-oriented."

When prayers are needed, there's space for them as well. "I've gone to synagogue with Riki and had Passover at her house, and she's taken me to her ashram," Mary says. "but we don't, like, bow our heads formally and pray together."

"Actually, I think Mary's got an edge with prayers," Riki murmurs with a teasing grin. "I think God understands and listens to her because she's so pure. And she's always there in times of trouble. When my husband was in the hospital, she arrived every night to take me home. I'd say, 'Don't come, don't come,' but she didn't miss one night."

"Riki has opened a lot of doors, a lot of opportunities for me," Mary says, eager to give her friend her full measure in the relationship. "But the most priceless thing she's given has been her friendship. Riki herself is a gift that makes my life rich and beautiful."

Riki blushes, deeply moved. "You know that sign on the stairs going up to your office, Mary. That one I saw the first day. I can't remember it exactly. *If you've . . .*"

Mary fills in, "*If you've come here to help me, you're wasting your time . . .*"

Riki finishes, "*But if your liberation is bound up with mine, then let us work together.* That's exactly it. This friendship has been my liberation. It's all about personal freedom. To transcend one's experience . . . to move out and beyond one's small world. Because of you, Mary, I've been able to have a real freedom of the soul and of the spirit. I think in certain ways I was already on that path before we met—but, oh, it's been so enriching to have you as my companion."

Larry and Naomi

Naomi Judd readily admits that friendship wasn't on her mind when she first set eyes on the man she'd eventually marry. "In 1979 I'd moved to Nashville with my girls, Wynona and Ashley," she begins her love story. "It was pretty pitiful. We had high hopes and big dreams, but we were living in a fleabag motel with all our belongings in some old cardboard suitcases. The three of us were sharing a bed, eating baloney and crackers. I was working as a secretary-receptionist down on Music Row. One unbelievably hot day in July, a guy walks in with long jet-black hair and a deep voice, wearing a red T-shirt and smoking a Marlboro. The guy he was with introduced him to me. 'This is Larry Strickland,' he said, 'but we call him Mr. Cool.' I couldn't believe the next words that came out of my mouth. I was so embarrassed that I ran into the office supply room."

"You said, 'I bet I could make him sweat,'" Larry recalls—as if she needs reminding. "When a guy hears a comment like that, it's a pretty wide-open door."

He waited about ten days to ask her out. "I was just about too cool for myself then," he says, smiling.

"He came to pick me up in his silver Corvette convertible," she says, "and I was real intimidated, because this guy had sung backup with Elvis. When they were on-stage, Elvis used to introduce Larry as his alter ego. He envied Larry his big bass

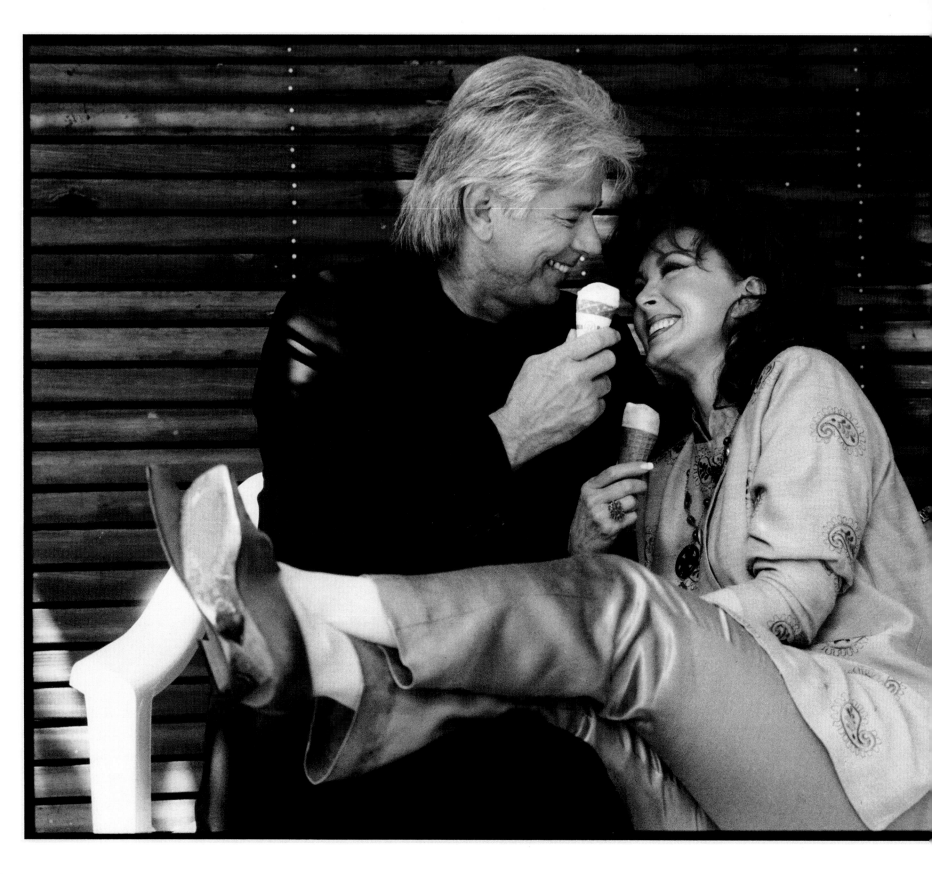

voice. And here I am in a fifteen-dollar flea market dress. We drove out to the country to see a little gingerbread farmhouse I was looking to rent. It was so run-down that the windows were broken out, and animals were living inside. We stood in the grass, which was almost up to our knees, and I told Larry that I knew he'd been around the world—literally and figuratively, with Elvis—but I said, 'This is who and what I am. My girls are the most important thing in my life.' And he kissed me, standing there in the moonlight."

"I think *you* kissed *me*," Larry suggests.

"Then we went to Baskin-Robbins for ice cream cones. I told the girls that night I felt the earth move."

"We kind of knew right away we liked being with each other," Larry says.

"And on our third date you told me you were in love with me," Naomi adds coyly, still flirting with him nearly two decades later.

They fixed up the little farmhouse, moved in with the girls, and, under the bed, Larry stowed his plastic trash bags filled with clothes that Elvis had given him at Graceland. Both men were the same size—six feet tall, 180 pounds. When Elvis began putting on weight, he'd pass on his stage outfits to Larry. "They were very sacred to him," Naomi says.

Over the next few years, Larry spent much of the time touring with his own band, singing in clubs and lounges. Naomi worked as a nurse in the local hospital. While he was on the road, she and Wynona would practice the singing act they dreamed of launching. When he was home, Wynona would climb into the beat-up traveling bus he'd parked in the gravel driveway, pretending that it belonged to her and she was a big country music star.

"I knew Wynona wanted to be a singer," Larry recalls, "but Naomi never talked about being a part of that. They'd go off to sing together in churches, but it never dawned on me they planned to be a duet. I was shocked when they signed a record deal."

Now it was his turn to be intimidated.

Naomi had just finished a road trip, and he'd come home from a gig at a local club in Nashville, when she got a call from the head of RCA Records. "Congratulations, girls," he said. "Your single, 'Mama, He's Crazy,' just became the number *one* song in the country!" Larry stared at the floor with a very troubled look

on his face. Then, without a word, he walked out and drove away.

"I will never forget," Naomi says softly, "standing in the front yard at one o'clock in the morning in the pitch black of the country night, watching his taillights going down the road. That same front yard where he'd kissed me five years earlier, and I'd thought everything would be so great. I'd been kicked in the teeth so many times. Been a battered woman. Been on welfare. I'd worked so hard getting myself together. Learning that we can't look for the right person to make us happy. We have to become the right person ourself. Then Larry comes along. And Wynona and I make our preposterous dream come true, getting into country music. And now Larry leaves. It was really hard. My personal victory was incomplete. I'm a great believer that artistic success without personal fulfillment is still failure."

A year passed. Naomi and Wynona were burning up the charts. Larry was burnt out—playing small clubs six nights a week and going nowhere. "I was flopping around like a fish," he says. "Not much direction. One night, Naomi calls—wanting to know if I would sell her some of the Elvis clothes. She wanted to make a special Christmas present for her manager, who was an avid Elvis fan."

Naomi read it as a positive sign when Larry agreed to the sale, because she knew how much he treasured those outfits. A few nights later he came to their performance. Knowing he was in the audience, she was as nervous as if they'd been singing at the Grammys.

"They blew me away totally," Larry says, remembering what it was like to watch them on stage. "I had no idea they'd gotten to this level. There was some serious stuff here."

After the show he came back to *their* superstar bus—a far cry from *his* beat-up, renovated home-on-wheels.

"Seeing Naomi again was a huge turning point," Larry

acknowledges in his low, quiet voice. "It helped me make the decision to change my life. I'd been singing since I was fourteen. Do I now swallow all my pride and ego about wanting to have this career and be a star? Because there wasn't any happiness there, and to keep it going would be a huge struggle. And here was Naomi, somebody I loved who loved me. Somebody I could have a life with."

They were married in 1989 at a big-deal, big-crowd wedding—a stark contrast to the lifestyle they maintain today.

Their office is a historic house in Franklin, a picture-book country town outside Nashville, where the main square has a cannon in the middle and the main attraction is a restaurant that specializes in fried catfish. They live in a two-bedroom house in the middle of nowhere on a thousand acres that they own. Ashley has a renovated farmhouse about sixty seconds from their front door, and Wynona, her husband and children will soon be moving into a home she's building nearby on their lake. "Our idea of a big night," says Naomi, "is to sit on the front steps, have ice cream sandwiches, watch the fireflies and talk about nature, the girls and our grandbabies. We're happy relaxing in our cheap Wal-Mart lawn chairs under a shade tree in the backyard, or taking a walk in the valley."

Recently Larry, Naomi, Wynona and Ashley took one of those walks down by the creek on their land. The water was very high, due to heavy rains, so Larry lifted Naomi up on his shoulders to get across.

"Right in the middle," Naomi says, chuckling, "the girls look over and yell, 'Dunk her, Pop!' I saw this look on his face that said, 'I shouldn't do this but I have to be a man here,' and he totally flipped me in the drink."

"Well," Larry replies with a grin. "They dared me. And if you dare somebody, what else are they gonna do?"

Larry thinks their professions helped to foster their

friendship. (Currently Naomi is a popular motivational speaker on mind-body healing and women's issues; Larry manages her business as well as Wynona's career.) "We didn't start out being best friends," he says. "We had to grow into it. Our lifestyle is all about being in the public eye. We're not like normal people, where we can socialize with friends on a Saturday night—since Saturday night means work. One of us is usually traveling. Because our time off is whenever we can get it, we aren't able to cultivate real close friends outside of ourselves—like most people do. So we've made each other our best friend."

While Naomi has very deep friendships with her daughters and her sister, no one holds the place in her life that Larry does. In 1991 a life-threatening struggle with a chronic strain of hepatitis forced Naomi to abandon the stage. (The only place she sings these days is in church.) She credits Larry with helping her make an amazing recovery from this illness, which doctors said would never go away.

"One of the reasons I am cured of an incurable disease is because of this man," Naomi says. "Many a time he would literally crawl in bed and hold on to me because I was so ill. There's critical documented scientific evidence of how your attitude and your mind impact healing. Larry was always so positive. When the doctors were telling me, 'You're gonna be taking a six-foot dirt nap,' he'd be saying, 'You're an amazing woman and you can beat this.' Today they cannot find a trace of the virus in my body. I'm a medical miracle."

"She'd always been so strong, the one that everybody could lean on," Larry explains. "For me to be helpless and not able to do anything but just be there for her was very scary."

"Friendship is about consistency and steadiness and know-ing you can count on someone," Naomi says. "We've been together nineteen years, and I still get butterflies when he walks in the room. That ain't slowing down. But the single most important thing for me is trust. I would trust this man with my life. He is totally dependable. Totally honest. And we never take each other for granted. I'm a real roadhouse mama. Very creative and free-spirited. To me, life is a menu, and I wake up every day hungry. Even though I'm this wild woman—when I'm with Wynona and Ashley we can suck the oxygen out of a room—Larry is my protective warrior. He's the psychological glue in our family."

Of the many facets of friendship, surely one of the most profound is this fusion of physical and emotional intimacy between a husband and wife. If you ask Larry why Naomi is his best friend, he answers with characteristic brevity. "Because she knows everything about me. All the skeletons in my closet. I don't ever have to pretend, or put on airs, or do anything but be completely myself around her. Completely comfortable and completely happy."

Naomi responds to the same question with characteristic loquacity. "Because he loves me for who I truly am. The older I get, the more I yearn to be completely known by someone. And we have that. Larry knew me when I was broke. He's seen me without my makeup. Stood between Wynona and me when we were fighting. Kept me from blowing my brains out when I was sick. He's been there to pull me out of the muck and to celebrate my victories.

"The other day we hiked up to a high spot in our valley at sunset, and we spontaneously went into prayer. That night I fell asleep thinking how in sync we are. How our priorities—our family and our faith—are the same. How blessed I am to have found someone who is on the same spiritual journey."

Jerry, Shirley and Dave

If you were to attempt to concoct a plot for a slightly zany but touching B movie, you couldn't come up with anything better than the true story of how Shirley turned her two ex-husbands into her two best friends.

Shirley and Jerry were married for thirteen years and had three daughters. It wasn't a bad marriage, but he liked to hang out with the guys, play the horses and watch TV. "I got restless and felt I was giving more than I got," she says. So she asked for a divorce.

Four years later, she married Dave, who worked with Jerry in the same insurance company. When Shirley moved out of her home to live with Dave, Jerry, who had joint custody of their daughters, moved back so that the children could stay in the house where they'd been raised.

Within a few years, an easy amicability replaced the initial animosity caused by the divorce. The girls even considered Dave their second dad.

Now the plot thickens, so pay attention.

Jerry began to date Helene, who, with her former husband, had been a close friend of Shirley's when they were all married. Well, wouldn't you know

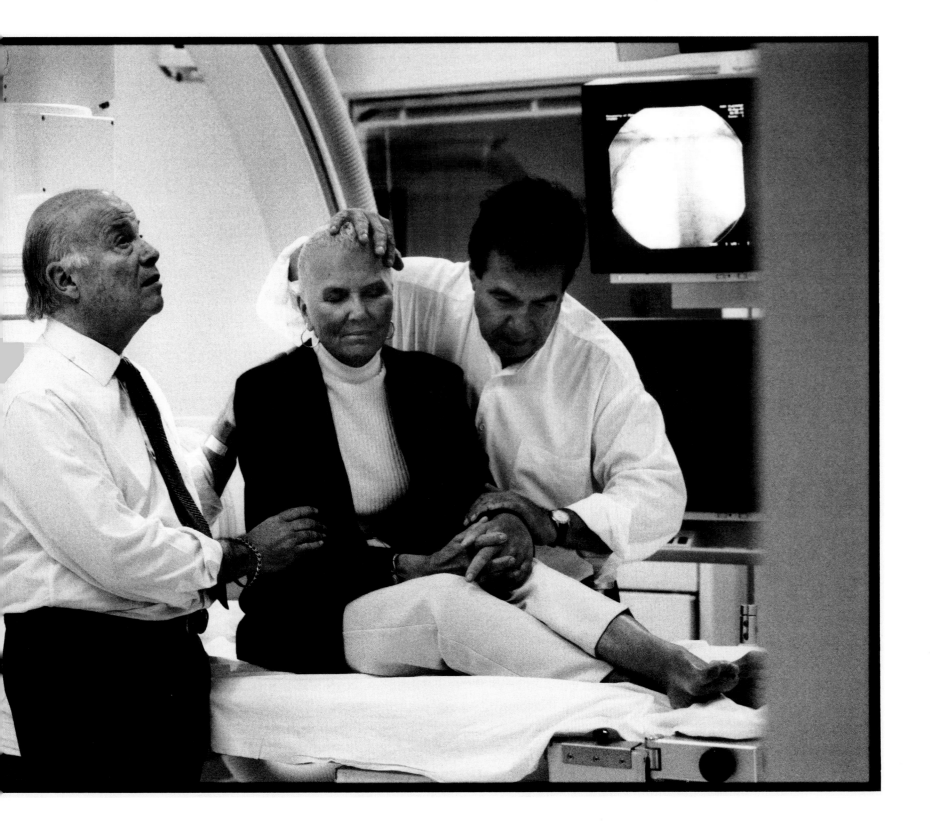

that soon Shirley, Dave, Jerry and Helene start going out regularly as couples—dinner, dancing, drinking—and the chemistry is dynamite. They have a terrific time together. Except sometimes, like when Shirley and Jerry get to talking about their kids or singing the old Cole Porter or Gershwin tunes, leaving Dave and Helene feeling like two outsiders.

Time goes by. Shirley develops a career as a massage therapist and, after a decade of marriage, divorces Dave—for many of the same reasons she left Jerry.

But after a year or so dating other people, they missed each other's company. "I kept comparing other women to her, and she's a pretty classy lady," Dave says. "And maybe the guys she dated weren't as much fun as me." Soon he and Shirley are back doing the town with Helene and Jerry. Then Dave buys Shirley a condo in the same complex where he lives, and he falls into the habit of staying the night. "But there's no more hanky-panky," he says. "Now that sex is out of the question, we gotta be friends! And when we get on each other's nerves, I can walk home."

And that's how Shirley's failed marriages became her wildly successful divorces. She sees Dave every day and talks to Jerry daily on the phone. You know how it is: there are some people you can't live with—but you can't live without them, either. Dave says, "Jerry and I were friends when I was married to Shirley, but we got to be much better friends when we both became ex-husbands. It's not like either one of us succeeded! Shirley's too fiery for one guy. Too much for either one of us. Now that we're both divorced from her, we totally understand her. She's real mature in some ways, and in others she's like Dorothy in *The Wizard of Oz*, always looking over the rainbow."

"You love people for different things," is the way Jerry defines their relationship. "You can love people for sex, for companionship, for what they do for you. Shirley is the mother of my children. She does all the holidays. Makes sure everybody's together. All the kids and grandkids. She's definitely the matriarch of the family. And there's no jealousy because she loves Dave one way, which is marvelous, and me another."

Shirley explains their unusual relationship with her own peculiar logic. "When I fell in love with Dave, it replaced the romantic love I had for Jerry. Then I fell out of romantic love with Dave, and now I love them both like you'd feel about a favorite relative. They're much better as friends than husbands. I have so much fun with both of them. I think there was a block when I was married to them. I didn't see things as clearly. I didn't appreciate them as much."

Shirley has come to truly appreciate Jerry and Dave because of the way they've rallied to help her battle breast cancer. "You hear the word 'cancer,'" Jerry says, "and you start to feel how life is like a flickering candle and you shouldn't take things for granted. I think her illness has created an additional bonding."

Shirley was first diagnosed in 1979, while she and Dave were still married. He supported her through the chemotherapy treatments, reporting daily to Jerry on her progress. Ten years later, when the cancer recurred in her other breast, she and Dave had split. On the night of her bilateral mastectomy, he had to be out of town, and Jerry sat alone in the hospital. He finally left when they wheeled Shirley out of surgery and into the recovery room, but halfway home, he turned around and went back. "If it were me," he said, "I knew she'd be there waiting to the end. So I stayed until they brought her into the room and she could see me."

In 1991 tests showed new cancer in Shirley's lymph nodes. The doctor said that unless it had originated in the breast, her chance of survival was less than a year. Two weeks later, Dave rushed Shirley to the hospital for some kind of emergency and called Jerry to meet them there. They were all together when the

doctor delivered the encouraging news that tests showed the new cancer did, in fact, emanate from the breast and was treatable. "We went out to the store and bought a bottle of vodka," Dave remembers. "We put it in a paper bag, sat on her bed and got really stiffed. Together."

Because of the heavy medications Shirley takes, she frequently requires sudden hospitalization, and Dave does the lion's share of the hospital runs because he lives close by. He says, "I can't tell you how many times I call Jerry and say, 'This is it. Meet me at the hospital. She's in bad shape.'

"Just three months ago she was delirious and shivering and I'm going through red lights to get there. Jerry's waiting and I tell him, 'She's not gonna make it.' And he says, 'You just watch. She's a tough broad.' The doctor shoots her with steroids and a few hours later Shirley's complaining the soup is cold. And a week later she's dancing at a birthday party in a miniskirt. What I've seen her go through, no human being should have to do. I really admire her. She's strong. *Strong*. She can take more than Jerry and me put together."

"That's what I respect about her," Jerry says. "The hard times she's been through emotionally, physically, financially. There's a lot of people who'd have buckled under—me being one of them. But she's a survivor. And I know that if the roles were reversed, she'd do for me whatever I do for her."

What they both do is help Shirley with her bills, give her advice and supply unstinting emotional support. "Dave and Jerry are always there to lift me up if I'm feeling bad or sad," Shirley says. "I don't think I could rely on a girlfriend as much as I rely on them. For some reason I never feel like I'm imposing. It just feels natural."

"She never asks for anything," Dave says. "She's fiercely independent."

"It's very upsetting to me when I can't do something for myself," Shirley says. "And these guys are very generous."

"Right," says Jerry. "Whatever we don't give to the horses and bookmakers we give to Shirley."

Dave gives Shirley a look that's part admiration and part wonder. "You know what her favorite song is?" he asks rhetorically. "'Someone to Watch Over Me.' One night we're sitting in a restaurant and she tells me that it's our song. Then later I find out she told Jerry it was their song. She used the gimmick twice."

"But I did find someone to watch over me," Shirley says with a coquettish smile. "I found two people to watch over me."

"Right." Dave grins. "Two schmucks sitting right here."

"And don't forget what you promised me," Shirley says, egging them on. "When I die, you're going to cremate me and sprinkle my ashes over Bloomingdale's." That will conveniently solve the problem of which ex-husband she'll be buried with.

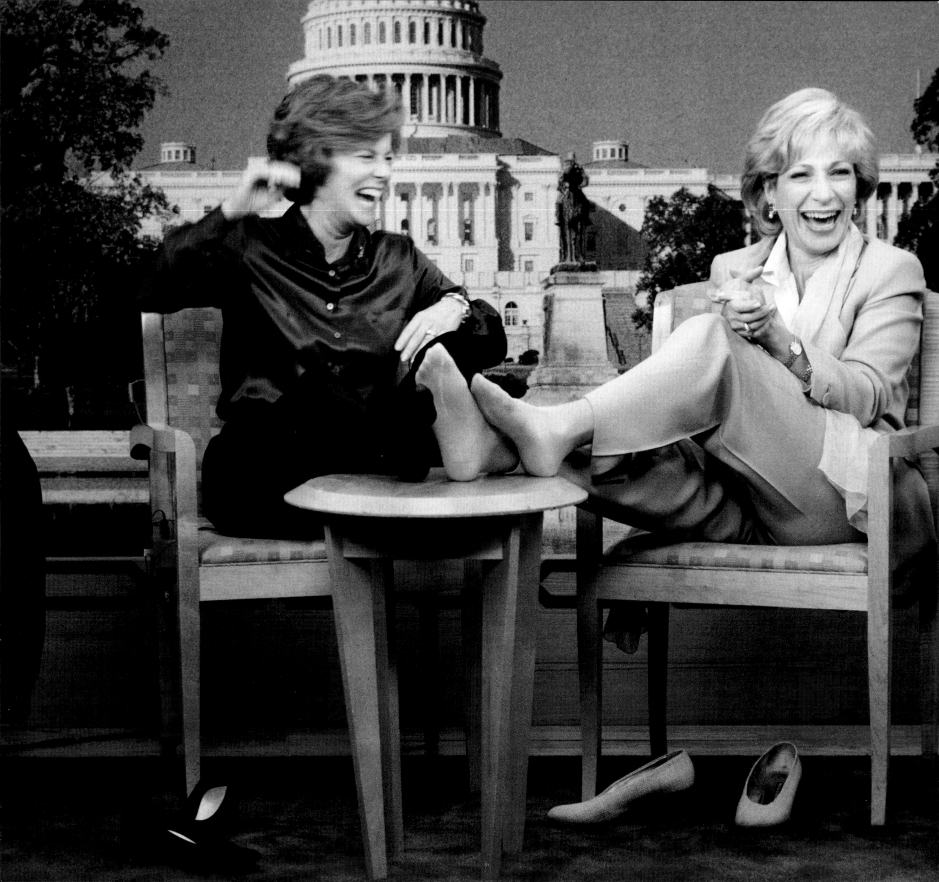

Mary and Andrea

"**A**re you taking estrogen?" Mary blurts out, tossing her overnight bag onto a chair in the Washington office of her best friend, NBC-TV correspondent Andrea Mitchell.

Andrea gives her a hug and answers, "Of course. Ever since my surgery."

It's a rainy night in May. Andrea hasn't seen Mary face-to-face since March—but why would they waste time with formalities like "How are you?" or trivia about the traffic or weather? Like most best girlfriends, whether these two were together last night or last month, they'll spontaneously slip into intimate womantalk as if they've taken a momentary pause for one of them to use the bathroom.

Mary, as bubbly as champagne, is a mile-a-minute yakker. Andrea is more like still wine—contained and thoughtful. Typically, their conversations ricochet from girlish gossip to heated social analysis. That night, their chatter about the pros and cons of hormone replacement skitters to Andrea's difficulty selecting a topic for a commencement speech, to the mental health conference Mary's attending, to what Andrea wore at a White House party, to a headline in the evening paper about the latest Clinton scandal. This isn't the public Andrea Mitchell—the coolly professional television icon. This is the chummy, warm and downright schmoozy private Andrea she turns into ... when Mary is around.

"My whole life I've been trained not to show emotions," Andrea says. "To be the observer and not the participant. Go to a state funeral and report on it. Go to Jonestown,

Guyana, and talk about mass suicide without responding to the horror. Mary is the key to that other part of me that comes home and comes undone. She lets me lose control. I don't have to explain myself with her. We were young women together twenty years ago."

"It was *more* than twenty years, my dear Miss Mitchell," Mary playfully reminds her.

"Well, twenty-six, actually," Andrea concedes, raising her penciled eyebrows with a where-has-the-time-flown expression. "How we met was a pure, wonderful accident. I was house-sitting for friends. Before they left, they said, 'We have to warn you that there's a neighbor who's going to come and swim in the pool. She'll make herself completely at home, open the refrigerator and drink out of the water bottle. Don't let it offend you. That's just Mary.' So one day this teeny tornado arrived, swam madly and athletically, checked to see what was in the fridge—and we connected."

"We share the same values," Mary says. "Family. Loyalty. Character. Making the world a better place."

What they also had in common was a passion for politics. Andrea was then covering city hall for a local all-news radio station, and Mary was in the throes of her community activist phase. (Today she is a lobbyist and public policy specialist for the Mental Health Association of Southeastern Pennsylvania.)

"That was the height of my political involvement," Mary remembers, "and here was Andrea observing and commenting on what I cared most about. In my soul, I'm much more political than any of my friends. They thought I was nuts to be a Jesse Jackson delegate to the Democratic convention. But it was a white liberal thing to do. I never had to justify that to Andrea. I never felt judged by her for my political beliefs."

"I spent my career as a journalist learning to be detached and objective," Andrea points out, "and Mary spent hers being passion-ate about things. She is the purest example of someone consistently true to her beliefs. Though we may disagree, it's always been great to bounce ideas off her about politics and government.

"Also, she had these two fabulous kids who filled in the gap for the children I never had. By the time I finally met the man who would be my great romance and friend [Federal Reserve Board Chairman Alan Greenspan], I was too old to have children, and adoption wasn't possible. But for all the years that I was single and married to my job, Mary and her husband, whom I dearly love, took care of me in all sorts of ways. They always included me in New Year's Eve—whether or not I had a date. Every summer they'd rent a house in Nantucket at tremendous expense. And when the last thing they needed was a houseguest, they'd always call to ask, 'When are you coming?' As part of those vacations, I started experiencing things I'd never done—running, bike trips, beach trips, fishing. Mary really enriched and extended my world by including me in all the wonderful ceremonies and rituals of family life."

Sometimes it went the other way and Mary got to celebrate Andrea's milestones. In 1991, Andrea was honored with a major award from an important women's organization in which Mary had been very active. At the time, Mary was off in Africa with her husband, a neurologist who'd taken a year's sabbatical to work in a hospital there. She flew back to the United States to surprise her best friend.

"Andrea gets off the elevator for the reception," Mary recalls excitedly, "and there I am. I'm supposed to be in Zimbabwe and I'm standing in front of her. She was incredulous!"

"For a moment, there was this disconnect," Andrea says. "I couldn't believe she'd done such a loving thing. I was simply overwhelmed. It was a very special moment in our friendship."

As was a recent weekend in New York when Andrea was asked to meet Mary and her daughter, Leslie, to shop for Leslie's

wedding dress. "I was incredibly moved that they would ask me to join them in such a mother-daughter process," Andrea says.

Mary shoots her a dead-eye stare. "That's because Leslie smartly knew the spending ceiling would be higher if you came along," she says, blithely making fun of her own thriftiness.

"Well, Mary doesn't spend enough on clothes," Andrea says diplomatically. "It was typical of us that at the end of our shopping, I went off to buy shoes at Bergdorf's—"

"—And I went to a street vendor to buy an evening bag," Mary finishes. "I own three coats of yours, honey," she reminds Andrea. "The red one's gorgeous. And then the blue six-button benny that's so warm and nice."

"Oh God, I was ready to give that coat to Goodwill," Andrea says, rolling her eyes.

"Andrea is so classy and I'm not," Mary says. They're both laughing. "She can walk into a French restaurant and smell the truffles. I love that."

"But I was raised with nothing financially," Andrea insists. "You had the wealthy childhood I would fantasize about. You were beautiful and spoiled. A great dancer—and I was a klutz."

"My family was *intellectual*," Mary explains. "There were lots of books, but no taste. Did you ever see how we dressed? So I get such pleasure out of the fact that Andrea has wonderful taste and that I can come visit her and we have a ladies' day and go shopping. I marvel at the beautiful things in her home. Even her bathrooms have gorgeous towels and lovely soap. This woman is astounding. She balances fifty-five things at once. She maintains this overwhelming career, says yes to charity events, remembers to send flowers to someone in the hospital and puts on phenomenal dinner parties."

It was at one of those dinner parties that they realized how valuable they are to each other from a historical perspective.

"Alan gave you that wonderful fiftieth birthday," Mary says.

"Am I past fifty?" Andrea asks in mock astonishment.

"Maybe it was forty," Mary corrects herself, smiling. "Anyway, there were about twenty of us at the table and I said something about where you got started. That stimulated you to talk about your beginnings, and afterward someone thanked me for opening up that part of you. I realized that in this interesting city of Washington, nobody has a history or roots. All the people who love you here don't know what made you. *I do.*"

"It's very important to me for someone to know how hard I worked in those early years and what made me love reporting," Andrea says. "The curiosity and love of searching for facts. The challenge of someone saying, 'Here's the puzzle. Go find the answer.' You start hitting the phone, making a million calls and connections, and one piece leads to another. Too many people today think a career in journalism just happens. Get a degree. Get hired. That's it. Mary is witness to the fact that every step was a struggle."

"It becomes more important as you age to have some record of where you've been," Mary says.

"Every stage we've been through gets more interesting," Andrea notes seriously. "Painful things like our parents aging and Mary's loss of her father. And wonderful changes, like her kids growing up. My marriage. My husband is painfully shy. He's not a social animal. So it means a great deal to me that Alan has connected with Mary. I love when I come home and Mary's visiting us, and they're eating out of the open refrigerator together.

"I actually feel I'm a more complete person today because I have all the strands of my life reflected in Mary's memory bank. And Mary is fun to grow old with because she's such a child."

Mary responds by placing a wet kiss on Andrea's hand.

"Ooh, look how pretty your nails are!" Andrea exclaims.

"I regrew them," Mary brags. "I've been getting manicures."

"I can't grow mine anymore," Andrea complains.

And they're right back into the girl stuff all over again.

Barbara
and Toni

"Hi, I'm Toni, and I'm an alcoholic."

That was Barbara's introduction to the woman who would become her best friend, although meeting a best friend was just about the last thing Barbara anticipated when she walked into the meeting that night. Seated on a hard chair among a roomful of strangers, she was fixated on only one thing: this was her last shot at recovery. She was in her mid-forties and had been in and out of the program now for fourteen years. In and out of psychiatric hospitals and emergency rooms for attempted suicide. In and out of jail for drunk and disorderly conduct. In and out of financial trouble. In and out of marriage. She'd used up all her checkout slips.

"The night before I came back into the program," Barbara remembers, "nothing truly awful had happened to me. No auto accident. No overdose of pills. No fist through the door. My husband had already walked out. I'd done nothing more than fallen, skinned my knee and scraped my hand. But when I woke up the next morning, I thought, I just can't do this anymore. I felt utterly hopeless. Utterly helpless. I'd hit rock bottom."

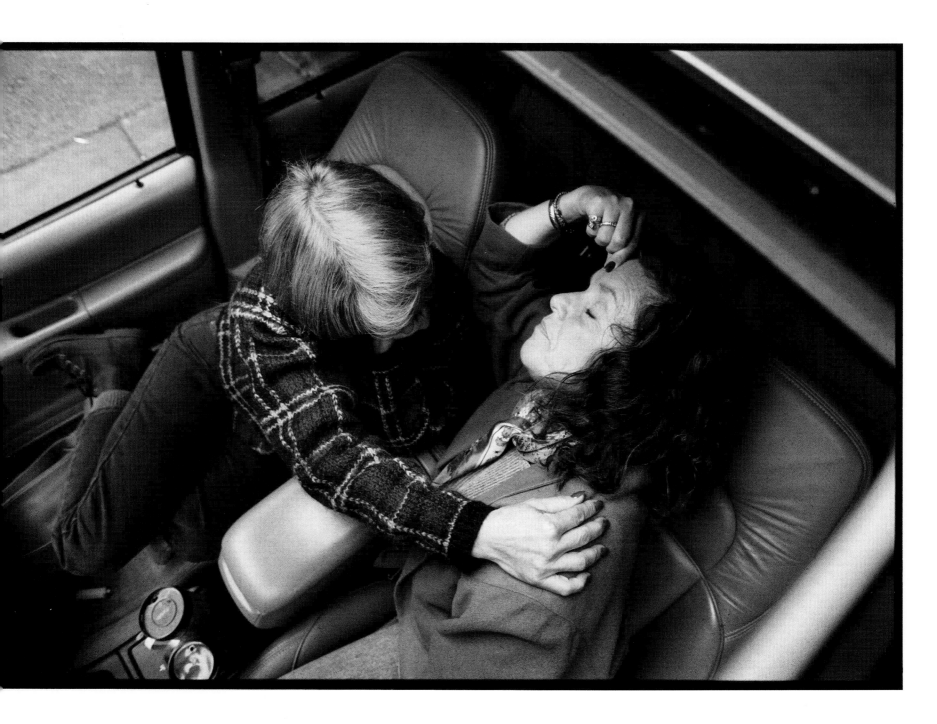

Barbara had finally fallen to the nowhere place where recovery begins. That nadir where you don't want to live but you don't want to die—and you don't know what to do but pray to God to please help stop the pain.

For a brief moment that night at the meeting, listening to Toni share her story, Barbara felt a glimmer of hope for herself. Toni, an attractive, dynamic woman, looked to be about her age. "I didn't notice Toni because of her hair or the way she dressed. It was the things she shared from her heart that I related to. She struck me as totally, totally honest and sincere. She didn't share anything specific like 'I had a rotten day at work and this is what my boss did to me.' She shared the pain she was in. And I was in that pain. She shared the shame she felt when she was drinking. And I was feeling her shame along with mine."

Toni's style of sharing is to show her vulnerability. Because she speaks passionately and openly, her words are especially powerful. "I share my experience of what it was like for me when I first came into recovery and was so afraid to admit that I had this disease called alcoholism. I didn't even know it was a disease. I thought it was a weakness. Because I don't want to drink anymore, I don't want any secrecy inside myself. So I go to this place that's very uncomfortable and say out loud what I used to do and how I did it and sometimes still do today. And I guess that allows other people to admit they feel the same way."

Barbara nods her head in agreement. "Exactly. I was pretty beat up when I came back to the program this time. I can't even describe where I was coming from in terms of my low self-esteem. "They tell you in the program to identify people who have something you want, and that's what I saw in Toni. I felt that if she could do it, I could do it. She's been there; maybe she can help me. Make me better. Fix me. And even though I was so scared of rejection, I took the chance and walked up to speak to her afterward. 'Wow,' I said. 'I can't believe you shared that

way.' We talked a little about how I related to what she had said, and that was how our friendship started."

Barbara soon became a regular at the same meetings Toni attended so that she could be assured of running into her. "I worked like a little kid at getting her to notice me," Barbara says, laughing, "because now I knew I wanted her for my friend." Soon they were going out afterward, sitting in her car drinking coffee, smoking cigarettes and discovering how much they had in common. Both had a couple of kids. Toni was divorced and worked in sales. Barb was a widow who'd remarried. Both had parents who had died from alcohol-related illnesses. Barbara's brother was dead as a result of his drinking. Toni's brother, also in addiction, would be gone within the year. It was obvious from the onset that this friendship was different from anything either of them had ever experienced. They knew the worst things about each other before they'd had so much as a glimpse of the best. They bared the most intimate details of their lives before they knew each other's last names.

"If I wanted you as a best friend, I certainly wouldn't start by telling you the deepest, darkest secrets that I'd packed in the back of my closet," Barbara points out. "But our friendship developed out of need, out of horror stories, out of pain and shame and sadness. Out of all the things that drive people away. It's totally the opposite of everything you think about normal friendship."

"In the real world, you make a best friend because you go to the same school, or live next door to each other, or your husbands are pals," Toni explains. "You go shopping, spend holidays together, take trips, giggle. Well, this is nothing like that.

"I'm not saying Barb and I have don't have fun. Some of my best laughs are with her. But what binds us is real-life stuff. I'd always had girlfriends before. I knew I needed them, but I didn't do girlfriends real well. See, it didn't matter how I felt about

them. It was making sure *they* needed *me* so they wouldn't leave me to end up alone. My whole life was spent on this facade, on being whoever people wanted me to be so they'd like me. I felt that if anybody really knew me, they wouldn't want to be my friend."

Her two closest friends—one who lived around the corner and had gone all through school with her; the other a woman she'd known nearly twenty years—didn't have a clue that Toni was an alcoholic. That's how cleverly she hid her true self.

"But Barbara knows more about me in three years than any friend I've had for a lifetime," Toni continues. "With Barbara the bullshit's gone. She doesn't know *some* of me; she knows *all of me!* To have a true best friend, you have to risk letting someone see the stuff buried inside your heart that you drank over and told lies over and hid from people. We don't have to protect each other. I don't ever have to worry, Well, I'd better not run into Barbara today, or I hope Barbara won't find out about this."

In the initial days of their friendship, Barbara was clearly the needier of the two, but she soon realized there was a valuable role she could fill for Toni. "I soon saw that Toni had nobody to dump on. Nobody to talk to. She would just give, give, give to everybody in the program and in her family. But I could be there to listen to her. Listen to *her* pain."

When doctors found a tumor in Toni's arm, she could turn to Barbara to reveal her fear that it might be cancer. (It wasn't.) When addiction killed her brother at age thirty-four, her first phone call was to Barbara. And when Toni flew back from his funeral, it was Barbara who met her at the front door.

"The hardest thing for any alcoholic is to pick up the phone and say I need help," Barbara explains. What makes these two especially important to each other is never having to ask.

They don't rely on each other to fight the temptation to take a drink—that compulsion has pretty much dissipated for both of them. Instead, they use their friendship to talk through the normal life problems that in their case can lead to drinking. For instance, Barbara, now reconciled with her husband, recently moved to a beautiful vacation home in Florida, where she was having great difficulty making new women friends in the program there. One day after a meeting, a woman who'd seemed like a promising prospect for a pal made lunch plans with a group of people right in front of Barbara without inviting her to join them. "I was devastated," Barbara says. "I called Toni and started complaining, 'I hate this goddamn town. It's awful. I hate the program. I hate the women here. I have a brand-new house and brand-new car and I hate them, too.' And I was dumbfounded to find myself bawling. Just weeping and sobbing. Toni is the one person I can't hide my feelings from. The one person I feel safe crying with because I know she's not going to throw me away."

That story evokes a similar memory for Toni. One Sunday she was desperate to talk to Barbara about a crisis with one of her kids. She drove to a meeting they normally attended expecting to find her, but Barbara hadn't come. Toni sat through the meeting and immediately afterward called her on her car phone.

"I didn't have to go through any chitchat," she recounts. "I just said, 'I need to talk to you,' and Barb came right away. That's truly what a best friend is. I got into her front seat and cried. Normally I don't cry in front of people. I remember when my mother died and everyone would say 'Isn't she doing great?' because I wasn't crying. Well, exposing my feelings is exactly what I need to do. And there, with Barb, I felt like I was four years old because I allowed myself to be vulnerable. I can do that with her because she's there for the long haul. She loves me unconditionally. The only other place I feel that kind of love is with my two-and-a-half-year-old grand-

daughter, Emily, who absolutely, totally loves her mom-mom. And with my dog, this golden Lab who wants nothing more than to lay in my arms and love me. My granddaughter, my dog and my best friend, Barb, all give me the same kind of unconditional love."

As their friendship has deepened, it has become an anchor that helps them hold on to their sobriety. "If I started drinking again," says Barbara, "Toni would be there for a while to try to get me back on track. But she could only do so much and then she'd be gone. As much as she loves me, she couldn't put her own sobriety at risk. This is very much a disease of terrible isolation and loneliness. Our friendship means too much to me to lose it by drinking."

Toni reaches for her friend's hand. "When you come into the program," she says, "they tell you that you'll find real friendship instead of loneliness. They promise you that things will happen beyond your wildest dreams. When I first heard about those promises, I interpreted them to mean I'd become wealthy, famous. You know, live happily ever after. But I could never in my wildest dreams have imagined that, if I stayed sober, I'd get a best friend like Barbara. Back then, I'd have said, 'Big deal. I have lots of friends.' But I didn't even know what the word meant.

"She's shown me that being honest about who I am is okay. I think Barb's a pretty good judge of character. If she likes me and wants to hang out with me and gets value out of what I say, maybe I can like me, too. Maybe, just maybe—because of her— I can learn to be my own best friend."

Irv, Herman, Jack, Ned and Marty

Three of the group call themselves "the birthday boys plus two" because Herman, Jack and Marty were born one day apart—June 14, 15, 16—in 1922. The other two, Ned and Irv, lived around the corner. Five inseparable pals raised within shouting distance, they walked to and from the same schools in rain, snow or sunshine for twelve years. First to Taggart Elementary, then Furness Junior High, and finally South Philadelphia High, where none of them graduated with honors. In their poor but decent neighborhood, where Jack's father owned the grocery store on the corner and Herman's dad had the candy store across the street, everybody knew them simply as "the guys from Third and Raspberry."

Together, they figure they've shared over two hundred ball games, at least ninety family picnics, the births of twenty-four children and grandchildren, eight family weddings (not counting their own), countless holiday parties and, thank God, so far the death of only one spouse. And, remarkably, for the last twenty-five years (with the help of their wives, who fortunately like each other, too), they've been meeting *every single* month either for brunch or for dinner. Usually they greet each other with big, warm bear hugs. Yet when asked why this friendship has flourished for nearly seventy-five years, they look blankly at each other. Men of their generation don't have a way—or, for that

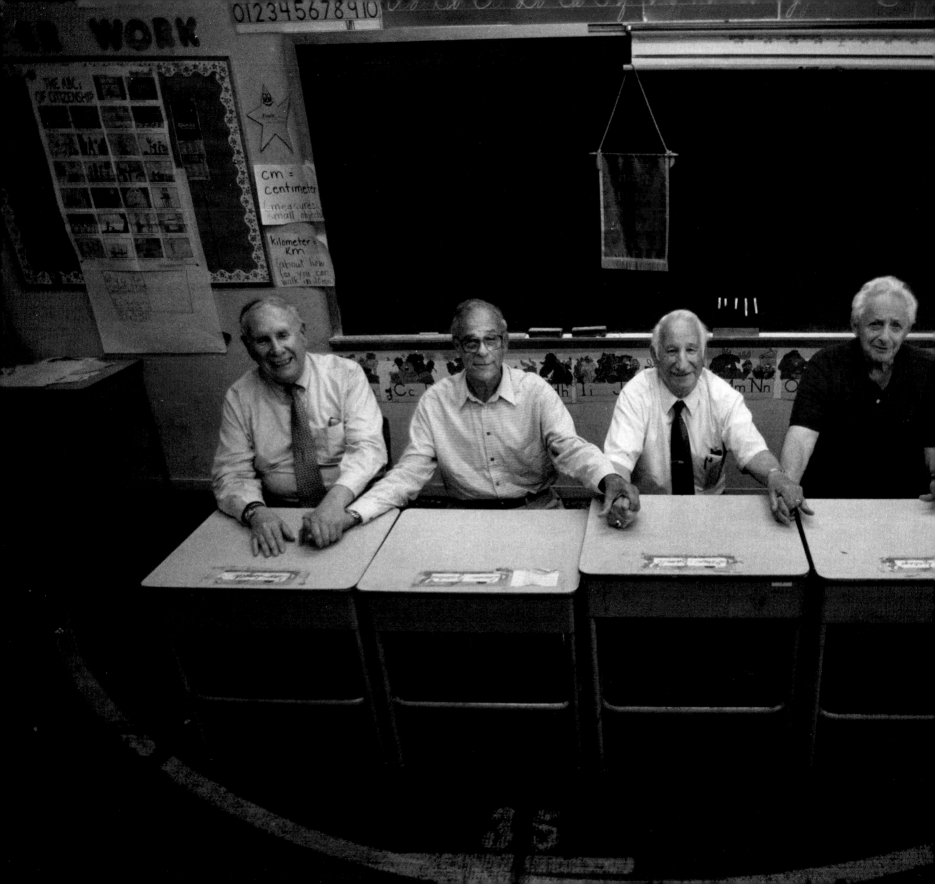

matter, a need—to express the deep feelings they share. They just know what's there: something solid, dependable and nourishing.

"How I feel about it is we all know each other from back when," Irv says, trying to fashion an answer in his gruff manner. "We can't pretend to be anything other than what we are. It's good when you can talk to people and don't have to worry about what you say. With these guys I feel very much at home."

"We've gotten to a point where we're easy with each other," Marty continues. "What you see is what you get. Nobody's trying to impress anybody else. We couldn't if we tried! We can go to each other's houses, take off our shoes, lay down on the sofa, go into the refrigerator and get a drink and not think about it. It's a tribute that we can be so free. Our friendship is a comfort zone, like a soft pillow. We just grew up liking each other. Never had to hide anything. Nothing lurked in the shadows. No secrets. We could always just be ourselves."

That is the mantra of their friendship. *Just be ourselves!* They've all married, had moderate rather than megasuccesses, moved to different parts of the city and into different careers—Jack into real estate, Ned and Irv into accounting, Marty into sales and Herman into textiles. But living and working apart have never kept them apart. In their eyes they eternally remain the guys from Third and Raspberry. As happens with best friends who are also lifelong friends, they're tightly bound up in an unbreakable net woven from the fibers of their common memories. The longer their friendship lasts, the more emotional souvenirs it produces—until the years spent together become themselves the magnetic force that keeps the group intact. "The old times, the things we did as kids growing up, that's what holds us together," Irv says. "And whenever we see each other, we pick up like it was yesterday."

Indeed, it seems like yesterday when after catching up about kids and family stuff or a recent vacation, they inevitably settle into reminiscing. How they played buck-buck and stickball in the narrow street between their row houses with the open porches where they slept outside on hot summer nights. How they earned a few pennies serving as lookouts for the cops when the older fellas shot craps on the corner. How they shot hoops in the after-school basketball league. How Jack introduced Ned to the girl who became his wife. How Marty taught Jack to drive a car when he came out of the service. "If it hadn't been for Jack calling me to go to Wharton Evening School with him," Irv recalls gratefully, "I'd have been a cab driver instead of a CPA."

"We never let anything fester. It always comes out in the open," Marty points out. "Yeah, we teased each other a lot, but we very seldom argued. And there was never any jealousy about why did you ask this one to do something and not that one."

"In that respect, I think our relationship is better than what I've observed among women," Jack says thoughtfully.

"Women are more sensitive than fellas if they're excluded," Herman says. "Me, I'm just happy that I'm part of them and they're part of me."

"Personally," Irv says, "it's okay with me if I'm not invited to some function. A friendship that goes way, way back is more important than being invited somewhere."

They all understand intuitively that a best friend is someone you not only do favors *for* but ask favors *from*. "We're always there for each other," Marty explains. "When my wife, Leah, died—we were married forty-eight years—these guys were at my beck and call. No hesitation. We could ask each other for something nobody else would. Many a time we cried together. We still sit and talk about her. They help keep her memory alive. My daughter, bless her, asks me all the time, 'Daddy, how do you feel?' But it's different with my friends. From being involved all these years, they already know how I feel. I think we can be more outspoken with each other than we can be with our own families."

The two things they almost never speak about are their finances and their health—unless it's something very serious. Ned

has diabetes; Irv's knees are shot and give him trouble walking. Marty had a triple bypass a few years ago. "We've all got pains," he says. "What's to talk about?"

And Irv adds, "We're just upbeat people."

As the years have passed, they've all developed roles within the group. Ned is the curmudgeon. Marty's job is to keep everybody happy—and to irritate Ned. Jack is the optimist and the historian, the one who reads the obits and spreads the general news. Irv considers himself the quiet, elder statesman type, and Herman, who was the Don Juan in their dating days, is now the sedate, conservative one. "But Herman never misses a thing," Marty notes. "Every once in a while he'll come out with a phrase that stops us in our tracks." They are all quite different.

"But we're compatible," Irv says. And however it is that they define compatible, they all nod in complete agreement.

"You cement a friendship when you're young and you carry it into old age," Marty says, "because you need your friends now as much as you did before. Maybe even more."

"To me, life is a book," Jack says philosophically, "and you're always writing new chapters." Through teary eyes, he looks lovingly at his gray, aging friends and sees the boys they once were. "Childhood they were there. College they were there. Getting married, they were there. I had children; they had children. We shared all these things, and fortunately it's been a very good book. Very blessed. But throughout these seventy-five long years, only the five of us could be in every chapter of that book. Imagine! Every single chapter!"